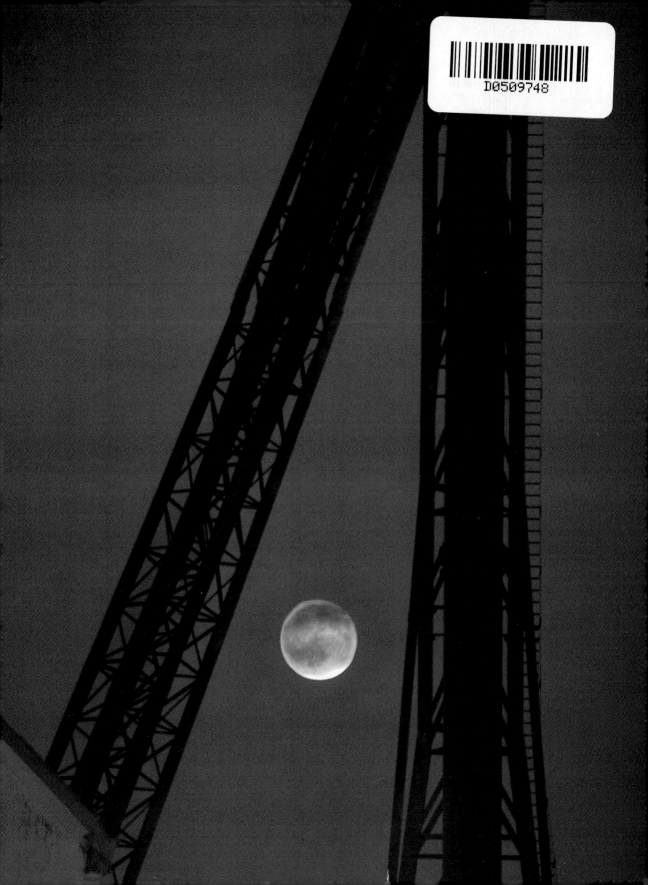

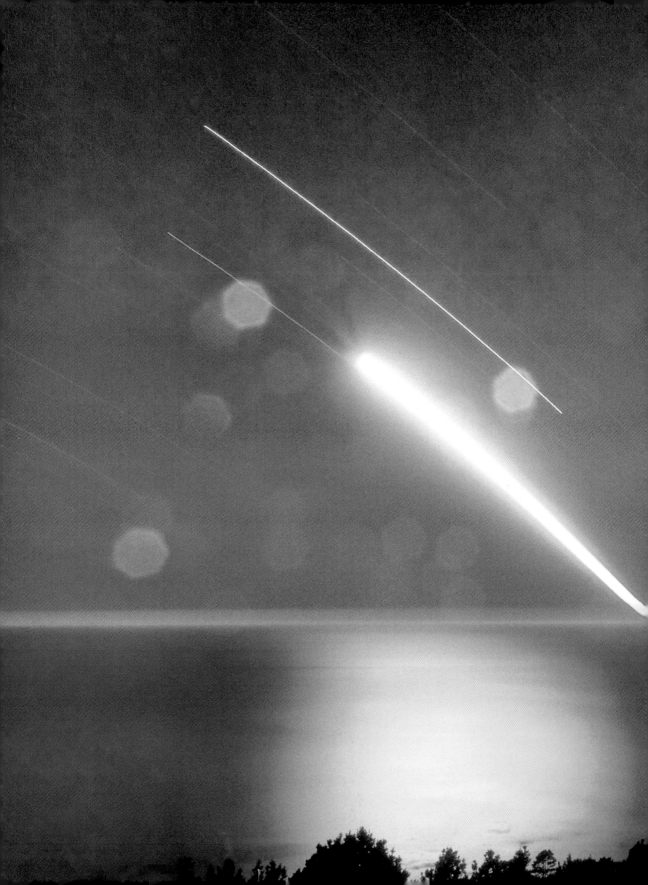

Creative Night

Digital Photography Tips & Techniques

Harold Davis

WILEY

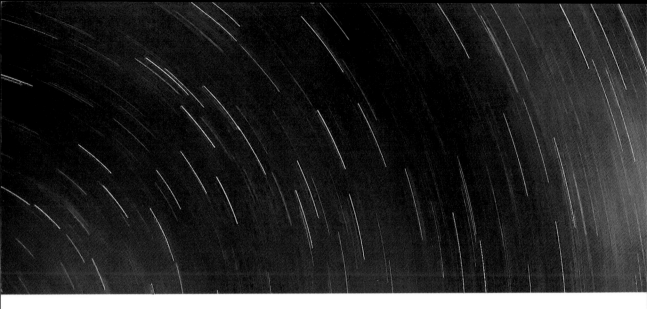

Creative Night: Digital Photography Tips & Techniques
by Harold Davis

Published by
Wiley Publishing, Inc.
10475 Crosspoint Boulevard
Indianapolis, IN 46256
www.wiley.com

ISBN: 978-0-470-52709-2

Manufactured in the United States of America

10 9 8 7 6 5 4 3 2 1

Acknowledgements

Special thanks to Courtney Allen, Mark Brokering, Jenny Brown, Gary Cornell, Katie Gordon, Jack Johnson, David Joseph-Goteiner, Barry Pruett, Joseph Siroker, Sandy Smith and Matt Wagner.

Credits

Acquisitions Editor: Courtney Allen

Project Editor: Jenny Brown

Technical Editor: Chris Bucher

Copy Editor: Jenny Brown

Editorial Manager: Robyn Siesky

Business Manager: Amy Knies

Senior Marketing Manager: Sandy Smith

Vice President and Executive Group Publisher: Richard Swadley

Vice President and Publisher: Barry Pruett

Book Designer: Phyllis Davis

Media Development Project Manager: Laura Moss

Media Development Assistant Project Manager: Jenny Swisher

▲ Front piece: This photo shows the full moon rising between abandoned construction cranes at an old naval shipyard on Mare Island, California.
200mm, 4 seconds at f/5.6 and ISO 100, tripod mounted

▲ Title page: I used an interval timer to create this long exposure of the setting moon.
18mm, about 90 minutes at f/22 and ISO 100, tripod mounted

▲ Above: This is a detail from a shot straight up at the early morning sky from the top of Half Dome.
16mm, about 36 minutes at f/8 and ISO 100, tripod mounted

▼ Page 6: I stopped the lens down to as small an aperture as possible in this night shot of the Golden Gate Bridge so that the length of the exposure would exaggerate the light trails from car head lights.
90mm, 5 minutes at f/22 and ISO 100, tripod mounted

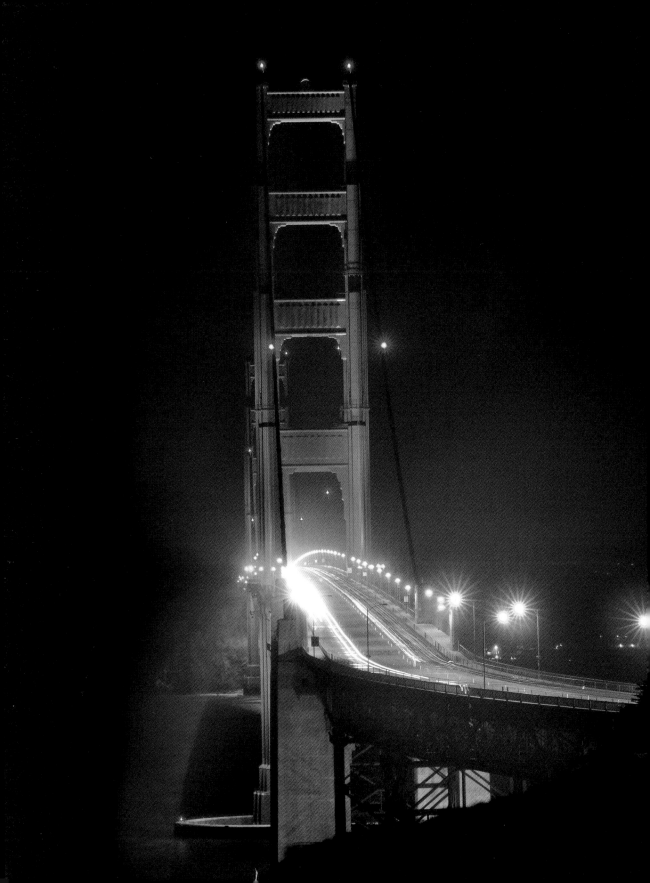

Contents

Introduction

In 1888, the great artist Vincent van Gogh wrote in a letter to his brother Theo, "It often seems to me that the night is much more alive and richly colored than the day." Van Gogh was right; the night is alive with vibrant colors, shapes and forms.

Night covers the world in darkness roughly half the time. It's a mistake to assume that because our sight is limited at night that there's nothing to see. Hours after sunset, when the world appears dull and gray, saturation lingers. In almost complete darkness, flowers exude electric colors. In the deep watches of the night, starlight produces subtle and glorious color variations.

The advent of digital photography has revolutionized the practice of night photography, because a digital sensor can record the spectacular colors of the night. These colors are created by light waves in spectrums that are invisible to the human eye. For the first time, we can truly "see" the world of the night around us. With digital equipment, there's as much to photograph at night as there is during the day.

Yet, to be fair, night photography does present some challenges that don't exist for photography during the day. To state the obvious, it is often hard to see what you are photographing, and it can be difficult to see what you are doing with your camera. Auto-focus doesn't work; forget about light meters; and exposures are all manual.

Creative Night: Digital Photography Tips & Techniques explains what you need to know about photographic technique to participate in the exuberant, and sometimes highly caffeinated, society of night photographers. I'll give you some ideas about how to stay safe as a night photographer. I'll tell you how to find the best subjects for night photography and how to approach night photography creatively. And I'll show you how to take the experience of photographing at night and use it to become a better photographer during daylight hours.

A student in one of my night photography workshops put it this way: "Now, when I'm out on the weekends, if I don't get lucky by the time the bar scene closes, I can still get a lucky photo with my camera, timer, headlamp and tripod in the truck."

Expand your horizons! Welcome to the wonderful, wacky and colorful world of creative night photography.

Harold Davis

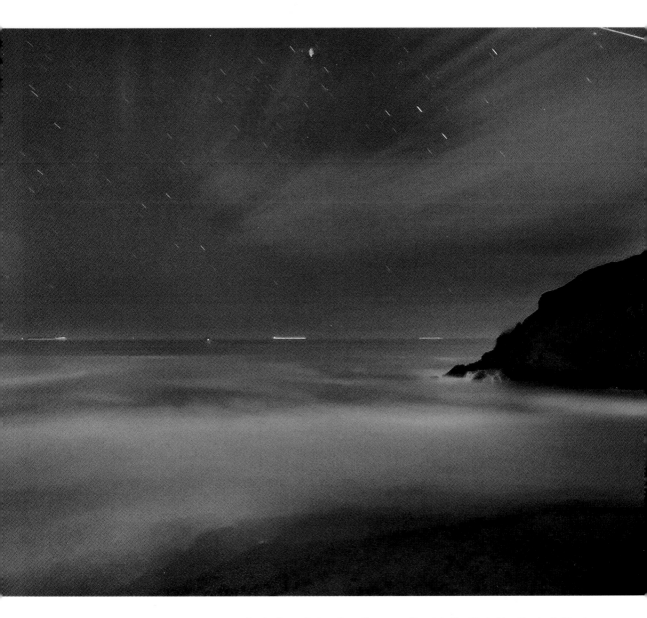

▲ Perched on a ledge above Tennessee Beach in the Marin Headlands, California, I was struck by the way the long exposure rendered the colors of the night…and made the pounding surf appear transparent.

12mm, 3 minutes and f/5.6 and ISO 100, tripod mounted

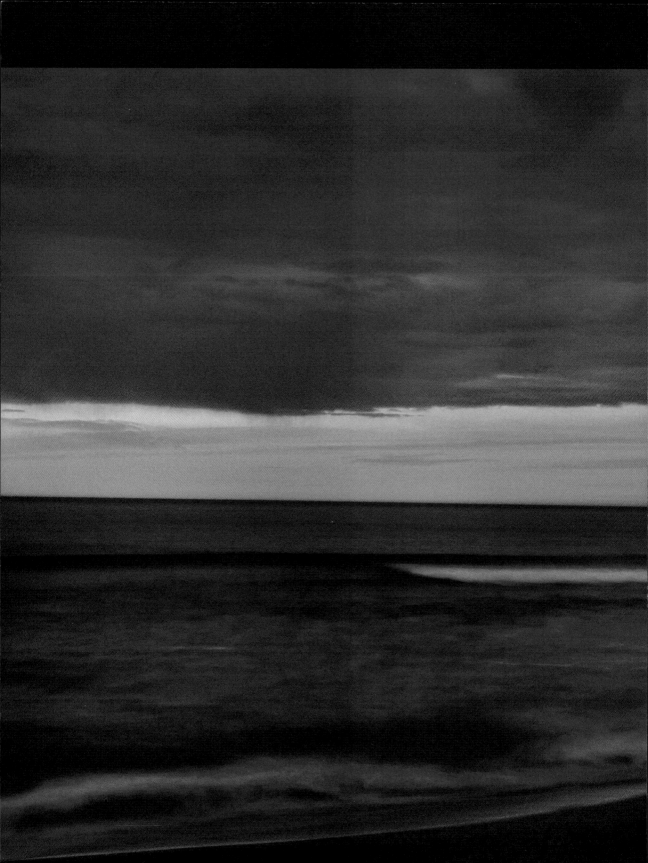

Benefits of Night Photography

As a night photographer, it's not uncommon to hear photographers who haven't worked at night say that they just don't understand. More than once, I've heard, "You blunder around in the dark and face a completely black landscape with your camera? Why on earth would you do such a thing?"

It so happens that this isn't a bad description of what I like to do with my camera in the night.

Along with the incomprehension there's a great fascination with night photography among serious photographers. A number of camera clubs have told me that night photography is the most requested topic for speakers, and good night photography workshops tend to sell out quickly.

So what is the point of night photography, and why does it draw both scorn and enthusiasm?

When figuring out whether night photography is for you, consider the following benefits of night photography:

- When you take a camera into the night, you enter *terra incognita*. Night is very

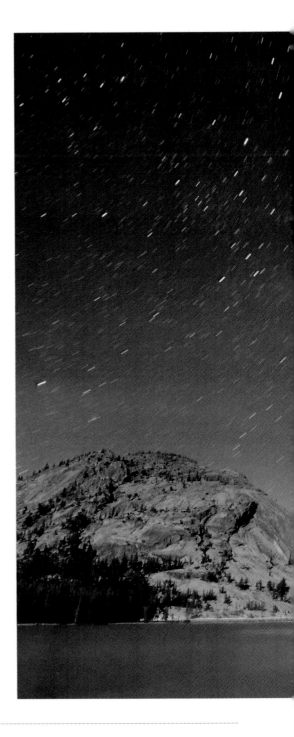

▶ Driving across the Sierra Nevada Mountains of California at night, I stopped to photograph Lake Tenaya, the subject of a famous Ansel Adams image. Lake Tenaya has been photographed innumerable times, but a night image presents a new way to view this well-known scene.

18mm, 3 minutes at f/4 and ISO 640, tripod mounted

▲ Pages 10–11: I photographed this view of a winter sea about half an hour after sunset.

34mm, 3.6 seconds at f/25 and ISO 100, tripod mounted

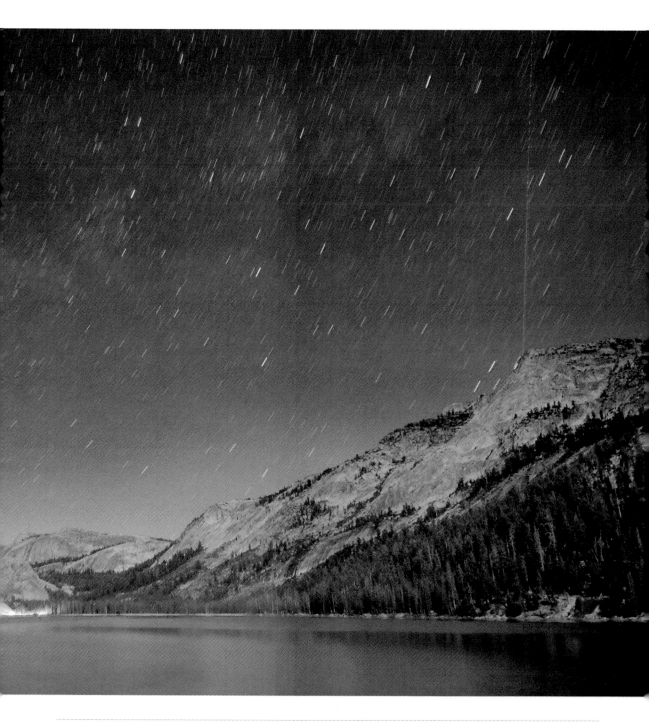

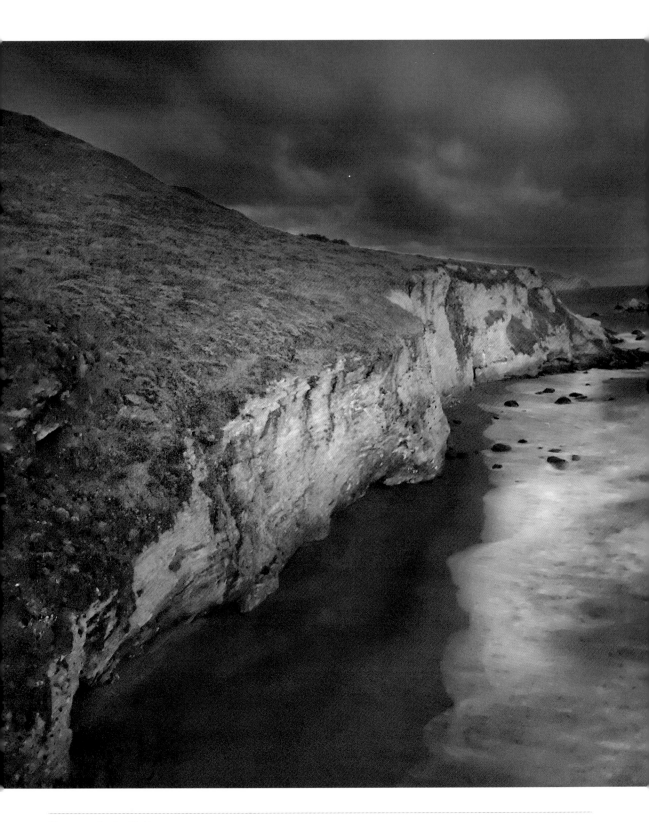

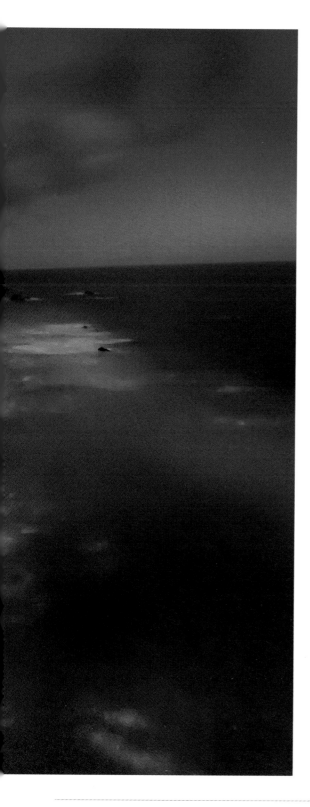

different from the day. To photograph the night is, in a very real sense, to become an explorer—with the added convenience that night is everywhere, and you don't have to go someplace exotic to begin your journey.

- Night blankets the earth half the time, and there are as many nighttime hours as there are of daylight. If you are open to the possibility of photographing at night, you'll vastly expand the opportunities available to you.

- It's possible to create spectacular photos at night—and nighttime imagery certainly arouses the interest and envy of other photographers.

- Photography at night requires going back to technique basics, as photography might have been practiced 100 years ago...except with digital equipment. Exposures at night are lengthy, manual affairs that can require great patience. So once you master the technical aspects of night photography, you'll never again have problems with photographic technique during the day.

- With the right equipment and a bit of practice, as I explain in this book, you'll feel comfortable working in the night. Having the freedom of the night lets you photograph late in remote locations, knowing you can get home safely in the dark.

◀ Taking this photo from Arch Rock in Point Reyes National Seashore, California, meant a long walk back in the dark. It was worth it because the long exposure time implied by the low light in the early night environment made the surf soften and flatten in a way that never would have happened in the day.

13mm, 10 seconds at f/4 and ISO 100, tripod mounted

Kinds of Night Photography

There are as many different kinds of night photography as there are of photography in the day. Well, not really. But almost.

The variety of subject matter that people find to photograph in the night never fails to amaze me! However, it stands to reason, because—day or night—you can point a camera at almost anything, and creative photographers are endlessly inventive.

A major interest in night photography has always been astronomical. In fact, many of the techniques used in night photography—such as stacking star trails, explained starting on page 192—were first developed by astronomers. Photographers with astronomy as their primary interest love to photograph phenomena such as lunar eclipses, meteor showers, and conjunctions of particularly bright planets and stars.

The vastness of the cosmos as exemplified by a star-filled sky at night stands at one end of the night photography spectrum. At the other end, you'll find images of the works of man: cityscapes, cars in motion, buildings and more. An important sub-category of this genre involves photographing ruined structures with night as an important part of the composition, or as backdrop.

City lights, car lights and lit-up buildings all make great nighttime subjects. In fact, the dark background of night means that almost any light you find can be used to create interesting imagery.

But why rely on existing light when you can bring your own light to the party? A significant number of night photographers enjoy creating compositions with light itself, using flashlights or other portable light sources. Light painting with these tools can be achieved in a dark room, but this technique also works well outdoors at night.

Portable light sources, including flashlights and strobes, can be used for fill lighting to light foreground areas of a night photo that would otherwise be too dark.

I enjoy most kinds of night photography, and you'll see examples of my work in a number of different nighttime genres in this book.

By day, I am fascinated by the wilderness landscape, so it was natural for me to try capturing landscapes at night. In my work, these landscapes are usually lit naturally: by moon or stars or leftover solar radiation. My night images show the world as a blade of grass, a tree or a rock might see it after dark. Taking these photos gives me a different, more patient view of a darkened world—which is one of the benefits of becoming a night photographer. There's a different rhythm and a discipline about night photography that makes you slow down and focus on what really matters.

▶ After climbing to the top of a steep ridge, I photographed this view of a lunar eclipse, as seen through light fog, using a telephoto lens. In post-processing, I cropped the image to emphasize the moon.

400mm, 1 second at f/5.6 and ISO 100, tripod mounted

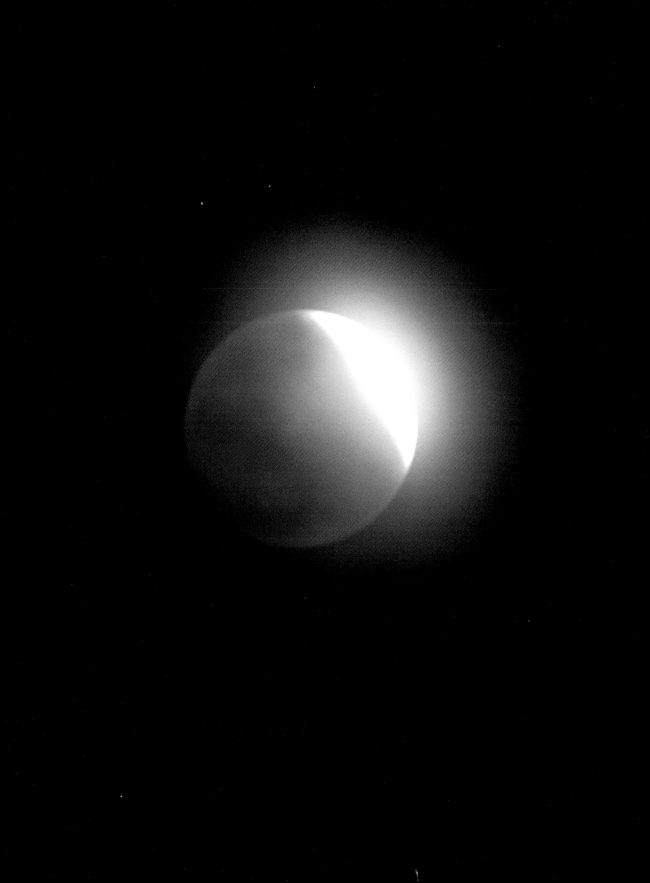

Planning for Night Photography

The requirements of planning for night photography depend upon your goals and destination. Night photography takes a little more effort than planning a shoot during daylight hours.

In addition to the normal preparation that goes into any successful photographic venture, you need to consider safety precautions at night (see pages 18–19).

Scouting your locations in daylight is advisable from a safety perspective. This will also help you identify your specific locations and lead to more successful photography. If you've seen where you'll be able to plant your tripod legs in daylight, you're more likely to get it right in the dark.

The best night photographers are literally able to operate their camera gear with their eyes closed. I suggest practicing in a dark room that has been equipped with blackout shades, or in a dark closet. At minimum, you must be able to get your camera out of the bag and on the tripod without sight before venturing out for a night shoot.

You'll need a camera that does RAW captures, has manual exposure controls and a Bulb shutter speed setting (see pages 20–47). You'll also want a sturdy tripod and a remote timer. (See page 226 for information about working with a programmable interval timer.)

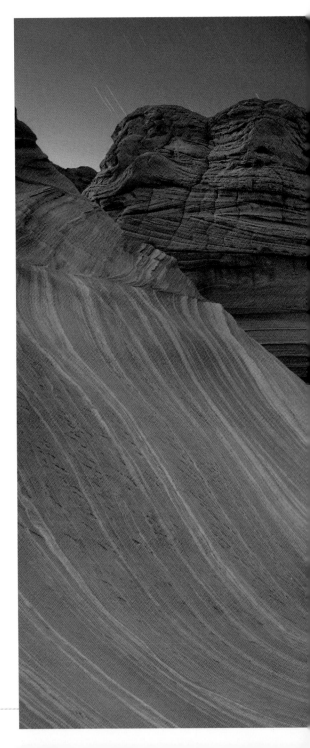

▶ This is a photograph of a well-known rock formation known as *The Wave*, located on the Arizona-New Mexico border. It was taken shortly after sunset in mid-November, as the stars began to emerge.

12mm, 8 seconds at f/11 and ISO 100, tripod mounted

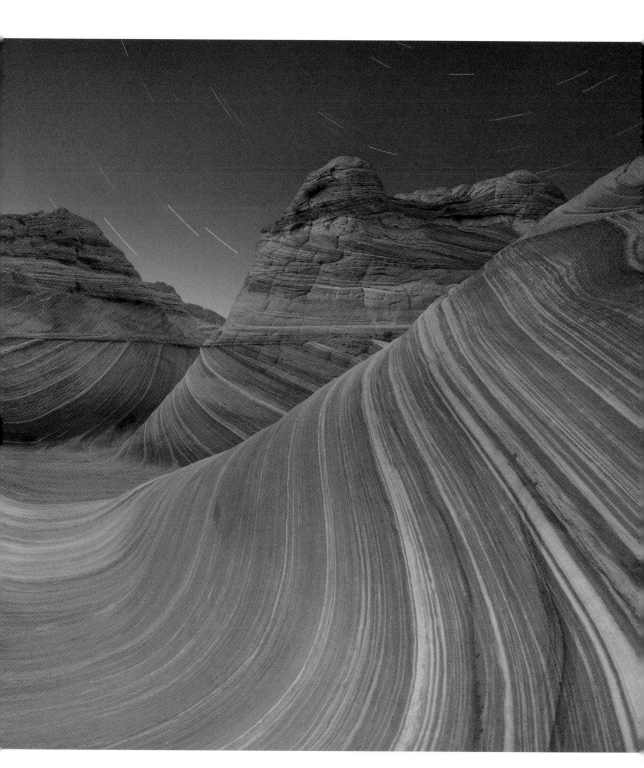

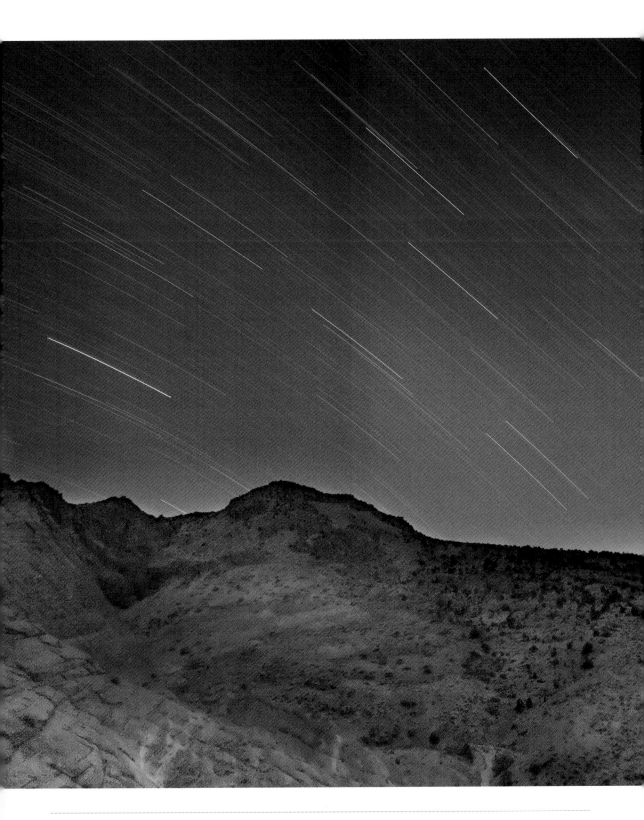

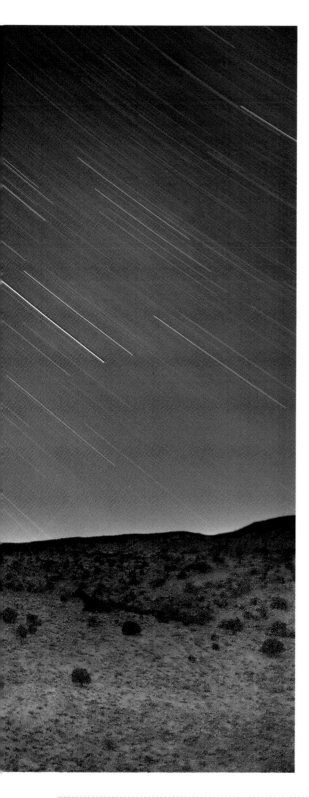

A great deal of night photography success depends on understanding the behavior of sun, moon and stars—because these will be the sources that light your photos and help to provide subject-matter interest. Experienced night photographers know in advance when the sun and moon set, and when they rise. If there are special astronomic conditions, these should be taken into account.

Good night photographers use this information to help plan night compositions. You'll find resource suggestions on page 234 that can help you pin down the information you need about moon phases, moon rises, moonsets and other celestial phenomenon.

In the northern hemisphere, star trails are more noticeably curved the more your cameras face due north (for more about this turn to pages 156–159). Part of planning a night composition that involves star trails is to consider how to have your earth-bound foreground subject visible against the northern sky. (See pages 164–165 for information about how to find north from the night sky.)

Generally, it's easier to read maps and see views that you'd like to capture during the day. So try to prepare your shots as much as possible while you can still see!

◀ After taking the photo of The Wave shown on pages 18–19, I headed across the desert toward the trailhead, where my car was parked. No doubt, in daytime I would have found my way out; but at night I got lost in the desert. I stopped on a ledge, just before the chasm shown here, and I spent the night pacing in circles to keep warm. By the way, this photo shows the vista much more clearly than I was able to see it at the time because it was almost pitch dark.

12mm, about 30 minutes at f/4 and ISO 100, tripod mounted

Safety Precautions

Your goal should be to experiment and go shooting at night ... and get home again. Great photos are icing on the cake, and safety is mostly an attitude. No photograph is worth putting yourself at risk, and there are a variety of hazards at night that you may not have considered.

Here are some suggestions for keeping safe while photographing at night:

- If you are uncomfortable being alone at night, go with a friend. Or maybe start by attending a night photography workshop.

- Know where you are going and how to get back. If possible, scout the area in daylight.

- Make sure someone knows where you are going and when you are returning. Then, don't forget to check in with your safety buddy when you do actually return. (You don't want them calling Search and Rescue when you are safely home in bed.)

- If you are taking night photos in deserted or industrial neighborhoods, be alert and make sure you are comfortable with your surroundings.

- Wear sturdy shoes, such as hiking boots.

- Always anticipate the possibility that you will get stuck out all night. Even if this is not your plan, it will happen sooner or later if you do enough night photography. Make sure you feel (and are) safe if you have to stay put. Bring warm, layered clothing, as well as food, a Powerbar or two, and water.

- Bring two light sources. One should be a good headlamp—so you can operate your camera with both hands. The second should be a backup. Bring spare batteries.

- Anticipate that cell phone coverage will not be available. (See sidebar below for a possible emergency alternative.)

Spot Personal Satellite Tracker

If you photograph at night in areas that don't have cell phone connectivity, you may be interested in Spot, a device that uses low-orbit satellites for communication. There's a charge to buy the transponder and an annual subscription fee. But the device works pretty much anywhere on the planet with an open view of the sky.

The Spot device lets you set up e-mail messages with a recipient list on the website in advance. Wherever you are, you can press a button on the transponder to send an e-mail to your list with your GPS coordinates that says either "I'm OK" or "I'm in trouble." Another button sends your GPS coordinates to local Search and Rescue agencies.

The transponder is a simple, lightweight, sturdy device that runs on lithium batteries virtually indefinitely. In my experience, it is reliable *if* you follow the directions. Keep in mind that it can take half an hour or so, facing the open sky, before it acquires a satellite to transmit your signal.

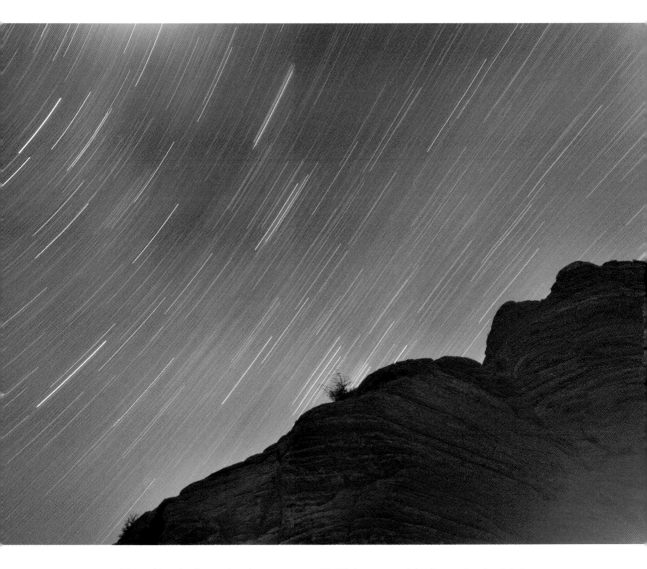

▲ After taking the desert shot shown on pages 21–22, I swung my tripod around and pointed my camera up at the sky. This was my last shot that night before my batteries gave out. (See the other photo taken earlier on pages 18-19.) The purple flaring at the edges of the image is sensor burn caused by overheating.

While waiting for dawn, so I could safely hike out to my car, without photography to distract me (since my batteries were out of juice) there was nothing to do but meditate on the vastness of the desert sky at night.

12mm, about 30 minutes at f/4 and ISO 100, tripod mounted

Cameras for Night Photography

Fancy exposures modes are almost entirely useless in night photography, because you will be making manual exposures in almost every case. Some other high-end features are also irrelevant to night photography. Image stabilization, also called vibration reduction, will not help you—because night photography is done using a tripod. And auto-focus requires a bit of visible light to work, and mostly fails at night.

Camera requirements for night photography are pretty simple. That said, the basics are absolutely necessary.

What you want is a simple, but sturdy, manual camera. The camera should have the following features:

- The ability to shoot in RAW format, the native camera file format that saves all the data from your captures. If you save your exposures as JPEGs, a great deal of information gets lost. Even more problematic, most JPEG conversion engines have no idea how to process night shots for good results.

- Have a manual exposure mode that lets you set shutter speed, aperture and ISO.

- Include a Bulb setting as a manual shutter speed option. This lets you take exposures that are longer than 30 seconds, for as long as the shutter is depressed.

- Provide a mechanism for keeping the shutter depressed, so you don't have to do it by hand. This is usually a connector for a remote cable release; it's best if the cable release automatically times long exposures.

- Have a convenient way to mount your camera on the tripod, such as a quick-release plate.

Although some advanced amateur compact digital cameras provide these features, most night photographers find that a DSLR best meets their needs. Handling a camera in the dark is tough enough without adding the hurdle of miniaturized controls.

In addition, it's a basic law of physics that the smaller the sensor, the more noise for a given size image. Since noise is an inherent problem in night photography, it is advisable to start with a camera with a larger sensor size. (See pages 34-39, 56-57, and 178-183 for more information about noise and night photography.)

▶ I dressed for winter and headed out into the night. The paths were icy but the stars were crisp and bright. I made my way to a clearing in the woods below Yosemite Falls. This would have been easy enough in the day, but it was a little trickier to find at night.

I knew that the North Star, Polaris, was right above the Falls. In other words, Yosemite Falls was pretty much due north when standing in the valley, implying that star circles above the falls would work well. I made ten separate exposures with the plan of combining the exposures using stacking (see pages 192-223). By the last exposure, dawn was coming to Yosemite. I was happy to capture the early morning colors on the mountains and water fall.

Ten combined captures with a total exposure time of about 40 minutes; each capture 10.5mm digital fisheye, 4 minutes at f/4 and ISO 200, tripod mounted

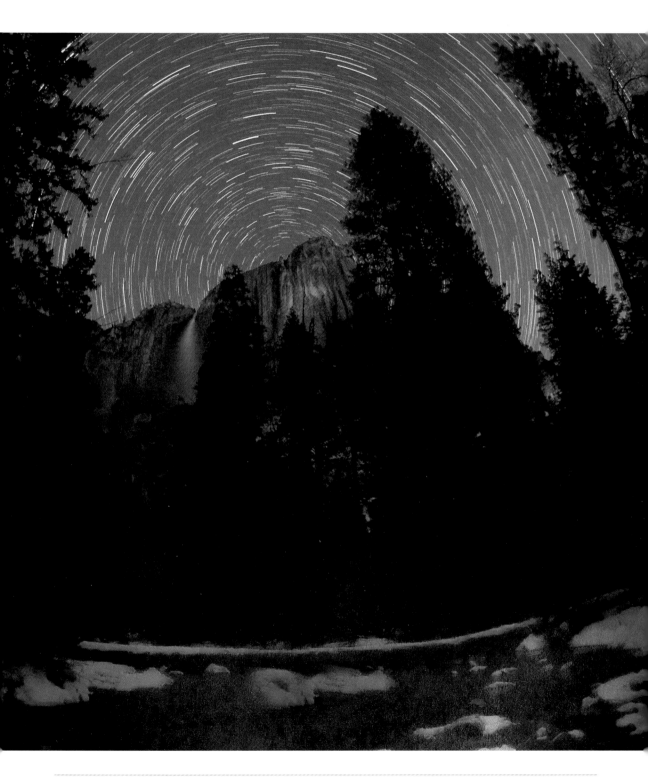

Tripods

A tripod is pretty much a requirement for night photography due to the length of exposures required. No one can hold a camera steadily enough to make sharp captures for seconds, let alone minutes.

Since night photographers will likely have their tripods longer than a given camera body, it is worth investing in a good tripod.

Professional-quality tripods come in two parts: the legs and the head. The best tripod legs are made of carbon fiber, the same material used in a variety of applications—from aircraft and artificial limbs to high tech windmill blades. Carbon fiber is lightweight, very strong and doesn't conduct cold—a surprisingly important point if you ever decide to photograph in

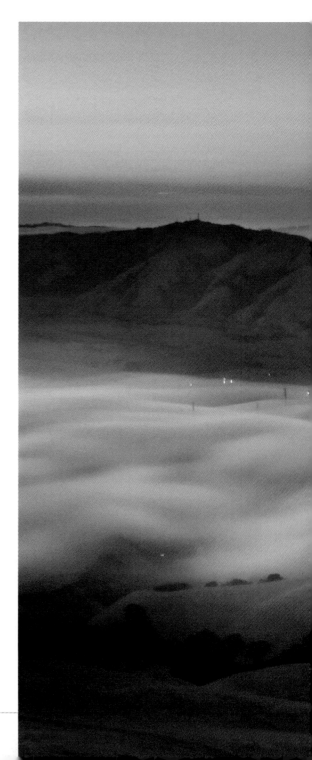

▶ This photo is from the top of Mission Peak, the highest spot in the San Francisco Bay area. It can only be reached on foot. The view shows Mount Diablo, the East Bay city of Pleasanton, California, with lights coming on, traffic on Interstate 680 and a fog bank sweeping across the foothills.

It's a steep hike up Mission Peak. When I got to the trailhead, I realized I had forgotten my tripod at home. It was too long of a drive to consider getting it, but I needed a way to keep my camera steady to take long exposures at night. What was I going to do?

Part of being a good night photographer is improvising and finding creative solutions, even when the materials at hand aren't perfect. On top of Mission Peak there's an old, hollow pipe that sticks about a foot out of the ground. I was able to plant my camera in the top of this pipe. Using a bunch of small rocks, I could pretty much get stable long exposures in all directions. Admittedly without the flexibility and precision of my tripod, but it worked.

40mm, 30 seconds at f/4.5 and ISO 100, rock and pole mounted

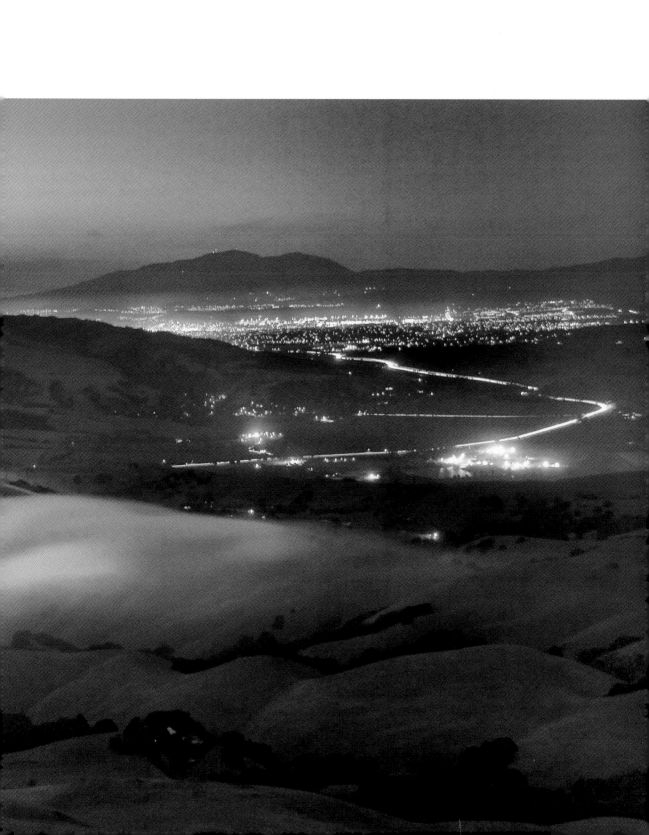

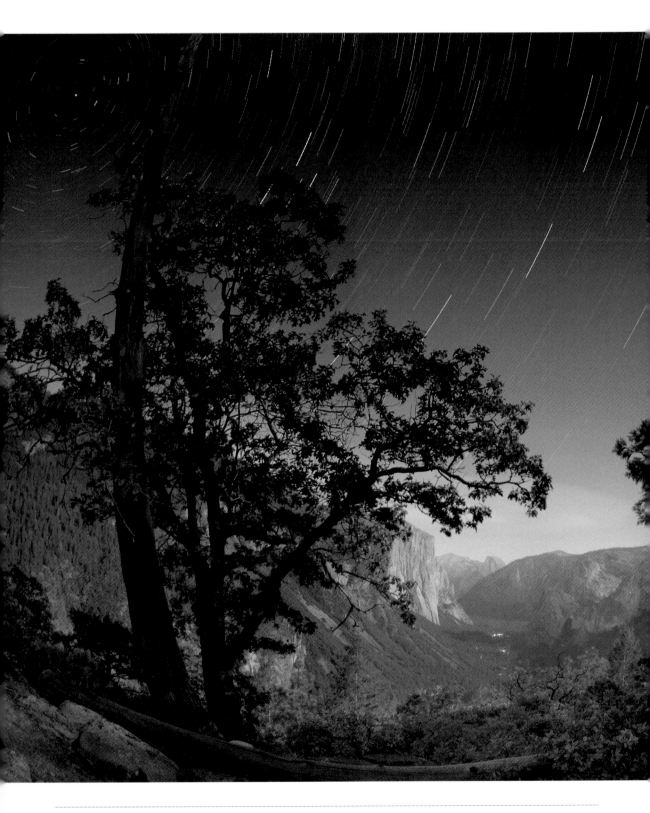

the snow. The premier manufacturer of carbon fiber tripod legs is Gitzo, a French company.

Tripod heads come in several varieties; the one you choose is a matter of personal taste. I recommend a ball head, like the ones made by Kirk Enterprises or Really Right Stuff.

If you look at your camera, you'll see that it has a tripod screw hole on the bottom. But the professional-quality ball heads that I've mentioned do not provide the screw to fit this hole. Instead, a quick release plate (sometimes called an *Arca-Swiss* plate, after the first manufacturer of the item) attaches to the camera using a hex screw. The plate can quickly and easily, but very firmly, get attached to the tripod ball head. This ease of secure attachment is very important for night photography.

It's sometimes possible to improvise camera supports. (See the story of the photo on pages 26–27.)

Depending on the weight of your camera, you can also look into alternative support devices like the Gorillapod. This is a light-weight tripod alternative with flexible legs that can clamp onto poles, rocks, chairs, trees—or almost anything.

◄ Having my camera on a tripod allowed me to create this unusual night image of Yosemite Valley. Because the background star trails were created as a composite from a number of different captures, it was critical that the tripod remained stationary during the shoot. When I combined the photos, they were in exact alignment.

Composite image, all captures tripod mounted 10.5mm digital fisheye; foreground 8 minutes at f/2.8 and ISO 100; background eight combined captures, each exposed for 4 minutes at f/2.8 and ISO 100

Power Sources

One of the few places that film cameras clearly have digital cameras beat is how they use power. If the batteries run out in a film camera, a photographer might lose the light meter and exposure auto-mation—neither of which are needed for night photography. In this case, the basic functioning of the camera is undisturbed. But with a digital camera, if you run out of "juice," you can't take photos. In fact, the power supply is a severely limiting factor in night photography.

Most DSLR cameras run on rechargeable lithium-ion (Li-ion) batteries. How much shooting time you'll get on a single battery depends on many factors, including temperature (you get more battery life in moderate temperatures) and your camera usage (auto-focusing and extensive use of the LCD can wear a battery down faster).

But assuming you've started with a fully charged battery in good

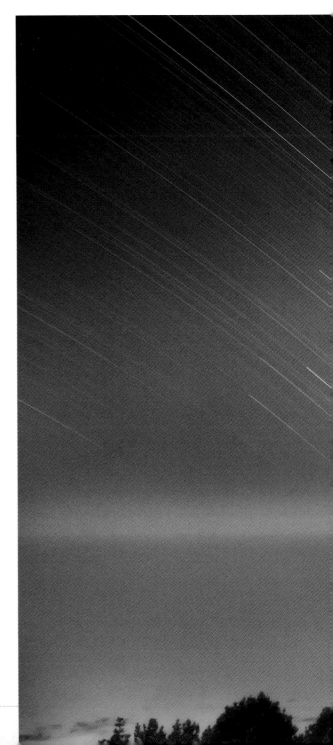

▶ Using an AC adaptor, I plugged my camera into an electrical outlet. Then, I set my interval timer (see pages 226–233) to delay the exposure until the moon had set and to keep the shutter open for about two hours.

Lest you think that night photography always involves heroic deeds, let me point out that while this photo of the Pacific Ocean at Sea Ranch, California, was expos-ing, I was lounging in a hot tub behind the camera.

18mm, about two hours at f/5.6 and ISO 100, tripod mounted

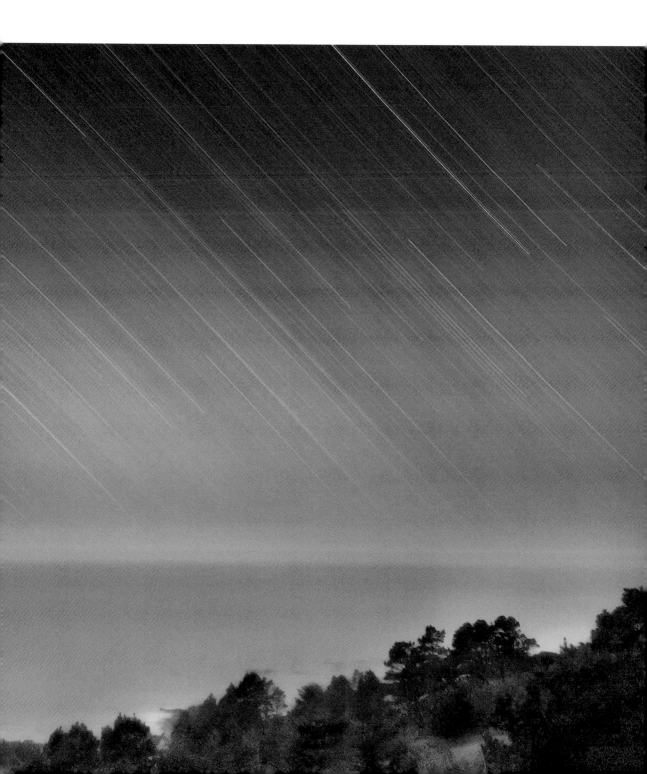

condition, you should get at least 30 minutes, but no more than an hour, of camera use per battery.

Since the exposure time for a single night image can deplete a battery, be sure to carry five or six fully charged batteries on night photography expeditions.

You can't change a battery in the middle of a single exposure, but if you are creating multiple night exposures for stacking (see pages 192–223), it is sometimes possible to use an extremely delicate touch to change batteries between exposures. If you try this, you need to take care not to shift the camera position even slightly.

Depending on your camera brand and model, there may be external power supplies or grips available that let you access the power from more than one battery.

Another alternative is to use a direct power supply rather than batteries. Direct power adapters are available for most DSLRs, but you do need an outlet. This is more problematic than it may seem, because if an electrical outlet is handy, you are likely to have unwanted "light pollution" in the area. That noted, standard electrical power can be a great solution if there are no other lights (except those you want) around.

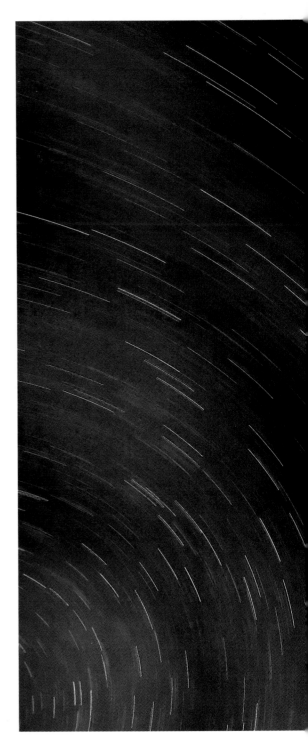

▶ Shot from the top of Half Dome just before dawn, this photo drained an entire battery. It's perhaps worth pointing out that if you are sitting on the top of Half Dome, when the power is gone, it is gone. When you use up the last of your batteries, you are no longer a functional photographer.

16mm, about 36 minutes at f/8 and ISO 100, tripod mounted

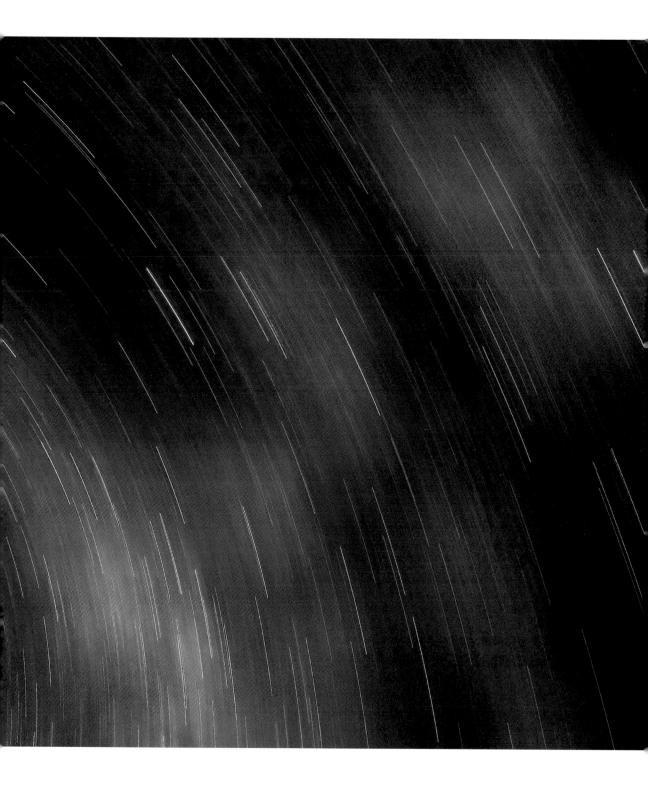

Lenses

Focal length is the distance from the end of the lens to the sensor. This measurement, in combination with the size of the sensor, determines whether a lens appears to bring things closer or makes them seem more distant.

Roughly speaking, normal lenses provide the angle of view of human sight, about 43 degrees, and are roughly 40mm to 60mm in focal length in 35mm terms.

Telephoto lenses bring things closer. Moderate telephoto lenses have a focal length from about 70mm to about 150mm, and stronger telephoto lenses go up from there.

Wide-angle lenses, with focal lengths up to about 40mm, show a broader angle of the world than we are used to seeing.

Much of the photography you'll do at night use *zoom* lenses, which have variable focal lengths. Some zoom lenses range from wide-angle though telephoto; for night photography, it's actually the focal length that matters, not the physical piece of glass.

In terms of focal length, the use of lenses at night are similar to that used during the day—with a bias toward the wide angle.

For most astronomical photography, and if you want to show the moon close-up, you'll want to use a telephoto lens with a long focal length (or a telescope). Personally, I gravitate toward wider angle lenses at night for a number of reasons:

- Most often, a compelling night image needs to show that it was taken at night. At the same time, to make an interesting composition, there should be foreground subject matter that compares and contrasts with the nighttime background of the photo. A wide angle of view makes it easier to combine these elements in a single shot.

- Critical focus is often difficult, if not impossible, at night (see pages 28–29). Wide-angle focal lengths are much more forgiving in terms of focus.

- When I am interested in capturing star trails, I know that the wider the angle of lens I use, the more curvature there will be in the star trails.

Sensor size and focal length

The smaller the sensor, the closer a given focal length lens brings you. For example, if a sensor has half the area of another sensor, then a given focal length will bring you twice as close on a camera with the smaller sensor.

The photos in this book were shot using Nikon DSLRs with a 1.5 times 35mm focal-length equivalency. This means that to compare the focal lengths in the technical captions with focal lengths on a 35mm film camera, you'd have to multiply by 1.5.

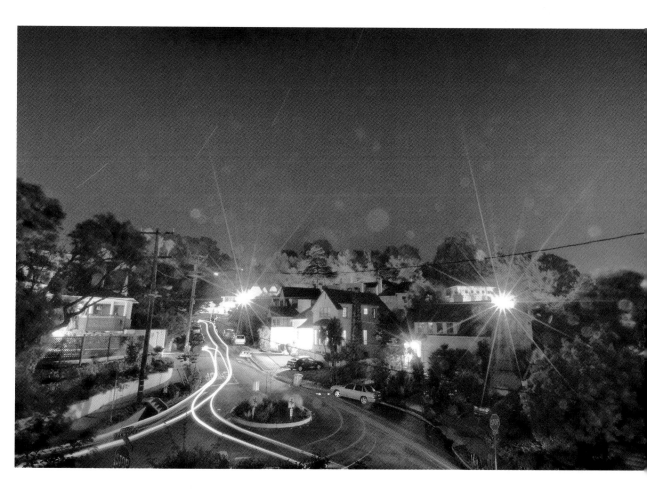

▲ I used extension cords and a direct power adapter to take this photo from a second story window overlooking a moderately busy residential street in the middle of the night. My idea was to make as long an exposure as possible—in this case, 32 minutes; to achieve the long exposure, I had to stop the camera down to as small an aperture opening as it would go (f/22).

With this long exposure and comparatively bright light sources, polygonal artifacts appear in the sky. These shapes are not dirt or rain; but are reflections and flares from the small opening of the lens. In most normal exposure situations, internal lens coatings prevent this kind of artifact from appearing.

The smaller the opening and the brighter the light source, the more you see these flares. They begin to appear in night photograph with the lens is stopped down to f/16 or below, and there is a bright light source such as the moon or a street light. The effect itself is kind of interesting, so you'll have to decide for yourself whether you like it, or whether it distracts from your overall image.

12mm, 32 minutes at f/22 and ISO 100, tripod mounted

Focusing at Night

Focusing at night presents considerable difficulties. Auto focus doesn't work. And when the auto focus mechanism can't "see" the subject to focus, most likely you can't either. So how can you focus without being able to see?

Many night photographs are taken with fairly wide open apertures because they are taken in low light conditions. The wide open apertures mean that there is less depth-of-field, and therefore less forgiveness if the photo isn't focused accurately.

As I've suggested (pages 26–27), the bulk of night photography that is not astro-nomical is created using wide angle focal lengths, which require less critical focusing. *Infinity*, marked on your lens as ∞, is the point after which everything is in focus. The more wide-angle your focal length, the less distance there is between the camera and infinity. This means that everything beyond infinity is in focus.

The most important point is to know your lenses and their idiosyncrasies about focusing.

If you know that you need to focus on infinity, the thing to do at night is to turn off auto focus, use your head lamp, and manually position your focus indicator at the center of the infinity mark. There are a

▶ Since this moody view of a single light across a bay focuses properly at infinity, I manually set the focus ring.

65mm, 8 seconds at f/5 and ISO 100, tripod mounted

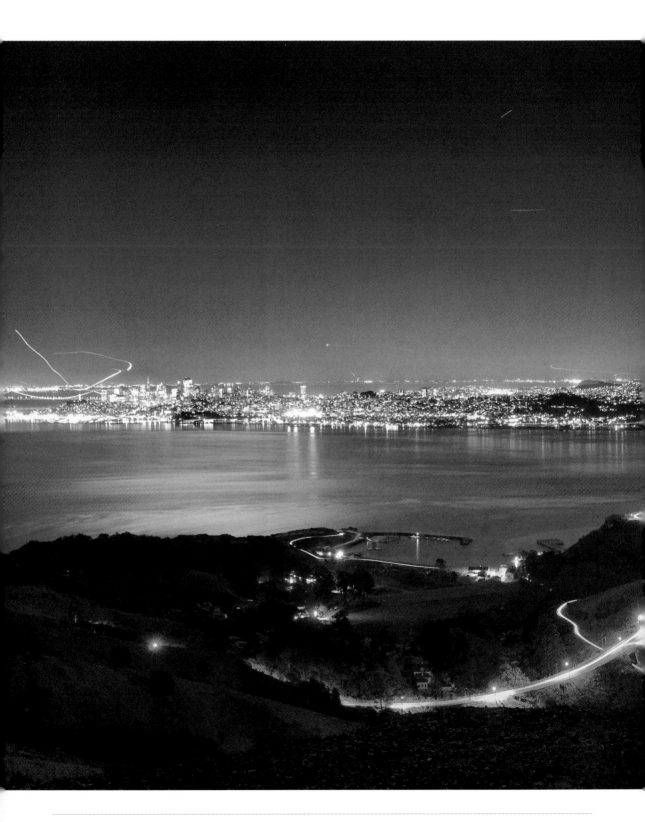

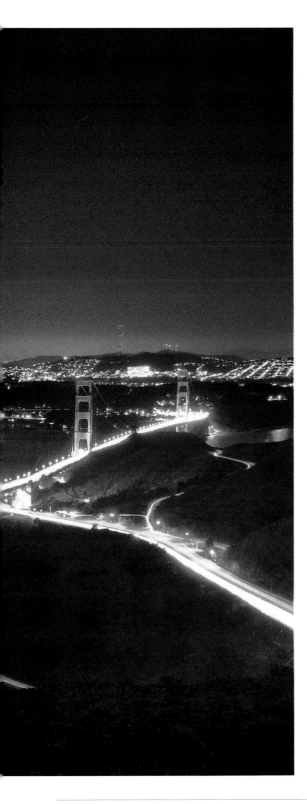

number of things to be cautious of in this scenario:

- Make sure that your focus at infinity doesn't shift between exposures because you've moved the camera or lens slightly. This can happen surprisingly easily without noticing it, and lenses vary greatly in how stiff the focusing ring is. (The stiffer the ring, the more the lens will stay in focus even if it is slightly jarred.)

- Many zoom lenses *over focus*, meaning that they focus beyond infinity on the focus ring. So, if your lens does over focus, set your focus by the infinity mark, not by feel. Of course, if you know that the end of the dial is actually infinity, it is easy to focus at infinity in the dark.

- Some zoom lenses do not focus consistently at the same spot for infinity across their focal range. The only way to determine this is to run tests during daylight hours and keep track of where to focus for infinity at a number of different focal lengths.

If you need to focus on closer subjects, there are two ways to go about it. You can guesstimate the distance from the camera to the subject, and use your head lamp to enter it on the focusing ring. Or you can light the subject and use the illumination to focus before you turn the light off to make your shot in the dark.

◀ This view of the Golden Gate Bridge and San Francisco clearly called for focusing on infinity, so I set my focus manually before starting the three-minute exposure.

22mm, 3 minutes at f/9 and ISO 100, tripod mounted

Using Manual Exposure

An *exposure* is the amount, or act, of light hitting the camera sensor. It's also the camera settings used to capture this incoming light.

There are only three settings that make up an exposure: shutter speed, aperture and sensitivity.

- *Shutter speed* is the duration of time that the camera is open to receive incoming light. It is how long the sensor is exposed to light coming through the lens.

- *Aperture* is the size of the opening in the camera's lens. The larger the aperture, the more light that hits the sensor. The size of the aperture is called an *f-stop*, written f/n, and n is also called the *f-number*. Somewhat confusingly, the larger the f-number the smaller the hole in the lens, and the smaller the f-number the larger the opening.

- *Sensitivity* determines how reactive to light a sensor is. Sensitivity is set using an ISO number; the higher the ISO, the more sensitive to light.

When you set your camera to manual exposure, you must set the shutter speed, aperture and sensitivity based on your assessment of the incoming light that will hit the sensor (see pages 46–61 for some suggestions about determining exposures at night). For the most part, when doing night photography, you should stick to manual exposure and forget about any other exposure mode.

Manual exposure means that you are the decider. But just because you are making

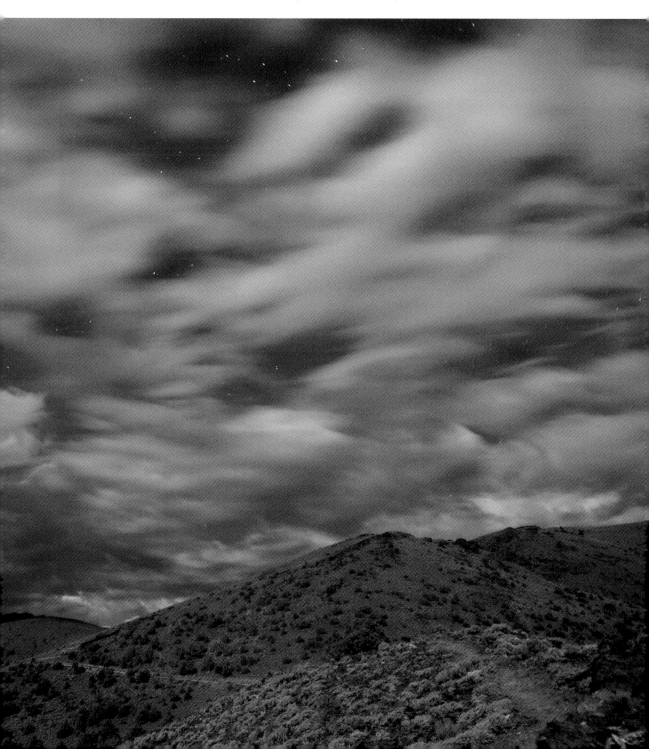

▼ The moonlit clouds in this shot were much brighter than the White Mountains (along the California-Nevada border) in the background. Manual exposure allowed me to pick settings that captured the moonlit clouds in this shot, without blowing out the highlights.

13mm, 2 minutes at f/4.0 and ISO 200, tripod mounted

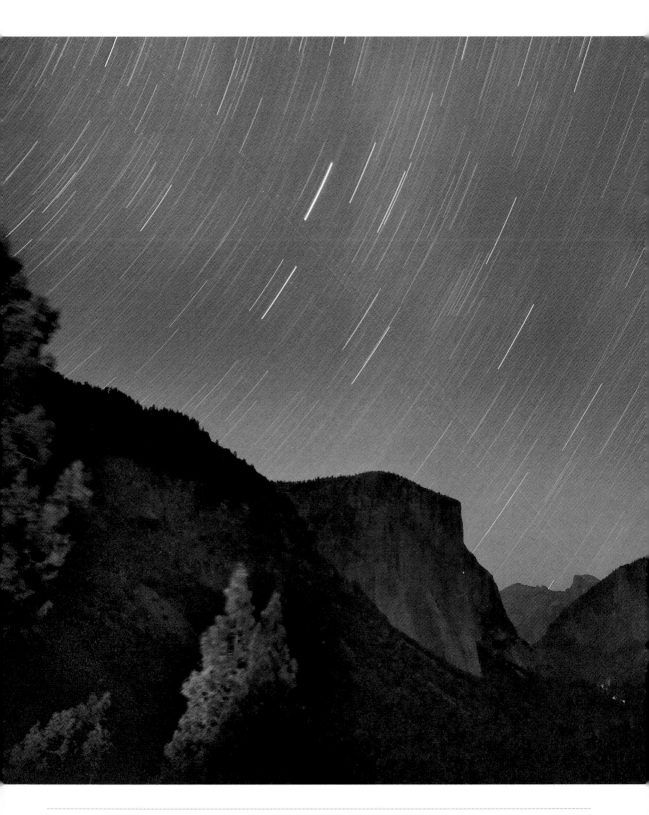

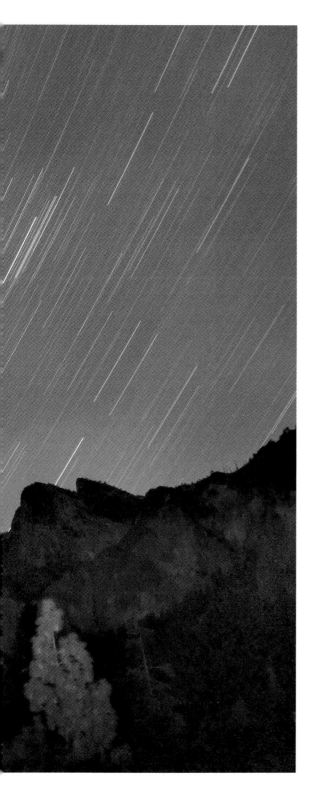

the decisions, it doesn't mean you don't have help. Most DSLRs provide exposure *readings*—light meter indications of the light out there. Light meters are helpful at dusk and as the evening progresses, but they will not help you in the deep night.

To accurately choose manual exposure settings at night, it is important to become familiar with the interrelationship of shutter speed, aperture and sensitivity, so you can adjust each setting as necessary. Shutter speed and sensitivity operate on a linear scale, so they are pretty straight-forward. However, aperture corresponds to the diameter of the lens and operates on a logarithmic scale. Put as simply as possible, each *full f-stop* lets in half the light of the full f-stop that is next larger, as shown in the table. Note that you are not limited to using "full" f-stops; but you need to know the relative values of f-stops in order to calculate exposures in your head at night as the stars twinkle overhead.

Full F-Stops	Light allowed in, compared to the maximum aperture
f/1.4 (max aperture)	N/A
f/2	1/2
f/2.8	1/4
f/4	1/8
f/5.6	1/16
f/8	1/32
f/11	1/64
f/16	1/128
f/22	1/256

◀ I had a great deal of time to calculate the difference in exposure values between f-stops in my head during this long exposure of Yosemite Valley from Tunnel View.

16mm, about 25 minutes at f/4 and ISO 200, tripod mounted

Bulb Photography

The longest shutter-speed time you'll find on most cameras is 30 seconds. To take a photo with a longer shutter speed than the maximum offered by your camera, select the Bulb setting, which is available on most DSLRs.

To select the Bulb shutter-speed setting, with the camera on Manual exposure, choose Bulb as your shutter speed. This is usually designated with a B in the shutter speed window.

With the Bulb setting selected, the shutter stays open as long as the shutter release button is depressed. But it is not practical to keep the shutter open by pressing the button directly. Apart from any other consideration, this would vibrate your camera, leading to less than sharp photos.

Generally, when you take a photo using the Bulb setting, a remote release is used. The simplest remote releases attach to a connector on the camera, although wireless connectivity is also possible on some cameras.

Very basic releases allow you to depress the shutter remotely, so that your act of pressing doesn't add vibration to the camera. The simplest releases also have mechanisms that keep the shutter depressed with a lock, so you don't have to physically hold the shutter down for the duration of the exposure; although you do have to time the mechanism. It can be a real problem to time things in the dark, because you don't want to use a light source, which would be needed to watch a clock. It's amazingly easy to lose track of time while waiting around in darkness.

More sophisticated releases add precise timing, programming and interval capabilities to Bulb photography. (See pages 226–233 for more information.)

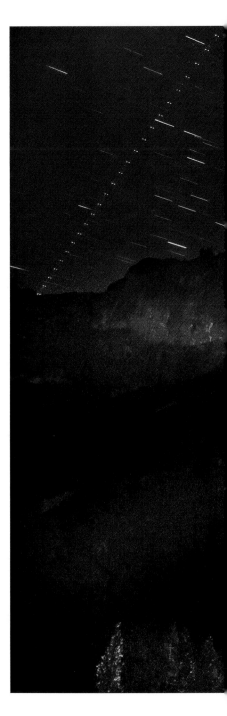

▶ I used the Bulb setting to make this five-minute exposure looking up the cliffs in Yosemite Valley.

18mm, 5 minutes at f/3.5 and ISO 100, tripod mounted

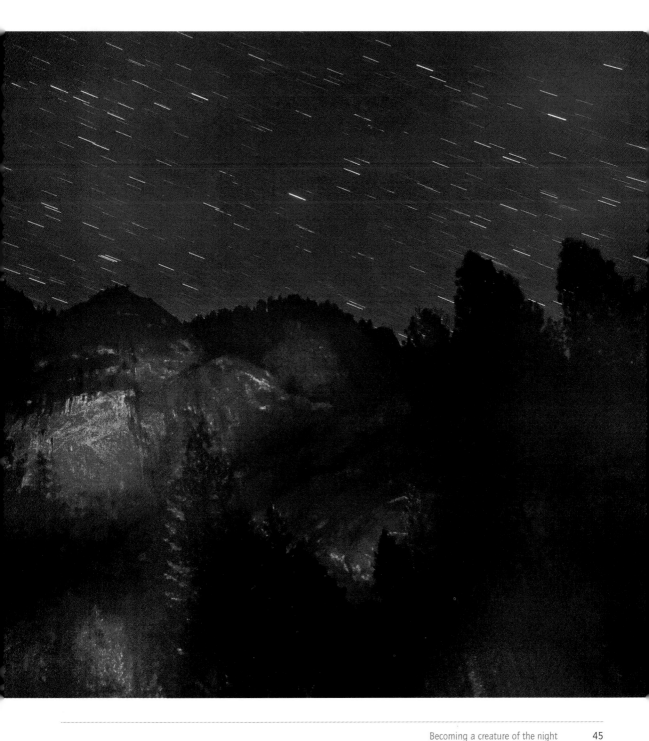

Exposing at Night

Given that the light meter in your camera won't help you at night and that night exposures are almost all manual, it can be tricky find a starting exposure in the dark.

The good news is that with digital, you can get instant feedback on your exposure choices using the LCD screen. A problem with this is that RAW night photos sometimes show as almost completely black on the LCD. Don't be discouraged with this. In most cases, the image files actually contain plenty of information for "teasing out" a gorgeous night shot. Sometimes the exposure histogram (explained on pages 58-59)—instead of the actual image—is more helpful in deciding whether your exposure is good.

Still, you don't get many cracks at night-time shots. Unlike photography in the day, when you can bracket many exposures to get one right version, the number of exposures you can make at night is limited by the length of the exposures themselves, logistics and battery life. So finding an acceptable exposure the first time is very important.

Experience helps. Ansel Adams supposedly was able to expose accurately for the moon

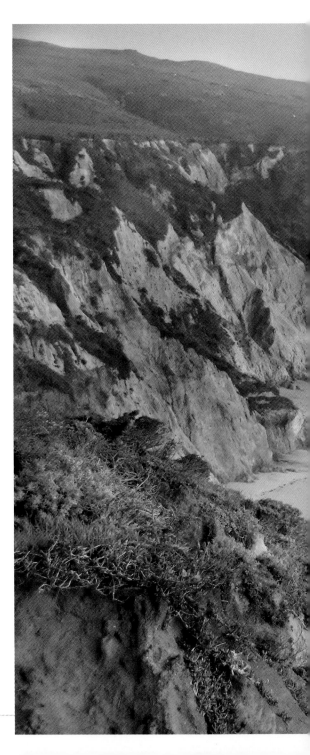

▶ A half hour after sunset, the world had gone apparently monochrome. I shot this photo using a pure guess exposure. I looked at a dark, grey image on my LCD and didn't think anything more of it. The next day, on my computer, it was clear that the colors of sunset lingered on these Pacific cliffs even though I hadn't been able to see them at the time.

40mm, 8 seconds at f/4.5 and ISO 100

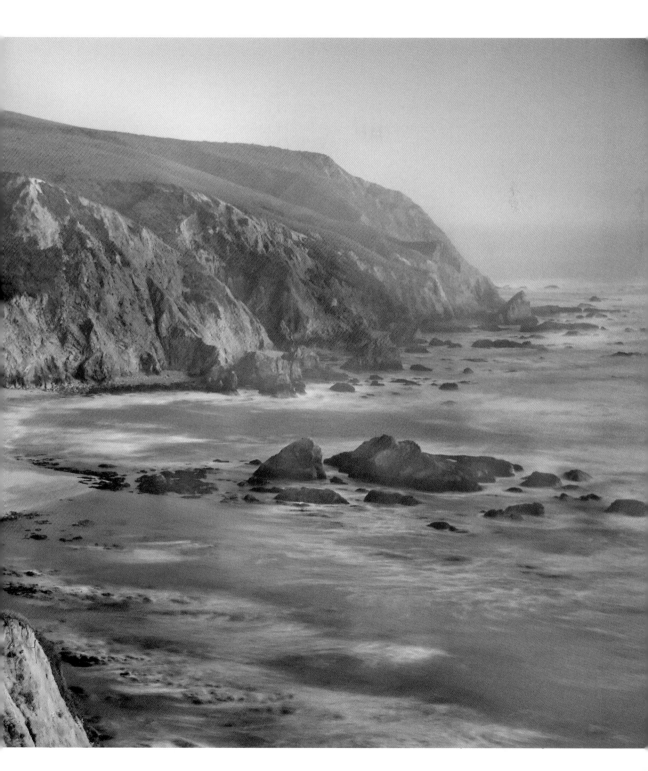

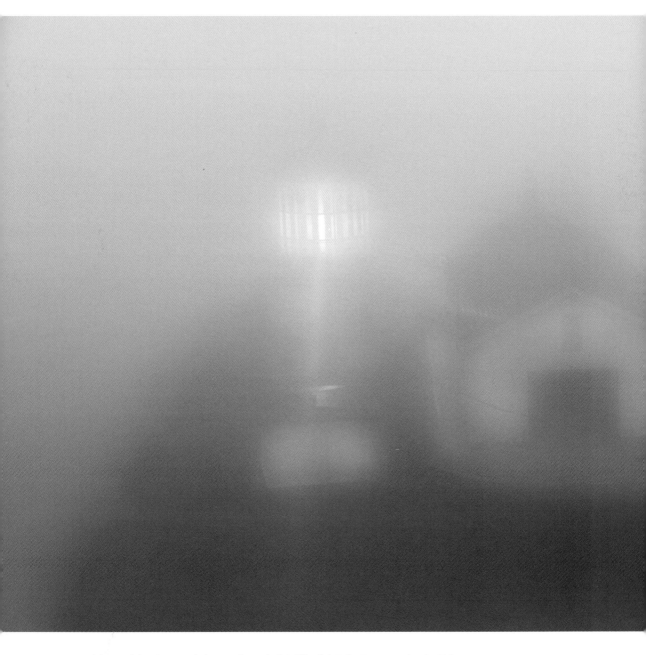

▲ I was giving a night photo workshop at the end of California's Point Reyes peninsula. This is the most western point of land in the continental United States, with weather that is often formidable. Despite the wind, rain and fog, workshop participants were in good spirits, and we went out to photograph the lighthouse in the fog. The fog acted like a giant, white diffuser, adding brightness to this early-evening scene.

50mm, 1/2 of a second at f/8 and ISO 100

in a number of situations without a light meter. He did so to create his classics such as "Moonrise, Hernandez." But until you are able to guess-timate night exposures with good results, here are a few ideas for coming up with an exposure starting place:

- Start taking pictures at dusk, after sunset. At this point, you will be able to use the light meter in your camera. Keep taking pictures as it gets too dark to use the in-camera meter, and adjust for the changing conditions. By the way, this way of coming up with initial exposure values is another good reason for being in position before it gets dark.

- Stars in the sky are accurately exposed at a range between three minutes at f/5.6 and ISO 100 and four minutes at f/4 and ISO 200. You can use this rule of thumb for exposures involving the moonless night sky, although the earth is darker than the sky.

- Make a test at a high ISO, such as ISO 1000, and then use arithmetic to find an appropriate exposure at a lower ISO. For example, if your test at one minute, f/5.6 and ISO 1000 works, then you can comfortably expose an image at ten minutes, f/5.6 and ISO 100.

Obviously, exposure issues change if you are capturing city or car lights at night; these are much brighter than the empty night, and your camera will probably offer auto-settings for starting exposures. In some situations, particularly when the moon is full (or nearly), fog can act like a giant diffuser and add a great deal of light. Try to be conscious of the kinds and vagaries of the light sources around you.

In-Camera Long Exposure Noise Reduction

Many cameras provide an in-camera noise reduction option (check your manual). This kicks in for exposures longer than about eight seconds, and it works by shooting a *dark frame* that is combined in-camera with your photo. The only downside is that your camera is occupied twice as long (to capture the original exposure and the dark frame).

Generally, you should turn on the long exposure noise reduction option. However, if you are going to combine multiple stacked exposures (pages 192–223), turn the option off. The delay caused by creating the dark frame keeps the camera from creating a stack without gaps in the star trails.

Shutter Speed

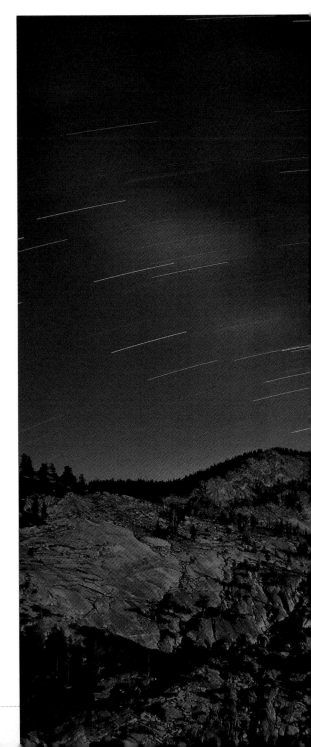

Shutter speed settings in night photography are selected for acceptable exposure *and* to render motion attractively *or* for technical reasons related to camera motion. Of course, you also need to select exposure settings that will capture the image in front of you. So if you are adjusting shutter speed to capture moving lights, or for some other reason, then you'll need to adjust either aperture or ISO (or both) to compensate.

The longer the shutter speed, the more that motion will convert discrete shapes to lines:

- At exposure times longer than four seconds, moving car lights become lines.

- At exposure times in the minutes, pounding surf becomes gentle, delicate and transparent.

- When your total exposure time reaches hours, stars become curved (and possibly circular) trails of light.

So in some sense, shutter speed acts paradoxically. On one hand, long shutter speeds turn violent motions—like that of the pounding surf—into a gentle and subtle image. On the other hand, a long shutter speed turns objects that are lit and in motion—such as stars, car lights and so on—into apparently solid lines.

▶ This is a photo looking down toward Half Dome from Olmsted Point in the Sierra Nevada Mountains of California. The shutter speed was long enough to make the motion of the stars highly visible as curved lines.

15mm, about 25 minutes at f/8 and ISO 100, tripod mounted

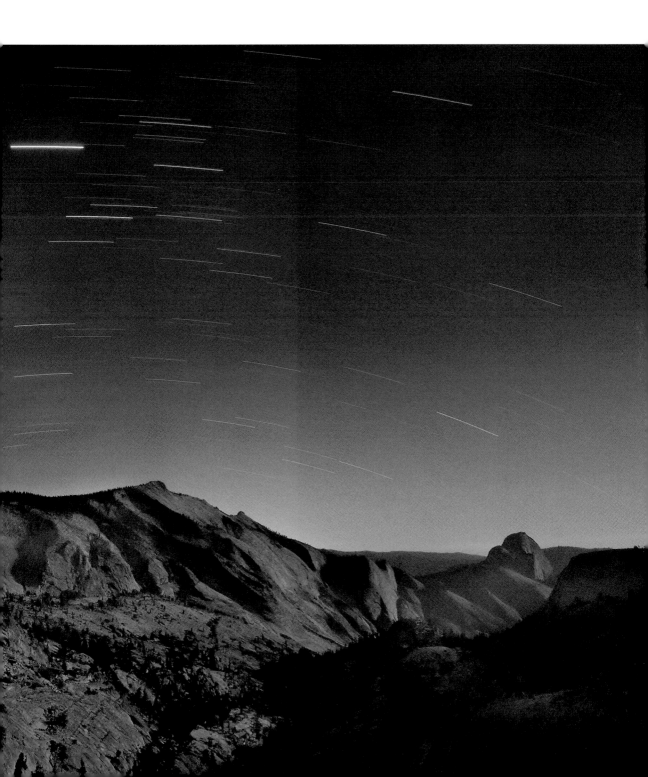

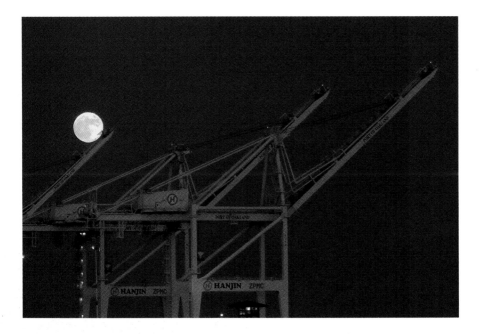

As the moon rose over the industrial cranes of Port Oakland, California, a very stiff wind was blowing. My camera, with a telephoto lens, was mounted on a tripod, but I could see it vibrating in the wind. I chose a fast shutter speed so the camera motion wouldn't ruin the photo. I also raised the ISO (800 to 1000) to accommodate the shutter speed.

Above: 190mm, 1/160 of a second at f/5.6 and ISO 1000, tripod mounted

Right: 400mm, 1/200 of a second at f/5.6 and ISO 800, tripod mounted

Aperture

The primary creative impact of aperture choice in daylight photography is on depth-of-field. For many night shots, depth-of-field is not an issue, as these photos are entirely at infinity.

If the range of in-focus subject matter is no concern, then the only impact of your aperture choice on the exposure of a photo is its effect on shutter speed and ISO. Note that stopping down a lens at night sometimes produces a variety of artifacts related to bright light sources, such as halos, stars and floating hexagon shapes that refract from the lens diaphragm.

Aside from avoiding artifacts and aberrations, the primary reason to choose a small aperture for night shots is to make your exposure time longer—to take advantage of the wonderful visual changes that car headlights, waves, stars and almost anything that moves create. You can also add filters such as a Polarizer or Neutral Density to make your exposure time longer.

▶ I positioned myself on the divider of a busy highway after dark on a moonless evening. The biggest challenge was to remember where I was. I didn't want to stick any body parts into a traffic lane by mistake. Right behind me, as I took this photo, was a traffic light. A driver stopped at the light and called out to me, "Hey man! What's your shutter speed?"

To get the effect of the lines from lights on moving cars, I had to have as long a shutter speed as possible. So I stopped down the aperture to the smallest opening (f/29). This led to a shutter speed of eight seconds, long enough to capture the effect I had pre-visualized.

36mm, 8 seconds at f/29 and ISO 100, tripod mounted

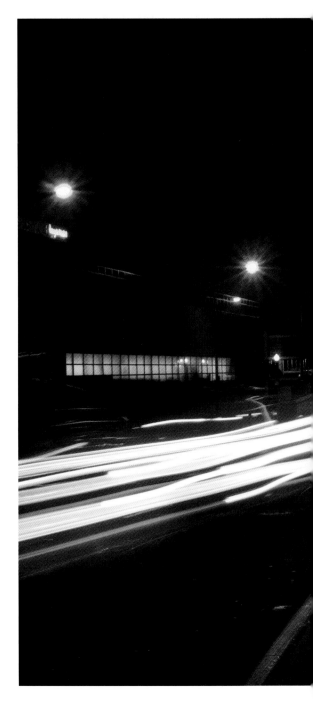

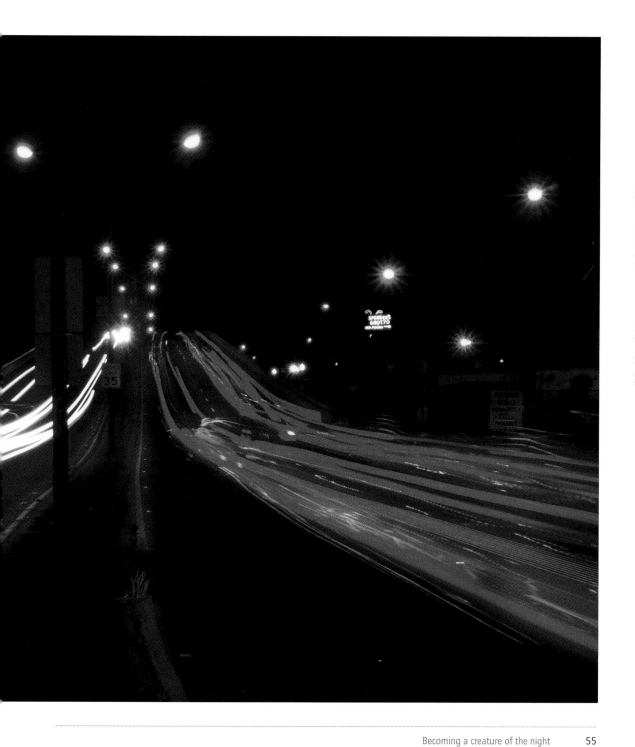

ISO

ISO, or sensitivity, can be raised or lowered easily on most digital cameras. The current generation of cameras handles high ISO settings much better than older cameras, and this technology is getting better all the time.

So one approach to night photography is to boost your ISO like crazy. If you could shoot at ISO 50,000, then the darkest corner of the world would be no obstacle…and to heck with tripods and extended exposure times.

Just keep in mind that the higher the ISO, the more noise. (See pages 176–183 for information about post-processing to reduce noise in night photos.) Underexposure, a frequent issue in night photography, also increases noise. (See the "Noise and Night Photography: A Perfect Storm" sidebar below.)

This means that even when using

cameras with improved noise-handling capabilities, ISO settings above 1000 are likely to lead to unacceptable levels of noise. So if you are thinking about leaving the tripod at home when you go out at night, consider the image to the right—shot at two minutes and ISO 640. (We're going to hold the aperture constant at f/6.3.)

To get it to a shutter speed where you wouldn't need a tripod, say 1/200 of a second, you'd need to let in $2 \cdot 60 \cdot 200$ more light than for the two-minute exposure. This works out to an ISO of 15,360,000 for the hypothetical exposure—and we're not getting there anytime soon no matter what hardware advances there are.

By the way, a fast shutter speed would probably also wreck the creamy effect of the moonlight on the moving water.

Noise and Night Photography: A Perfect Storm

Normally, noise—visual static in an image—comes from a camera's sensor and processing software. The smaller the sensor, the more noise; some noise is inevitable because that's the way digital signal processing works.

Night photography involves three factors that can significantly increase noise:

- The ISO setting: The higher the ISO, the more noise there will be. If you're thinking about boosting the ISO to get away from long-exposure noise, forget about it. You have just substituted one cause of noise for another.

- Exposure time: Exposures that are longer than about five seconds—most night photos—can become quite noisy.

- Underexposure: Underexposed areas tend to have more noise. There's a tendency, often for good reason, to underexpose night photos—but this leads to still more noise.

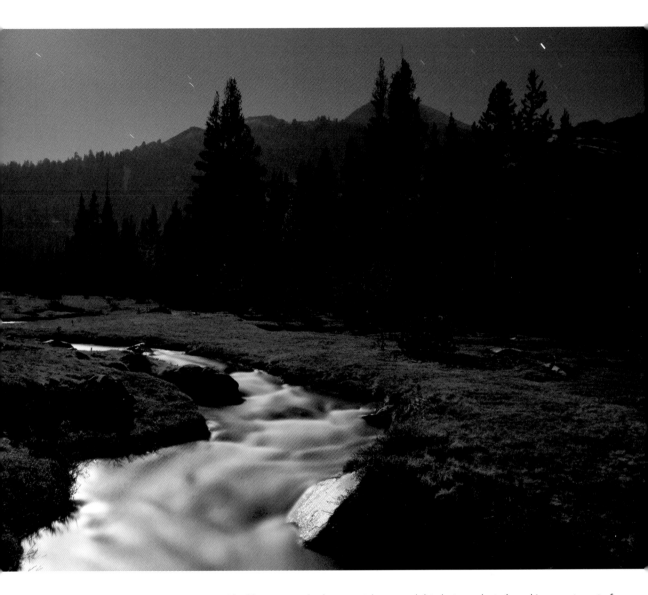

▲ I had lost my way in the mountains on a night photography trek, and I was wet most of the way through from having crossed and re-crossed the creek. But I was saved by the magic of the moment as I noticed the moonlight's effect on the flowing waters of Unicorn Creek in the Sierra Nevada Mountains of California. It made the water appear almost silken. To capture this effect, I needed an exposure of about two minutes, so I raised the ISO. This gave me a shorter exposure than I could have achieved with a lower ISO.

18mm, 2 minutes at f/6.3 and ISO 640, tripod mounted

Using the Exposure Histogram at Night

A *histogram* is a bar graph showing a distribution of values. An *exposure histogram* shows the distribution of lights and darks in an exposure. (See examples of exposure histograms on pages 60–61, or check out how they look in your camera.)

Your camera will show the exposure histogram for a capture you've made. Some cameras will show the histogram during composition before you've actually made the exposure. Check your camera manual for details on how to display exposure histograms.

Sometimes at night it's difficult to see on an LCD screen how an exposure came out. Some nighttime photos that are rendered as black, or near black, on the LCD turn out be full of rich and vibrant colors—provided the photos were shot as RAW images, and you take the time to tease out the information from them when you process the RAW file. In other cases, the rendering of night images on an LCD screen, even if they can be seen, is wildly inaccurate, and a histogram is a better guide.

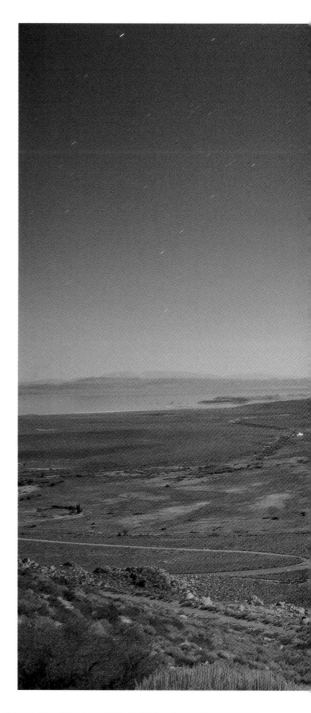

▶ In the middle of the night, Mono Lake in Eastern California was lit by a setting moon. From a high overlook, the scene appeared almost as bright as day, so I adjusted my exposure histogram toward the middle to capture the "day in night" effect in my image. You only really know that it is night by the single car careening down U.S. 395 that bisects the scene.

12mm, 85 seconds at f/4 and ISO 100, tripod mounted

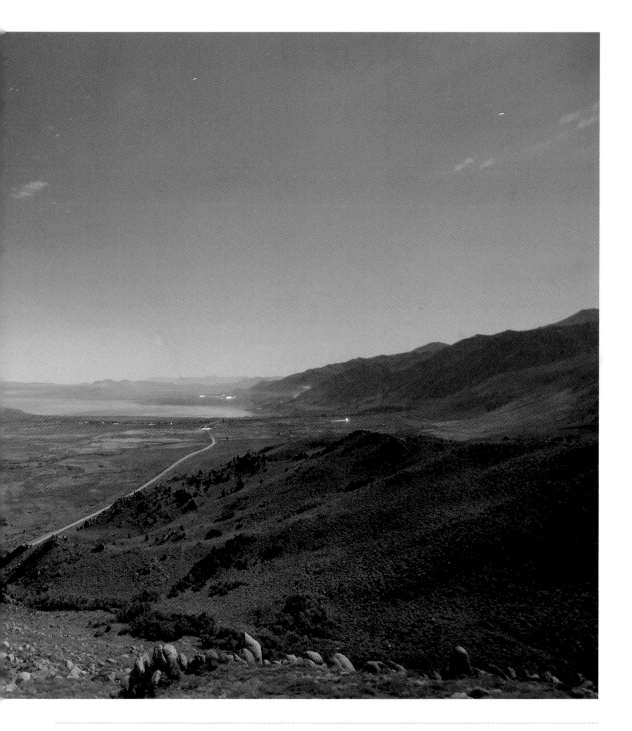

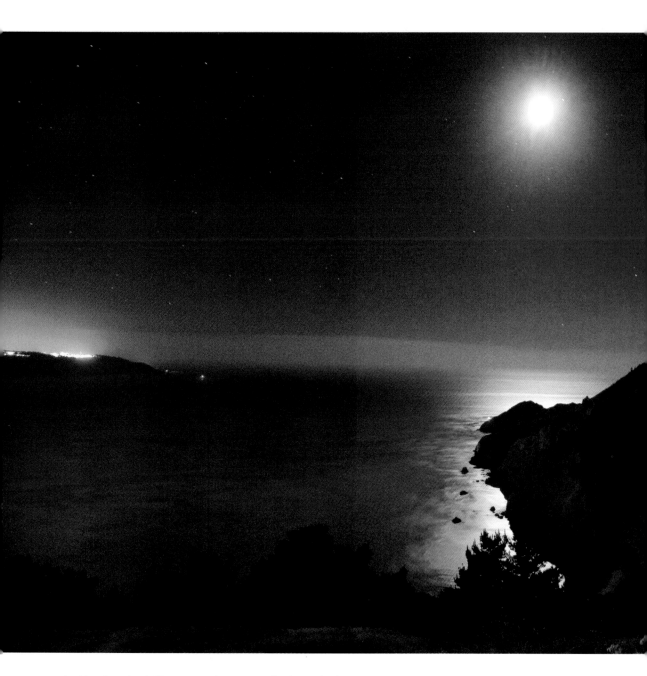

▲ Looking from the Golden Gate at the moon setting beyond Point Bonita, California, I felt that the scene was magical. I decided to concentrate on capturing the moonlight, allowing the hills and water to go dark. So I aimed for a histogram that was bunched on the left, with a few spikes toward the right, in order to capture the moon and its reflection in the water. The resulting image is a bit noisy, but I think that the noise is less important than the poetic qualities of this scene.

18mm, 30 seconds at f/3.5 and ISO 100, tripod mounted

The exposure histogram of an underexposed photo is bunched to the left, and the exposure histogram of an overexposed photo is bunched to the right. A theoretically "correct" exposure is represented by a histogram with a bell-shaped curve smack dab in the middle.

Underexposed

Normal exposure

Overexposed

The ideal position of your histogram in a night photo depends on what visual effect you are looking for.

Theoretically, if your histogram shows a normal exposure, then—besides the color temperature of the light sources—there will not be much difference in the appearance of a night image from a day image. Your viewers won't know your exposure time.

As an example, moonlight is a little cooler in color temperature than sunlight, but not by much. A moonlit scene that does not directly show the moon, and is exposed according to a down-the-middle histogram, will look much like daylight. This is a pretty weird effect... and sometimes worth attempting.

In other words, if you are trying for this "day in night" effect, then you should aim for a histogram graph in the middle of the exposure range.

But, if you want your night images to look like the night, then you'll want to underexpose your photos a bit. In this case, your histogram should be bunched to the left, which is only natural for night photography because the scene *is* pretty dark.

A night left-biased histogram should have *some* values that reach toward central parts of the graph; otherwise the photo may be too dark overall. Also note that underexposure is one of the causes of excessive noise in photos; like many creative aspects of photography, use of the histogram at night is one part science and one part art.

Light Painting

A photograph of star trails uses the light emitted by the stars to "draw" lines on a photo. Moving car lights are "frozen" into lines by time exposures. Both of these effects take advantage of existing moving light sources, so the photographer is capturing a scene somewhat passively.

However, there are ways for a photographer to take a more active role...to paint with light, particularly when a long exposure is being made.

Light painting is a technique that's generally used for one of three visual purposes:

- To make darker areas of a photo, such as an important element in a dark fore-ground, acceptably bright. This is called *fill lighting*.

- To light something in a special way to increase its visual interest.

- To create an image in which the subject of the photo is the light itself.

Most night photographers use light painting at some time in their career. Some photographers use light painting almost exclusively.

There are all kinds of light sources that can be used for light painting. Keeping it simple means using the head lamp or flashlight that you use for navigating the night terrain. This can produce perfectly acceptable results. You can get more elaborate with colored lights, glow sticks, gels and transparencies. The only real limiting factors are what you can carry to your night photography locations and the availability of power for your illumination devices.

Whichever kind of light painting you do, some general principles apply. You never, ever want to point the light source directly at the camera because this can produce unsightly bright spots. And you most likely want to keep the light source moving. When I'm light painting at night, I think of it as the "Dori wiggle"—named after an animated character in Pixar's *Finding Nemo* who repeatedly chants, "Just keep swimming, just keep swimming." In other words, keep your light source moving.

Light painting that moves from right to left or up and down in front of the camera tends to produce stronger lines than light painting that moves toward or away from the camera.

It can be difficult to judge the exposure you need to use when light painting. And it's tough to know what adjustments you need to make to an exposure when you use lighting to fill in the foreground of a scene that you are exposing. With fill lighting, just don't overdo it. Somewhere between a third and half of the exposure time should be the maximum for light painting as fill light.

No matter how you use light painting, plan to experiment and to try many times with many variations, because you never know what will work and what won't.

▼ This image was created by David Joseph-Goteiner while he was participating in one of my night photography workshops. We pointed flashlights at our faces, so that we appeared to be disembodied spirits in the night.

22mm, 20 seconds at f/5.6 and ISO 100, tripod mounted

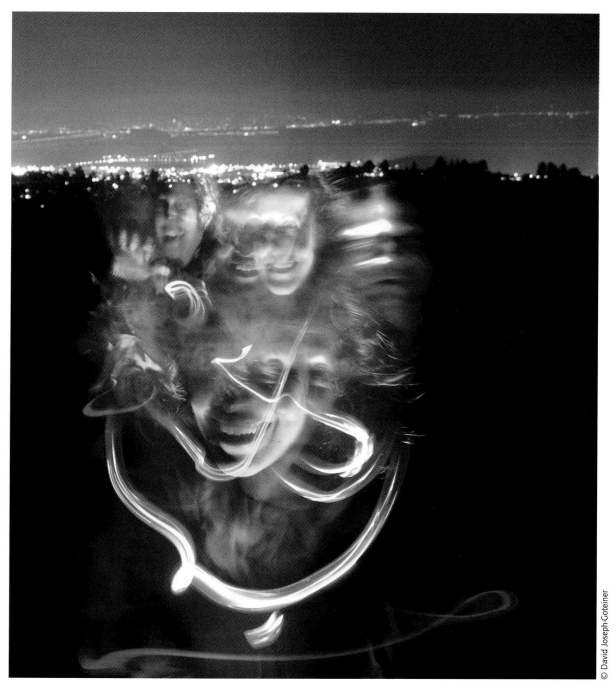

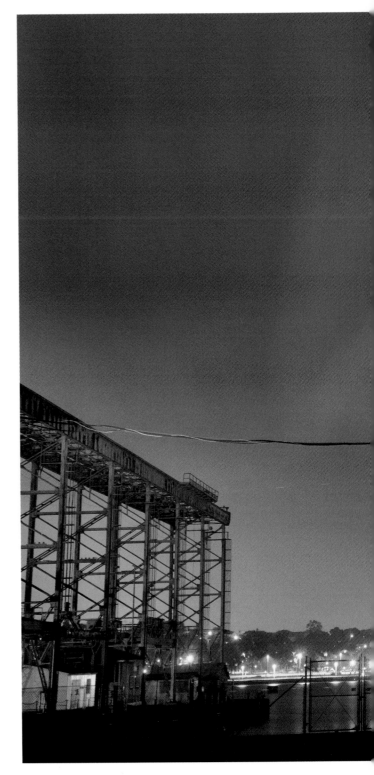

▶ The overhead railways shown in this photo were used to provision tall warships during World War II at the Mare Island naval base. I lit the structure on the right with a powerful 15,000-watt portable light source that was powered by a car battery. The light source was in motion for the duration of the exposure. My idea was to provide fill lighting for the structure on the right and to use the light painting to grab the viewer's attention.

28mm, 3 minutes at f/10 and ISO 100, tripod mounted

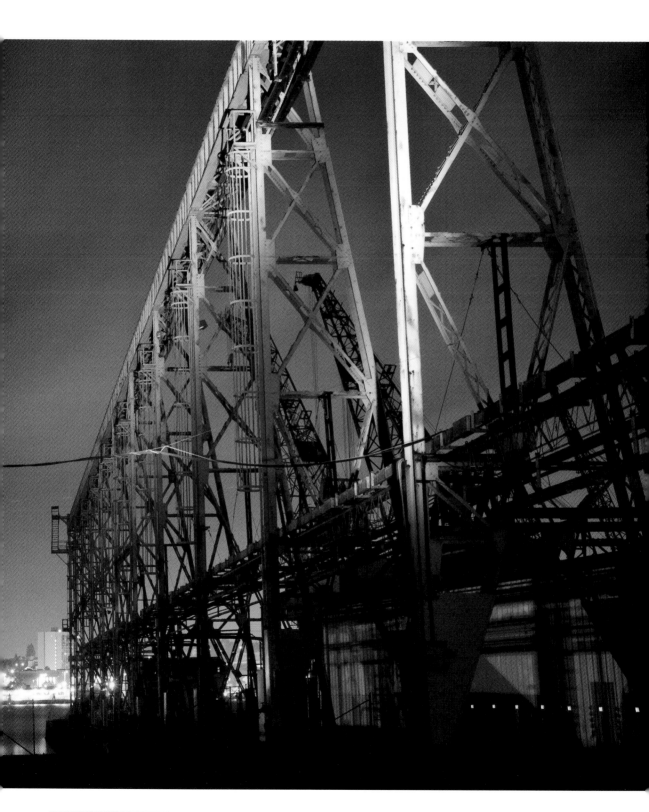

▶ The south face of this old church in Bodie, a ghost town in Eastern California, was lit primarily by moonlight. I positioned the camera to face north to maximize the movement of the stars.

The interior of the church was pitch black. So during this long exposure (about 18 minutes), I "painted" the interior of the church using a small flashlight. To do this, I walked round and round the building continuously, circling behind the camera, careful never to stop the light in one place, directing my light at the side and rear windows. The result is the interesting green effect in the interior shown in the photo.

12mm, about 18 minutes at f/16 and ISO 100, tripod mounted

▼ I camped on Angel Island, in the middle of San Francisco Bay, right across from Golden Gate Bridge. My campsite was dominated by the stump you see in this photo.

In the middle of the night, I got up to take photos of the Golden Gate Bridge. But the stump seemed so interesting that I had to include it. I used light painting to make sure that the foreground in the photo, including the stump, was bright enough for the photo.

18mm, 1 minute at f/5 and ISO 100, tripod mounted

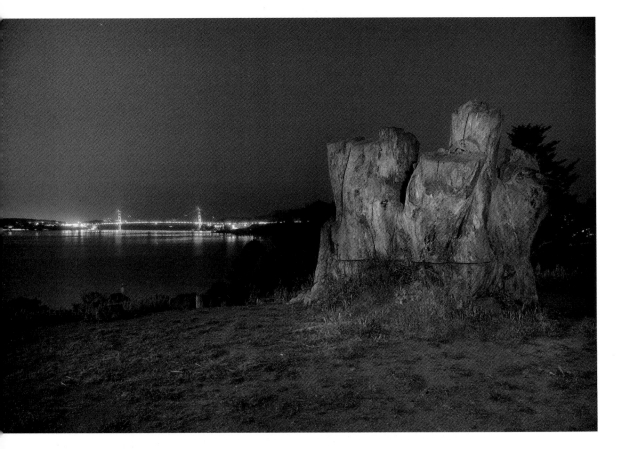

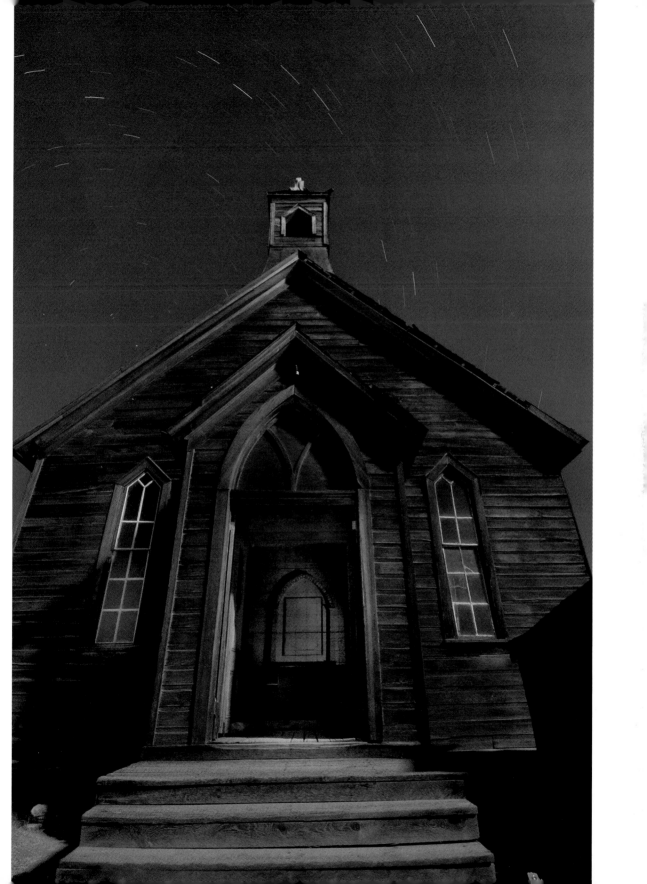

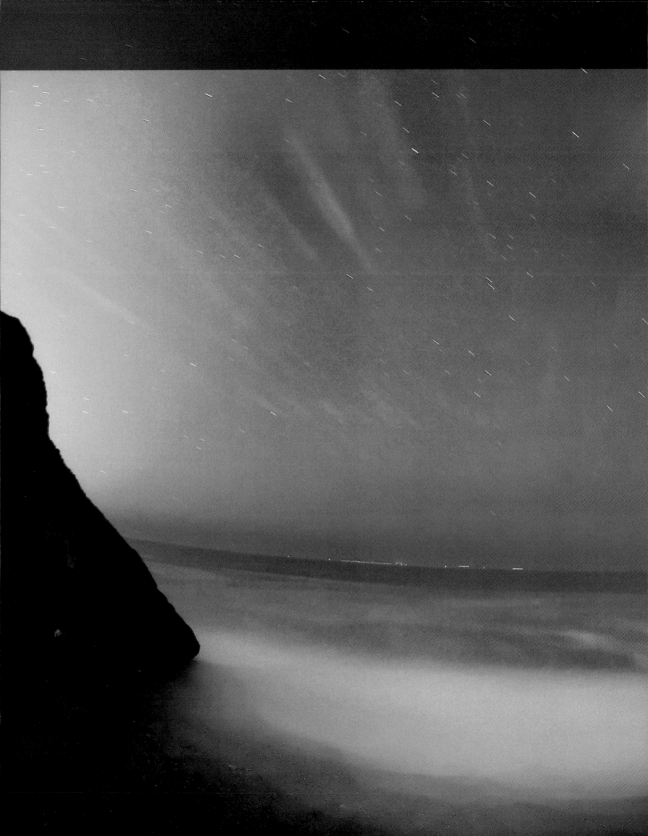

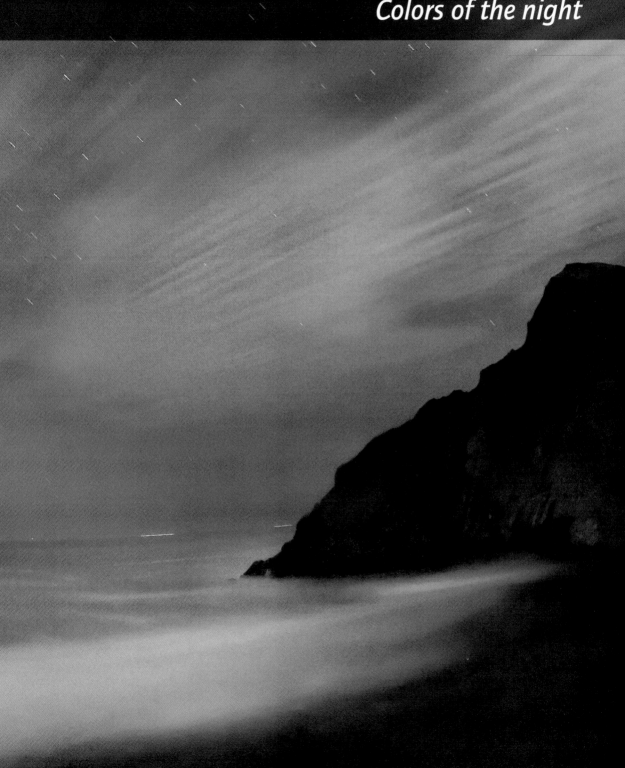

Photographing Cityscapes at Night

The suns sinks below the horizon and the lights of night come on. What better way to get introduced to the pleasures of night photography than to start by photographing the night lights of the city where you live?

Long exposures of the city night may lack the subtle pleasures of nighttime in the wilderness, but the reward is capturing the effect of many different color temperatures of different lighting sources.

Besides ambient light from the setting sun, lunar light and light from the stars, light sources you may see at night include the varying color temperatures of argon, fluorescent, halogen, mercury vapor, tungsten, xenon and more. You'll see the tell-tale signatures of the color from all these lighting sources in any broad cityscape photo with their varying qualities of yellow, green, blue and orange. This lighting "soup" can turn mushy, but in the best case it creates an exciting story of the varieties of light on display, especially when viewed in contrast in a way most people don't often get to see.

Long exposures at night can also turn motion into lines and patterns. Cars, helicopters, buses, trains and airplanes are no longer apparent except in the tracks made by the lights they project.

City views at night are made using the shortest amount of time for the shutter speed—usually between 4 and 30 seconds. This is short enough that you do not need to use the Bulb setting. You may even be able to take advantage of your camera's light meter and exposure modes. In fact, city exposures are so short (by night photography standards) that you may need to take steps to make the exposure longer. These measures may include stopping the camera down to a small aperture or even adding a Polarizer or Neutral Density filter, which would reduce the amount of light reaching your sensor.

▶ This is a photo of the lights of Emeryville, California, San Francisco, and the Bay Bridge shortly after a crisp, winter sunset. Winter tends to have less pollution and atmospheric haze than summer, so this time of year can be better for city night photography, even if colder for the photographer. The air was particularly clear on this night, so I went out looking for a location to shoot. High up in the Oakland Hills, I got permission to climb on to a roof using a ladder, and I took this photo while the family who lived there had dinner.

170mm, 30 seconds at f/8 and ISO 100, tripod mounted

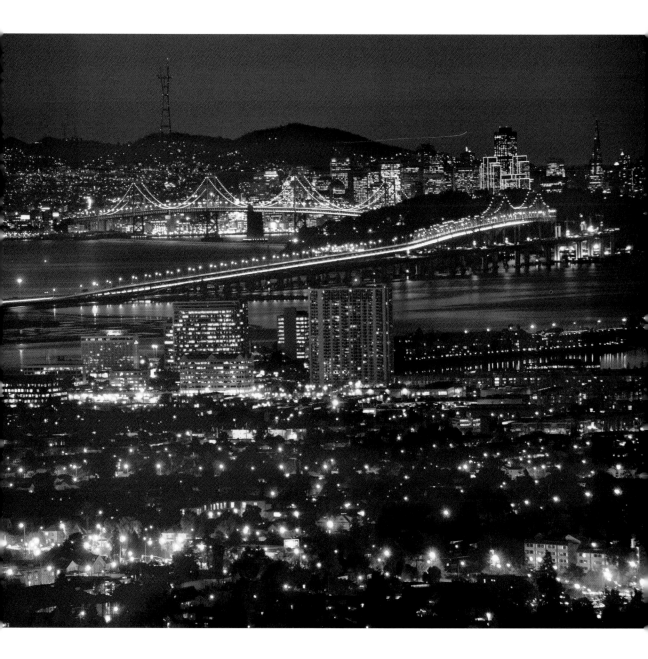

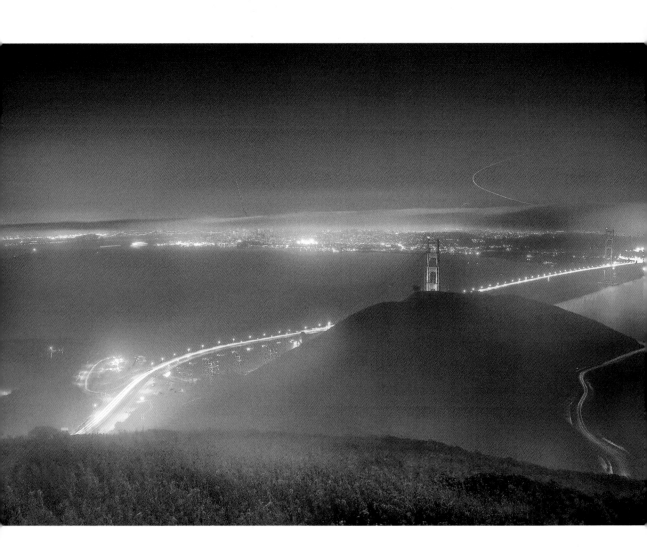

▲ This photo of the Golden Gate Bridge and the San Francisco skyline takes advantage of fog in the atmosphere to create an interesting, soft look at the hard edges of moving colored lights.

18mm, 2 minutes at f/8 and ISO 100, tripod mounted

▶ This photo takes a familiar landmark—the Transamerica Tower in San Francisco—and shows it at night, where it seems quite different from how it appears in the standard, daytime view you'd see on a postcard. The thirteen-second exposure was long enough to convert the headlights of speeding traffic into straight, semi-transparent lines.

18mm, 13 seconds at f/20 and ISO 100, tripod mounted

▼ Pages 74-75: Taking photos while looking down on cityscapes from high places, as in this image of Silicon Valley from the summit of Mission Peak, can remind us of the sprawling nature of human life. I find that when I compose this kind of image, I start wondering about the purpose of humanity and thinking about all the living moments that are happening under bright lights while I sit on the fringe in darkness making photos. Photography, as critic Susan Sontag pointed out, is essentially a voyeuristic act. To me, making this kind of night image brings home the inherent voyeurism in photography.

32mm, 30 seconds at f/5.6 and ISO 100, tripod mounted

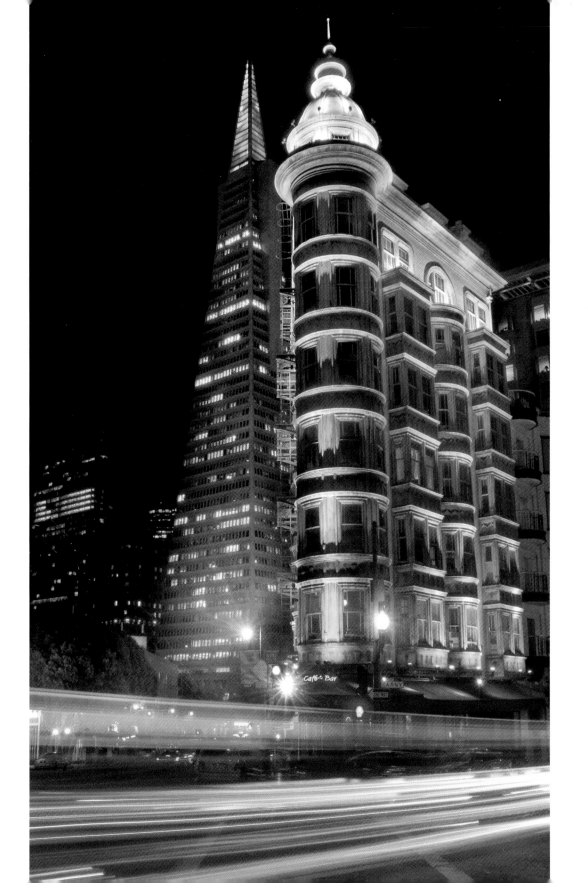

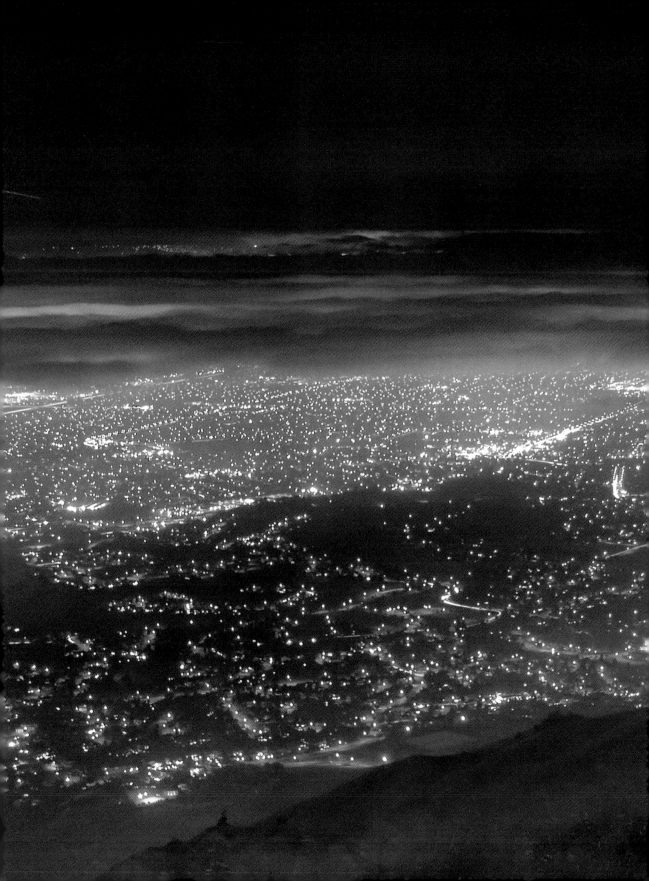

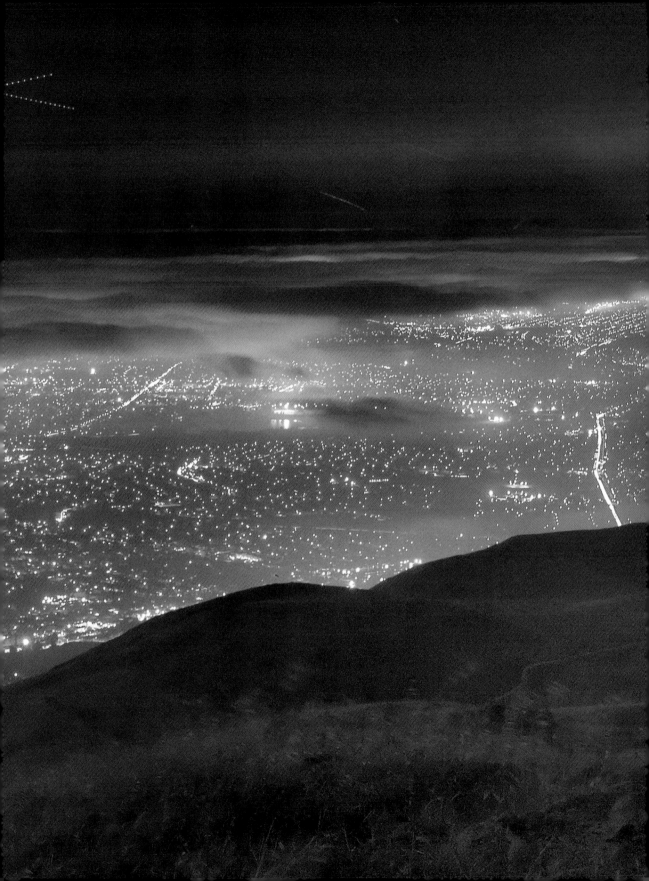

Buildings at Night

It's fun to photograph buildings in a city at night, and buildings by themselves can also make dramatic nighttime imagery.

Starting in early evening, lights go on in windows around the world. There's a sense of melancholy for those on the outside looking in, and images showing a single light in an otherwise dark building can create romantic or eerie atmospheres.

As the night darkens, the appearance of the facades of buildings changes. You are no longer looking at straight architecture. Instead, the issue becomes how light sources interact with the building and the patterns created by light and shadow. With some notable exceptions, night light sources on buildings are more serendipitous than intentional. It's hard to predict how the combination of lights in neighboring windows will work together; but when they combine, the question from a photographic perspective is how the resulting lights, darks and shows will work as a composition.

A photograph of a city building at night poses the question, "What is going on inside this building?"—especially when only a single window is lit.

A key issue when creating a dramatic night landscape is finding a foreground point of interest. The right building can solve this compositional issue.

Now, I happen to like night landscapes that are wild and show no evidence of humanity. But it is also undoubtedly true that some of the night photos with the greatest emotional punch show buildings and structures—essentially contrasting the vastness of the night sky with the small scale of humanity.

Using a Tripod in Public

Tripods are pretty much a requirement for night photography, but many a night photographer is asked not to use a tripod. While private property owners have the right to keep you off their property with or without a tripod, you are allowed by law to photograph in most public places. (The few exceptions include reasonable things like military bases and nuclear facilities.) Unless your tripod is a public hazard, you should be able to use it.

Law or no law, many public or semi-public facilities don't like photographers using a tripod, and security guards may harass you or ask you to leave. Like other night photographers, I've been told to "move on" by park rangers, cops, transit police, airport security, irate private property owners and private security guards. This kind of interaction might even be regarded as a badge of honor in the fraternity of night photography.

Because the issue can come up, it's a good idea to contact facilities in advance, to find out if you will be allowed to photograph with a tripod on the premises and to complete any paper work that may be required. Advance contact will help to ensure that your photography trip isn't wasted, and it will increase the chances that you (and your tripod) will be allowed to remain and photograph.

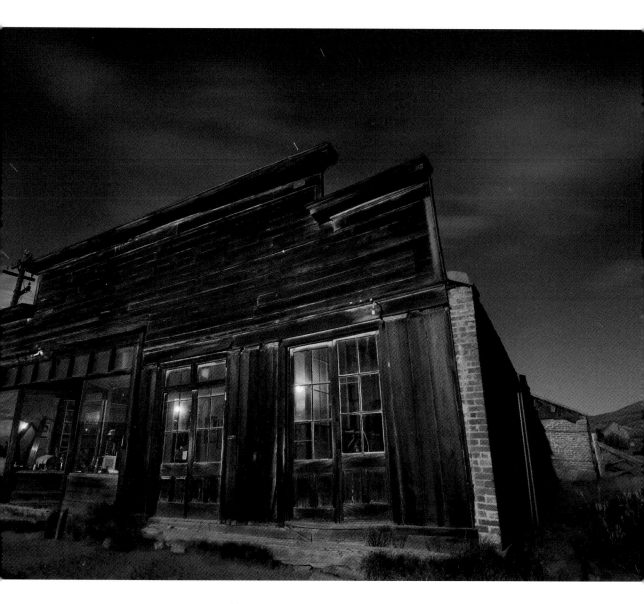

▲ This is a photograph of the general store in the old ghost town of Bodie, California, where I had special permission to photograph at night. The orange lights you can see in the store windows are from extremely low-light tungsten bulbs. I didn't want them to "blow out," and I wanted to give the photo the feeling of true, deep night. To do this, I set the exposure so the curve on the histogram moved far to the left.

12mm, 4 minutes at f/11 and ISO 100, tripod mounted

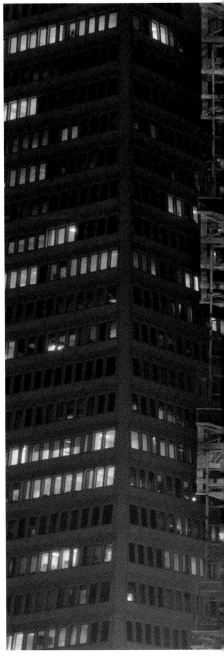

▲ After sunset, as dusk quickly faded to night, I looked up at this partially occupied modern apartment tower and saw a single lamp burning.

95mm, circular Polarizer, 1/4 of a second at f/29 and ISO 100, tripod mounted

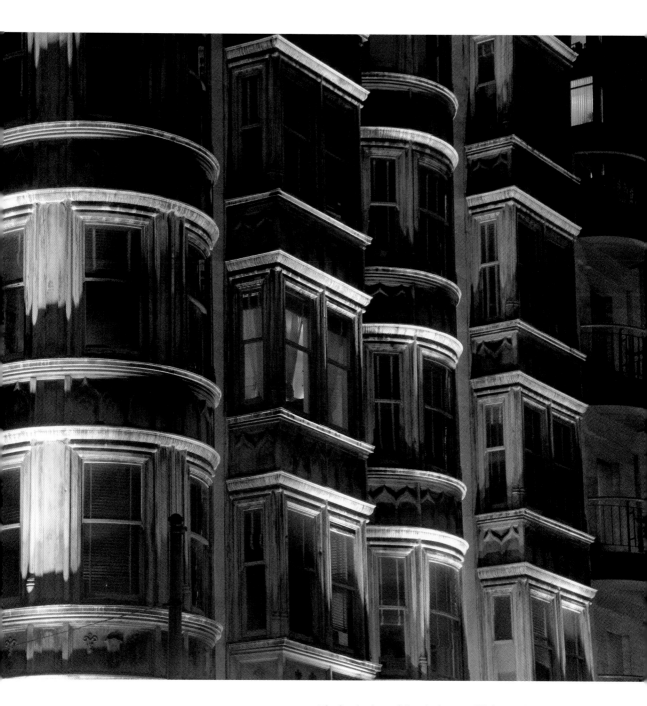

▲ The hard edges of the shadows and lights made me wonder what drama was occurring within the lit window in this older building.

60mm, 3 seconds at f/10 and ISO 100, tripod mounted

▶ The historic lighthouse at the tip of Point Reyes, California, adds to an intriguing photo that features a background of oncoming night.

If you look carefully at the photo, you'll see a trail of light that begins at the lighthouse building and heads about halfway up the stairs. This is the flashlight of the park ranger who was helping me make the photo.

I started my five-minute exposure from my position on the stairs above the lighthouse. As the ranger came up the stairs toward me, I called, "I'm exposing." He turned off his flashlight about halfway through the exposure, at the spot you can see as the end of the flashlight trail.

18mm, 5 minutes at f/9 and ISO 100, tripod mounted

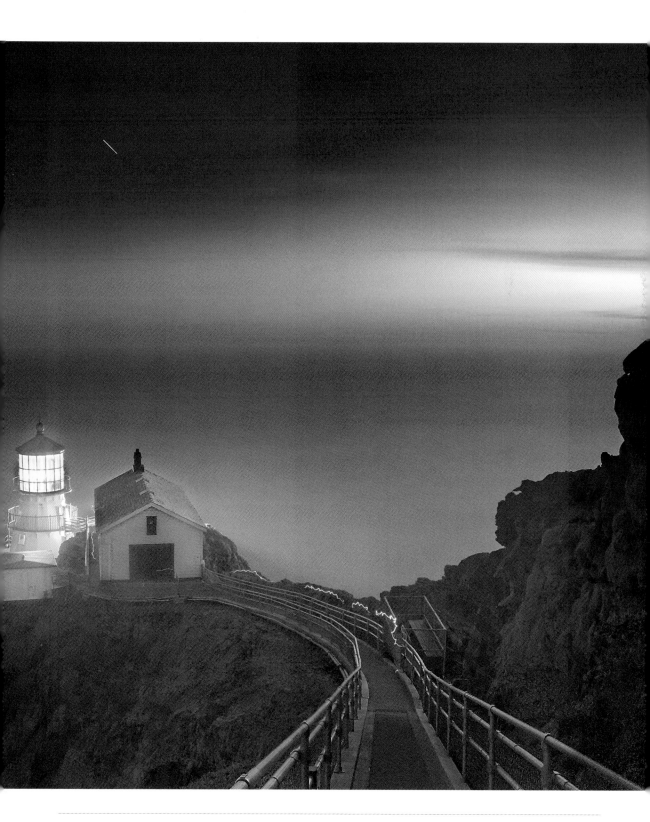

Bridges and Water Reflections

Bridges and water reflections each (and sometimes together) make a great subject for night photography, but they need to be treated differently at night than in daytime exposures.

The key difference is caused by the long exposure times necessary for night images. And when you are working with long exposure times, anything that moves will change shape. Subjects in motion will not be rendered crisply; in fact, it can be hard to pre-visualize how moving objects will appear. Taking as many captures as possible, and viewing preliminary results on your LCD, is a good way to deal with this kind of unpredictability.

Specifically, water in oceans, lakes and rivers is almost always in motion. And reflections in moving water will themselves move, too. The visual impact of this motion in a long exposure is unpredictable. But, in this situation, it is a fairly safe bet that the fields of color in the reflections will extend to a greater area than they would when the shutter speed is quick. At the same time, colors will become less saturated. These effects take place *because* the water is moving; you capture a broader area with somewhat less intensity at any given point.

An effective tool for enhancing the possibly diminished reflections is to use a circular Polarizer. This is a filter that can be rotated to change the appearance of reflections.

Since it is difficult to judge the impact of a Polarizer when it's dark, you should take the time to let your eyes adjust. Look carefully through your viewfinder once you are used to the dark to make sure that you've set it to best enhance the scene.

There are three special considerations for images that include bridges at night. First, you should try to combine night bridge compositions with reflections or shadows involving the bridge. This will almost always enhance your results.

Next, consider the motion of cars on the bridge. As your exposures get longer, the lights from these vehicles elongate and begin to resemble solid, straight lines. It's important to integrate this effect with your composition.

Finally, a bridge itself is usually fairly solid and straight. At night, a lit bridge is in stark contrast with the surrounding landscape: a brilliantly lit structure alone over dark water with the night sky above. Just keep in mind that pointing your camera directly at the straight aspect of the bridge may not create an interesting composition. So try to find unusual angles for your night bridge photos, so you can present the bridge and surrounding reflections as more than straight lines put together. An interesting camera angle can greatly increase the interest of night bridge compositions.

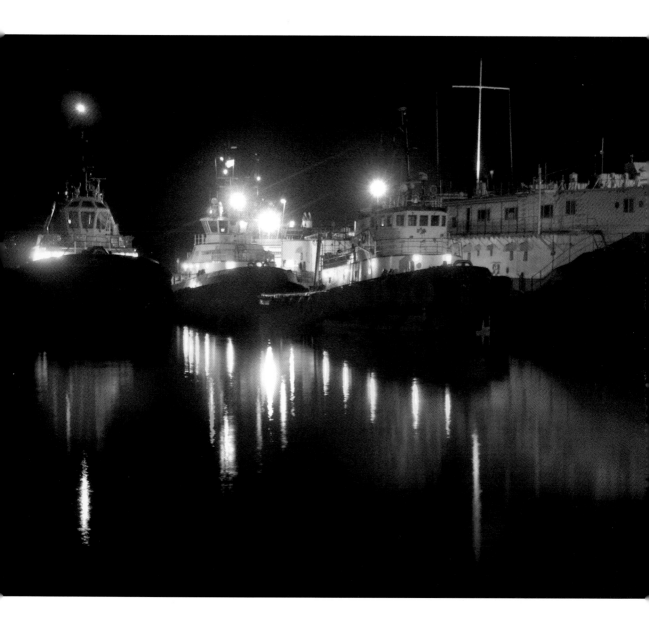

▲ Port Richmond, California, is a gritty, working harbor. A narrow road follows the coast. There are fields of imported cars and cargo in shipping containers behind a chain-link fence on one side; the working harbor is on the other. While exploring this route on a dark, moonless night, I came upon these working tugs and their reflections.

By experimenting with exposures ranging from 2 to 30 seconds, I was able to test the impact of the movement and lights. I like this relatively short, four-minute exposure best because it leaves the water dark and allows the colors of the reflections to stand out. The reflections were amplified because I used a circular Polarizing filter in front of the lens.

46mm, circular Polarizer, 4 seconds at f/6.3 and ISO 100, tripod mounted

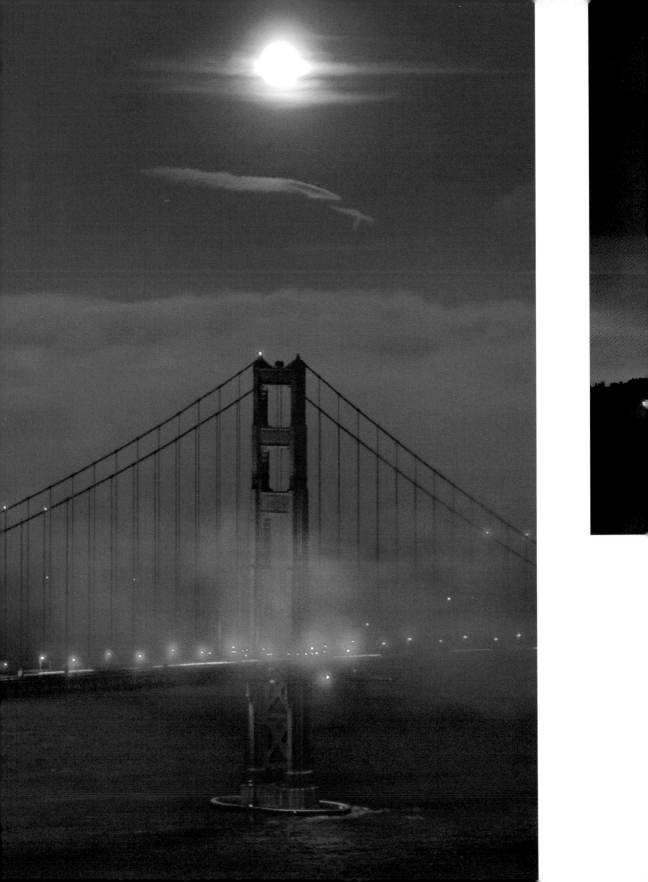

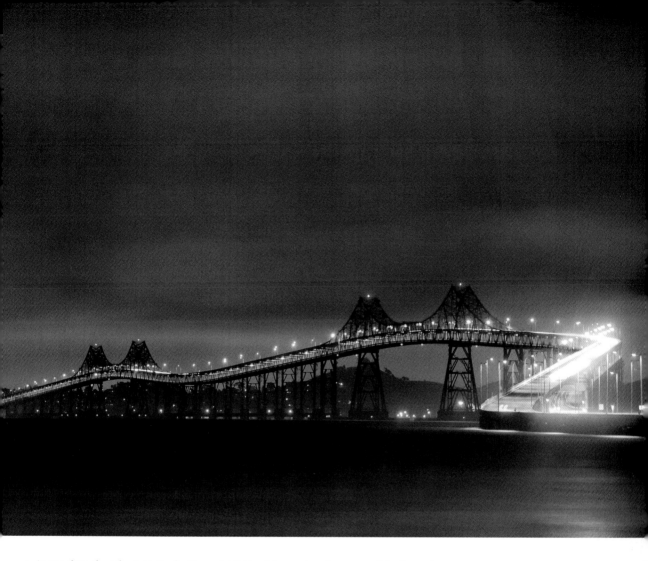

▲ At one time, the John F. McCarthy Memorial Bridge (shown above) was one of the longest bridges in the world. It is a double cantilever structure that stretches across the San Francisco Bay from Richmond to San Rafael—yet it is not as glamorous as either the Golden Gate Bridge or the Bay Bridge. I composed this night image to capture the snake-like twist in the structure by positioning myself at an angle to the bridge. The bright gleam from headlights adds visual interest under the cloudy night sky.

120mm, 13 seconds at f/6.3 and ISO 100, tripod mounted

◄ The rising moon and light fog add interesting colors to this photo showing the night lights of the Golden Gate Bridge, and the reflections in the water help to balance the composition.

95mm, 1.6 seconds at f/5.3 and ISO 100, tripod mounted

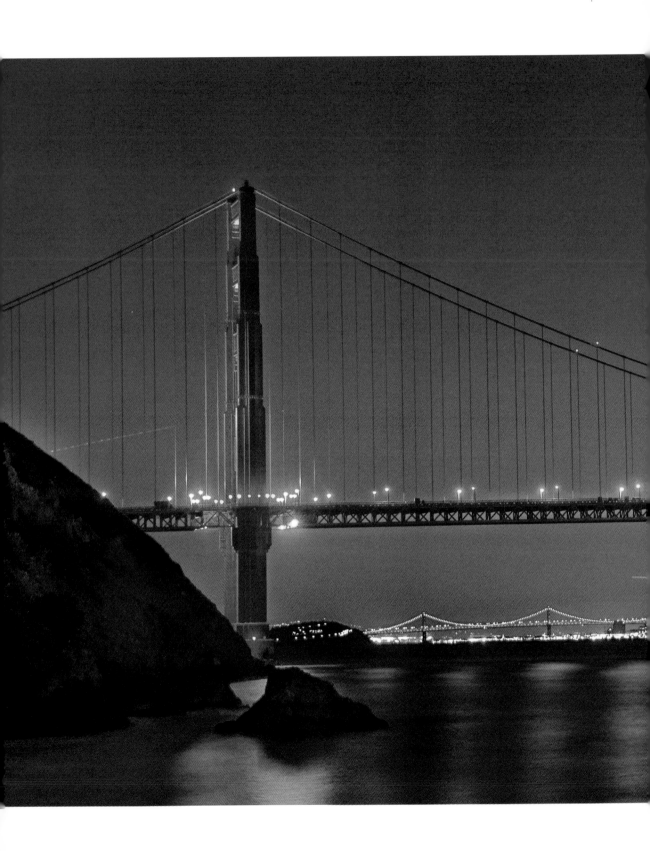

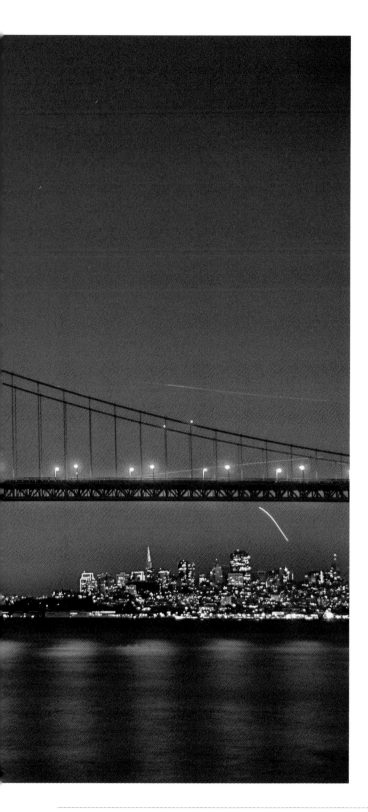

◀ This photograph is taken from Kirby Cove, a strikingly beautiful beach in Golden Gate National Recreation Area, California, that you can reach by hiking.

I composed the image to show the city skyline of San Francisco below the Golden Gate Bridge. As I looked carefully at the scene, the regular reflections on the water that were created by the long exposure of the bridge lights added to the compelling scene. They created a neat pattern, so I made sure that my exposure was long enough to allow these reflections to be fully visible.

46mm, 20 seconds at f/4.5 and ISO 100, tripod mounted

Industrial Scenes

Industrial scenes can make great subjects for night photography because buildings and facilities tend to have visually interesting shapes. Also, there's often lighting with a variety of exciting color temperatures, and factories are often deserted at night.

Night photographers' interest in industrial scenes is long-standing, and it includes both working facilities and historic structures. Older factories may be preserved as part of a historic park, or they may be abandoned and decaying.

With both new and old factories, there are some special safety concerns to think about. Industrial facilities can be dangerous places with unexpected hazards. Do your research! If a factory is currently operating, you should not be photographing on the premises without permission.

Fortunately, there are plenty of historical industrial structures that you can photograph at night from public locations; it's also true that many working facilities can be easily photographed from nearby streets.

If you do venture into an abandoned factory, as with any night venture into the unknown, be cautious. Don't go alone, and bring plenty of lights with you. If you don't need lights to see safety hazards, you can always use them to light your photos in interesting ways! (See pages 62–67 for info about painting with light.)

A Word about White Balance

Most industrial scenes are lit by many different sources. A single scene can include moonlight, starlight, mercury vapor arc flood lamps, tungsten lights, fluorescent lights, car headlights and more. There's no reasonable way to input an accurate white balance setting for the color temperatures of these mixed sources when you are in the field doing night photography.

So the best bet is to leave your camera set to auto white balance. But don't expect your camera to be able to make much sense of the color soup. The settings your camera chooses on the basis of auto white balance will likely be a weighted average of the various light sources—and accurate for none of them. This means that you shouldn't necessarily believe the colors you see on your LCD because they are based on the white balance settings. It also means that if you want to emphasize the light from one of the sources, you'll need to tweak the white balance settings for the photo in the digital darkroom.

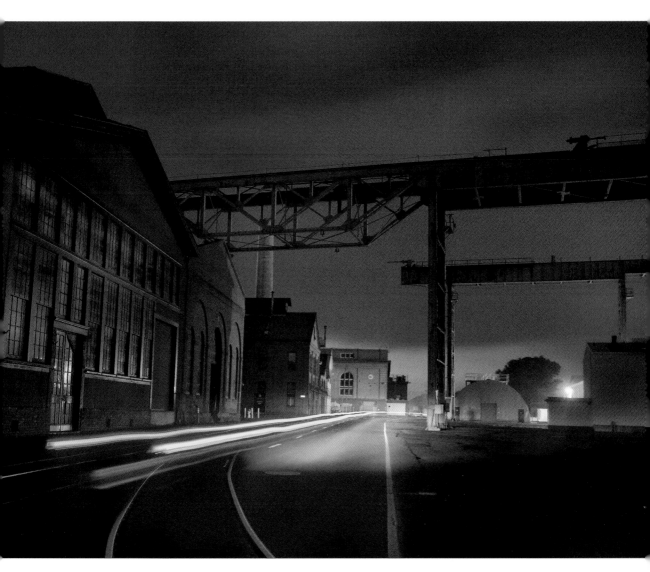

▲ During World War II, Mare Island, California, was the largest naval shipyard on the West Coast of the United States. Today, many of the abandoned buildings have been preserved as part of a historic park, and it's a fairly safe location for night photography.

When I pre-visualized this photo, I was struck by the contrasts involved. I love the direction of lines in the composition, and I was fascinated by the combination of the color temperature of the pink cloud, the green reflections in the factory window, the red reflections in the railroad track and the bright car lights.

22mm, 30 seconds at f/5.6 and ISO 100 tripod mounted

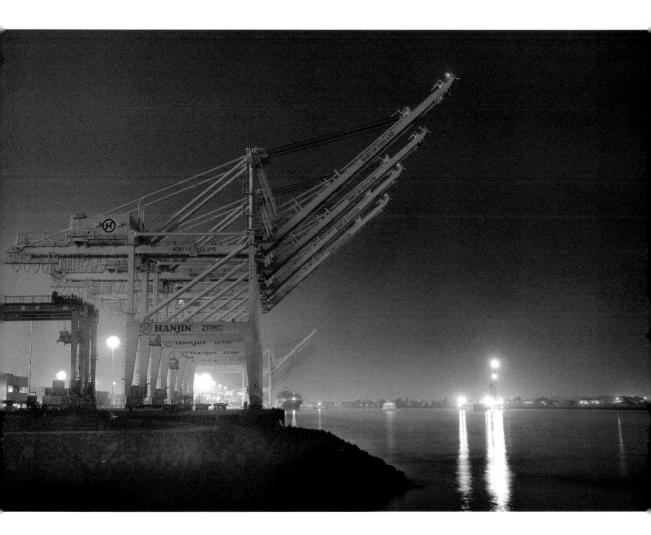

▲ The Port of Oakland is one of the busiest ports on the West Coast of the United States. I was struck by the strong, warm orange industrial lighting on the heavy port equipment. It was easy to get close enough to photograph this strange environment safely, because Oakland Waterfront Park is conveniently located next to the heaviest cranes.

26mm, 13 seconds at f/5.6 and ISO 100, tripod mounted

◀ Looking up at this giant crane in the Port of Oakland, I realized that the predominant light source came from orange mercury vapor flood lights. I composed the image on angle to emphasize the extent to which the stairs on the crane went upward. The photo looked gray and without much color on the LCD, but I knew I could adjust the white balance in post-processing to bring back the orange glow of the flood lights.

75mm, 25 seconds at f/32 and ISO 100, tripod mounted

Light and Motion at Night

One of the great things about night photography is that a dark overall background and low-light conditions provide some interesting creative options for rendering light and motion.

For night photography, those elements can produce cool effects. To capture light in motion, you need a subject that moves in relation to the camera. This subject must emit or reflect light.

While there are less of these subjects than you might expect at night, quite a few exist, such as moving vehicles, the moon and stars. Each lit and moving subject adds the potential of great interest to a night photo.

Add to this the possibility of moving the camera when shooting a stationary light, and there is a universe of creative possibilities.

The key exposure issue in rendering motion is the length of time used for the shutter speed setting. At half a second or less, most objects appear relatively ordinary, and at ten seconds or more, moving objects begin to appear spectral and fantastic.

The issues involved are actually a bit more complex than you might think, and I'll get

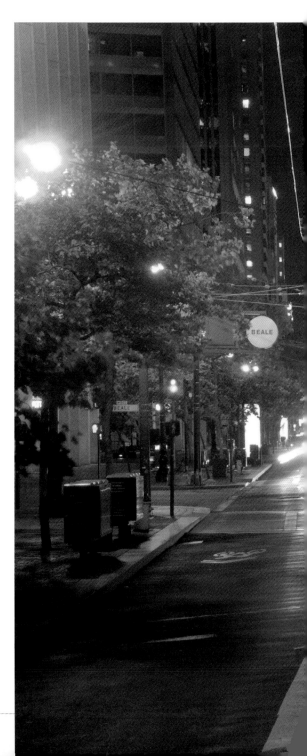

▶ During the day, Market Street in San Francisco is one of the busiest streets in the city. At night, it is a different, quieter story. So I was able to stand on a platform in the middle of the street to shoot this photo.

The right side of this image shows the lights of a street tram coming into its station. The eight-second exposure has both elongated the lights and made them transparent.

36mm, 8 seconds at f/16 and ISO 100, tripod mounted

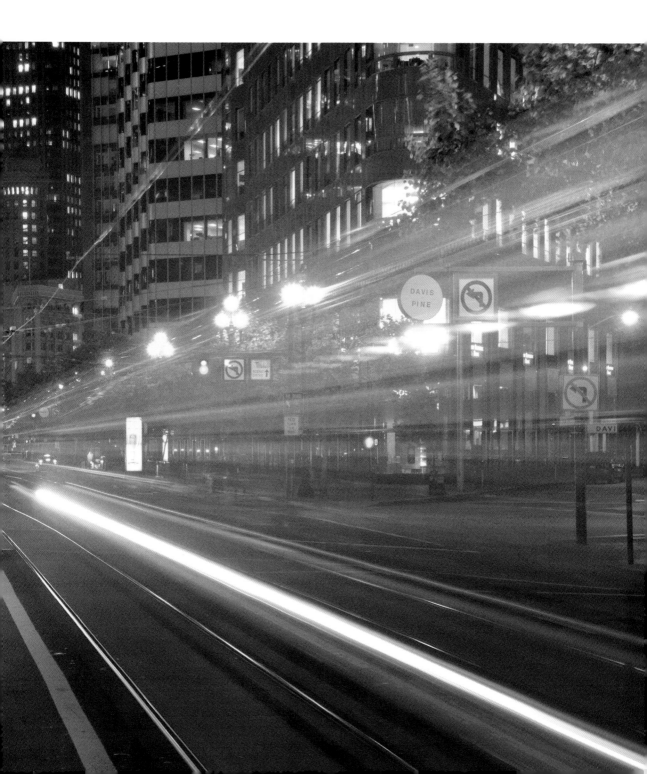

to them in a minute. Just bear in mind that your choice of shutter speed usually controls the aperture that you'll need to use. When the aperture is large (for example, f/2), you may not have enough depth-of-field, and when it is small (for example, f/29), you may get lens flares at night (for example, see the photo on page 35). So you need to balance aperture selection when you choose a shutter speed for creative motion effects at night.

When considering the shutter speed to select for an object in motion at night, think about the following factors: the speed of the lit object, its brightness, its angle to the camera (motion that is horizontal to the camera appears more pronounced), and whether there is camera motion involved. Generally, you want to time this kind of

photo so that the moving light occupies at least a third of your finished photo frame; otherwise it will not seem important in your overall composition.

In the field, determining the shutter speed that meets these conditions is often not easy. Goldilocks gets it: not too short, not too long, just right. There's just no substitute for experience, so in a given situation, shoot at many different shutter speeds to find out what works. Of course, by definition, an object in motion is moving, so you may not always get a second chance to get your shot.

Here are some ideas of, roughly, what you might expect from shutter speeds in relation to the most commonly photographed moving lights at night.

Object in motion	Shutter speeds	Rendering/Comments
Camera in Motion	Longer than 1 second	Try to control the motion of the camera so it has some pattern and regularity, for example by panning or moving up and down on a tripod. Camera-motion shots generally have shutter speeds in the 1 to 30 second range.
Cars (moving less than 30 MPH)	1 second to 30 seconds	Slow vehicles will generally "cross" a photo frame in 10 to 30 seconds.
Cars (moving faster than 30 MPH), Airplanes	4 seconds to 3 minutes	At 4 seconds, you can still see it is a car; at exposure times in the minutes, car headlights become lines of light.
Moon	Longer than 1 minute	You begin to see motion in the moon at exposure times over a minute. When the moon is setting, you can render motion attractive at times longer than 10 minutes.
Stars	Longer than 4 minutes	You can see the motion of the stars at 1 minute. Star trails begin to become interesting as photo subjects at about 4 minutes. Although to really see long trails, you need an exposure of more than 15 minutes up to several hours.

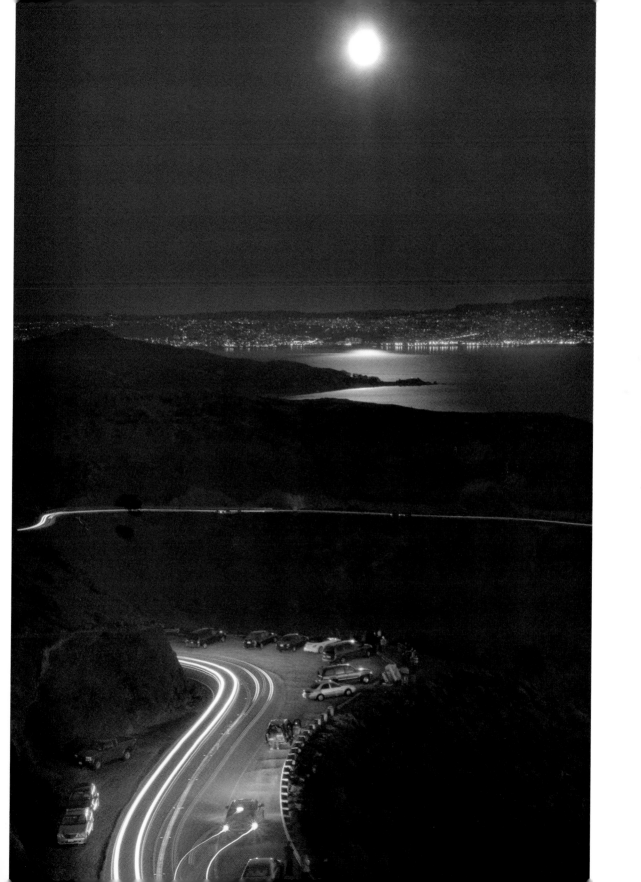

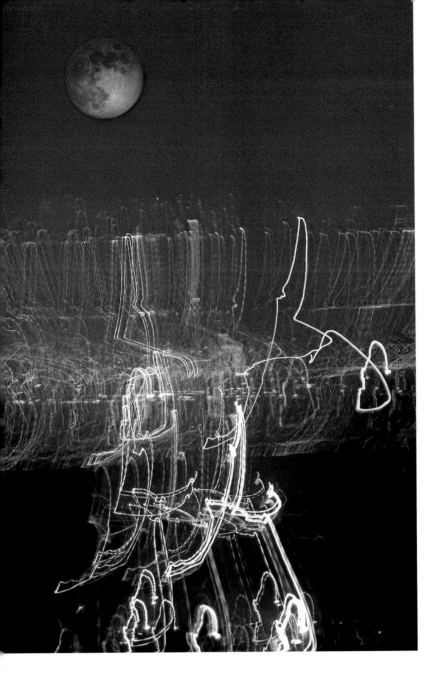

▲ I created the abstract light composition in the foreground of this image by using a telephoto focal length to focus on city lights. With my camera on a tripod, I rotated the camera up and down and side to side in a slow and deliberate way for the 1.6-second exposure.

Obviously, with this kind of photo, you won't know what you get until you try it. So the key is to experiment, and make a great deal of different versions.

Composite of moon and lights. Lights: 200mm, 1.6 seconds at f/2.8 and ISO 200, tripod in motion; Moon: 400mm, cropped in, 1/2500 of a second at f/2.8 and ISO 200, tripod mounted

▲ Page 95: I watched the moon rise over San Francisco Bay and tried to figure out how to balance the bright moon with something interesting in the foreground. Then I realized that if I extended the exposure time, I could create an interesting effect by contrasting the abstracted car headlights against the dark background of the hills that were in the moon shadow. A 25-second exposure did the trick.

50mm, 25 seconds at f/25 and ISO 100, tripod mounted

▼ I was photographing the Golden Gate Bridge at night from San Francisco's Baker Beach when a large wave came up, threatening to drown me, my tripod and camera. I had to quickly move the camera—while the shutter was still open—to higher ground.

There are really three components to this exposure, each about ten seconds in shutter speed duration: a fixed component before the wave hit; time when the camera and tripod were in motion; and a second fixed period on higher ground. The two fixed periods anchor this composition, which otherwise might be too abstract.

60mm, 30 seconds at f/4.8 and ISO 100, tripod mounted in motion and two fixed positions

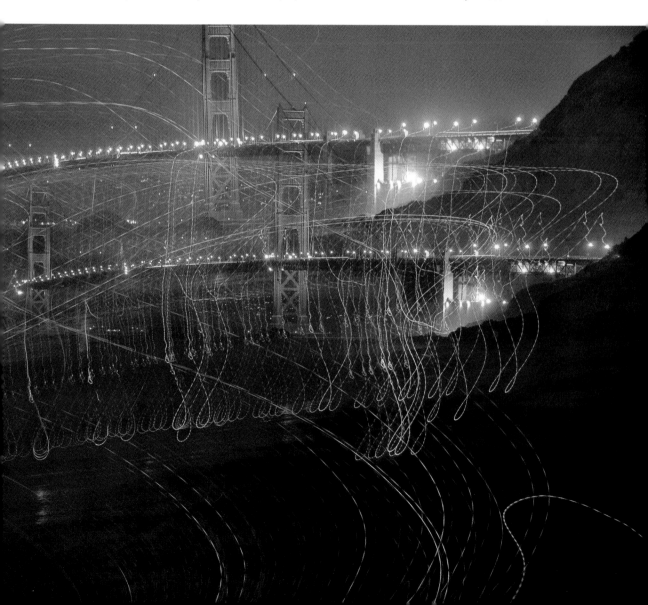

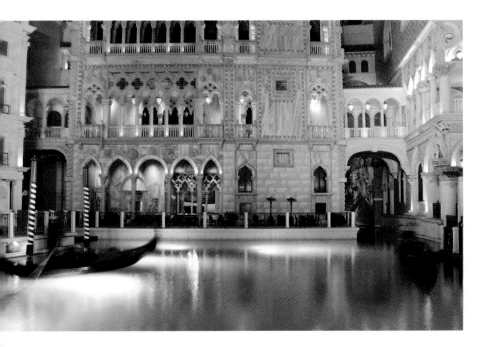

During a night photography session in Las Vegas, I became interested in the movements of "gondolas" in the artificial lagoon at the Venetian casino.

I experimented with a variety of shutter speed settings in my exposures to see which made the movement of the gondola most interesting.

At 2.5 seconds exposure time, the ersatz gondola appears essentially solid (above), like a gondola "should" be; while at ten seconds, the gondola becomes elegant and abstract (foreground right).

Above: 18mm, 2.5 seconds at f/22 and ISO 200, tripod mounted
Right: 18mm, 10 seconds at f/22 and ISO 200, tripod mounted

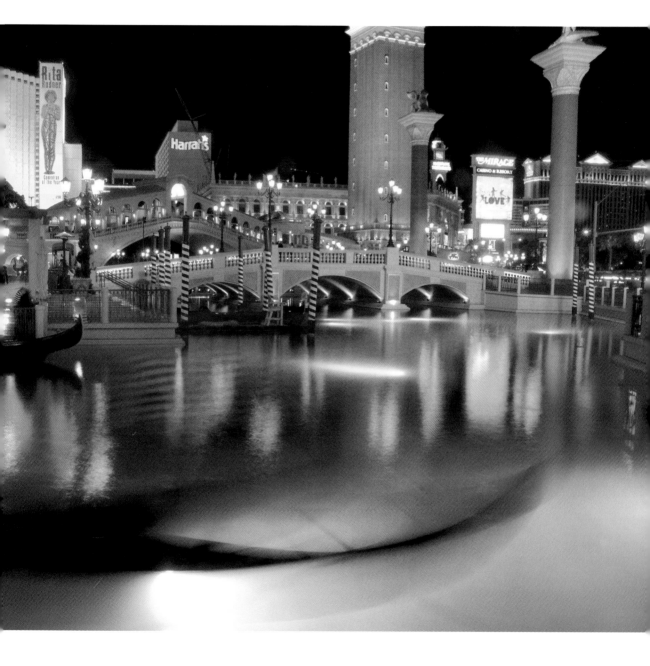

▶ I wanted to show the new moon setting into Mt. Tamalpais, California. I knew that a continuous exposure would render the moon as a bright, white line—and the detail of the moon's shape would not be apparent in the photograph.

I solved this exposure problem by combining multiple exposures, with a substantial interval between each exposure.

The technique I used for combining the multiple exposures is explained on page 192. You can learn more about programming an interval timer in Appendix A, beginning on page 226.

70 mm, stacked composite of eleven exposures at 2-minute intervals, each exposure 13 seconds at f/8 and ISO 100, tripod mounted

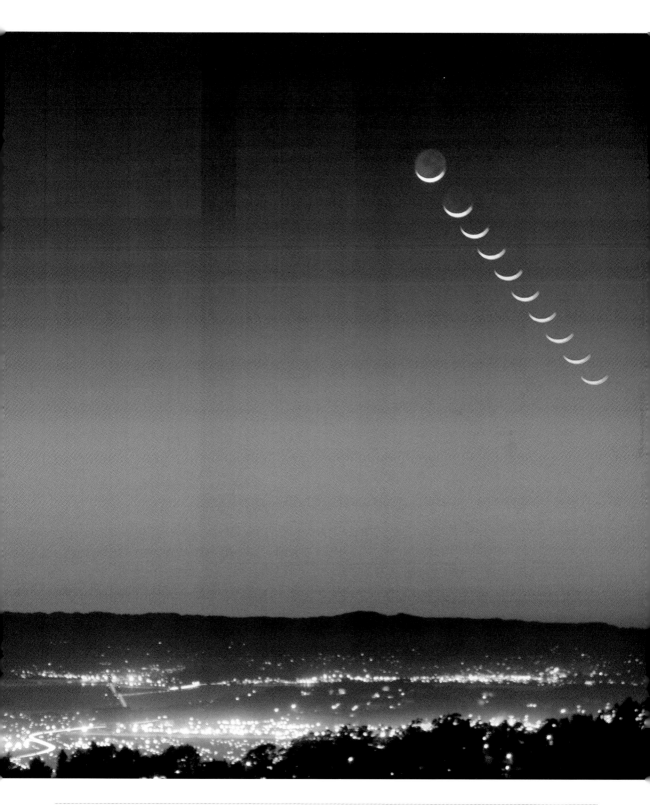

Photographing the Ocean

The ocean, and particularly where it meets the shore, makes for a great photography subject after sunset. At low tide, the intertidal zone is a lovely canvas for reflections and colors of all sorts.

At other times, waves create a motion subject for long exposures; the night tames violent surf so that it becomes transparent and delicate. The ocean itself reflects ambient light and interesting colors into the environment.

The surprising number of lights from fishing craft and other boats is an added bonus when you point your camera out to sea.

Before heading to the beach for an evening, or night, photography session, it is a good idea to check your local tide tables. Knowing where you are in the cycle of tides will help you plan your photography. It will also help keep you safe. In addition, it is prudent to never turn your back on the ocean—to help protect both you and your camera. It's easy to get so involved in photography that one forgets this elementary precaution. Several times I've almost been swamped unawares by a rogue wave.

Shortly after sunset, look for opportunities to capture light absorbed from sunset that is not yet discharged. Two good opportunities are the wet sand at low tide and cliffs that face a beach. At relatively "short" exposure times (thirty seconds or less), you'll most likely want to stop your aperture down to a small opening to make your shutter speed longer. The point is to make the motion of the waves appear more interesting.

With full night upon you, the beach becomes a mysterious place. Long night exposures, where the ocean meets the shore, add the movement of clouds and stars to the mix.

In bad weather, the outcome of night photography will be unknown until you try. What is out there in the dark ocean on a black moonless night? You may be surprised by how much there is for your camera to "see."

▶ The thirty-second exposure brought out lingering colors in the cliffs well after sunset, and turned the pounding action of the surf into fog-like vapor in this shot of the aptly named Sculptured Beach on the rugged California coastline.

18mm, 30 seconds at f/4.5 and ISO 100, tripod mounted

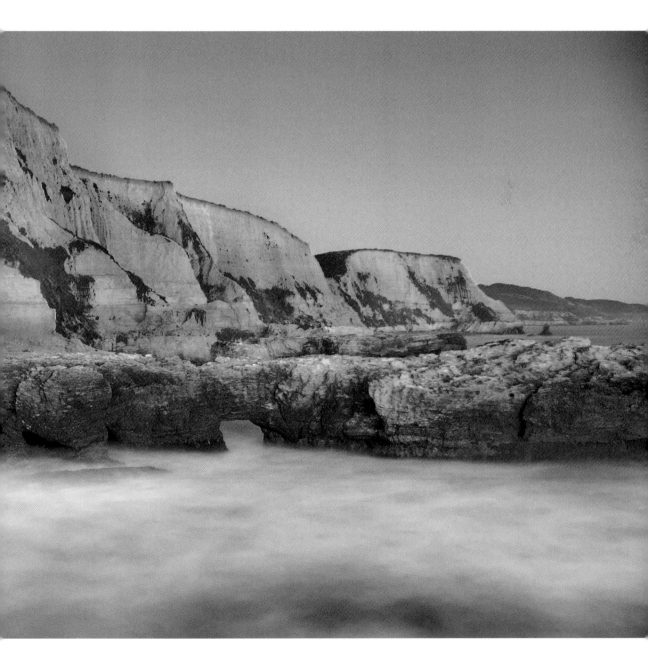

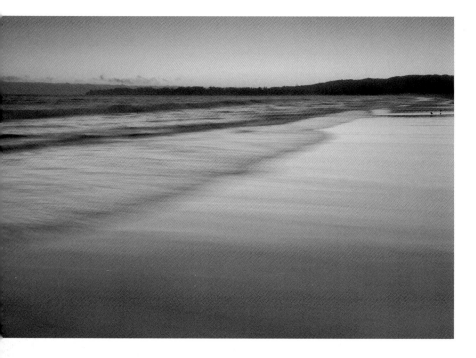

▲ I used a small aperture to force as long a shutter speed as possible in this low-tide beach shot that was taken shortly after sunset. My idea was to soften the appearance of the waves in the intertidal zone.

24mm, 7/10 of a second at f/22 and ISO 100, tripod mounted

▶ In this shot, the three-minute exposure was long enough to capture the movement of the clouds and surf and make them appear as translucent, without rendering stars and boats at sea as more than points of light.

12mm, 3 minutes at f/5.6 and ISO 100, tripod mounted

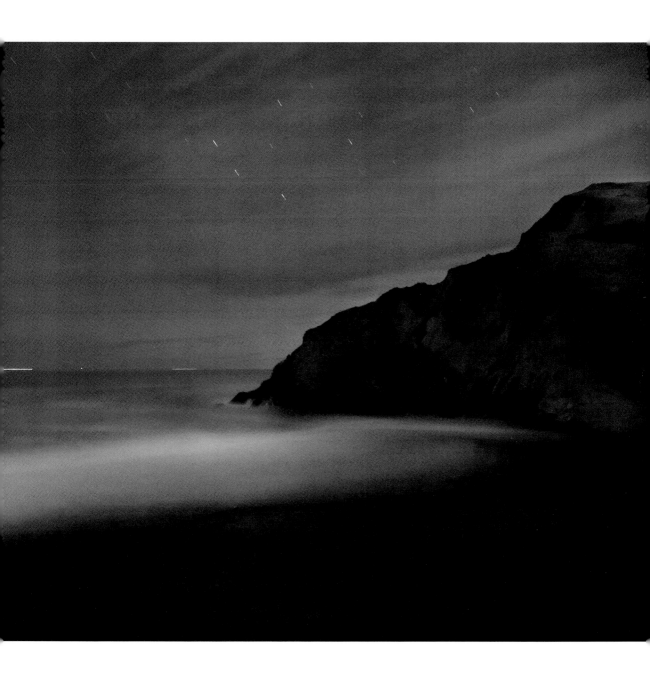

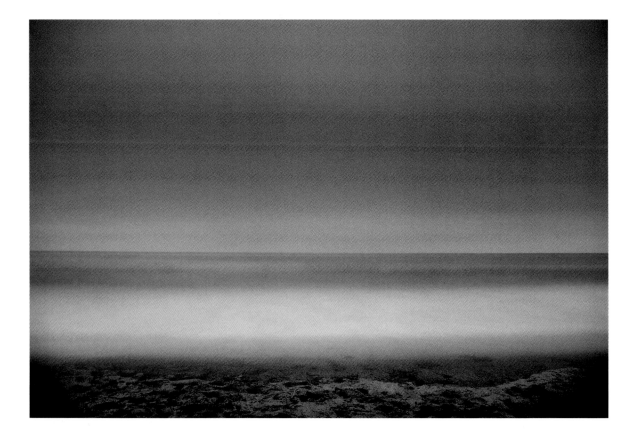

▲ On a dark, foggy night, it was pitch black, and I wondered *what* I would get by exposing straight out to sea. There was nothing to be seen by eye. But letting enough light into the sensor allowed me to capture a moody but subtle composition, giving a new meaning to the phrase *a shot in the dark*.

18mm, 4 minutes at f/3.5 and ISO 100, tripod mounted

▶ Perched on a high aerie along the rugged Marin Headlands coast of California, I made this photo pointing almost due north. At twelve minutes exposure time, the pointing surf was "flattened," and it seems almost gentle in this image.

12mm, about 12 minutes at f/5.6 and ISO 100, tripod mounted

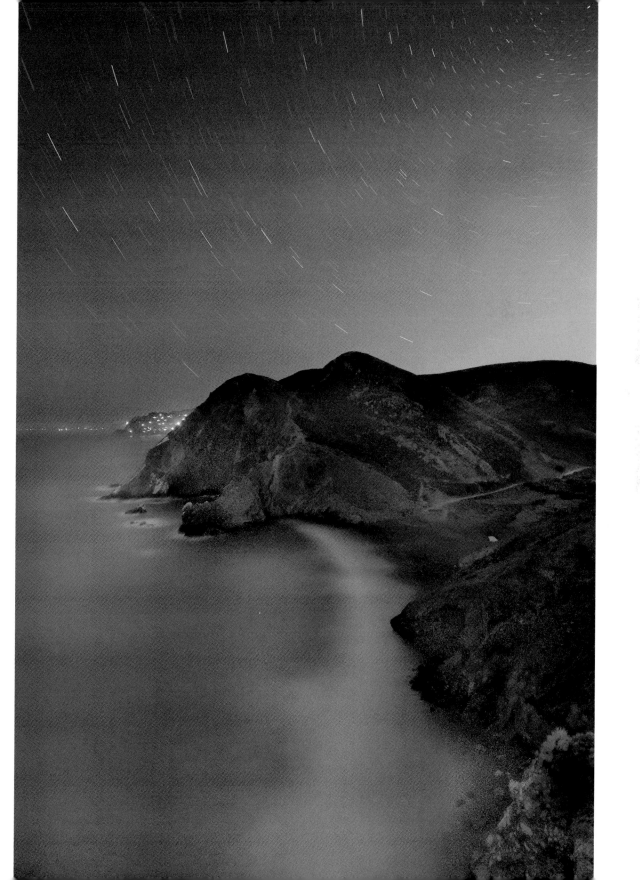

Fog at Night

At night, fog changes everything. You can forget about starry skies and the grandeur of the cosmos. The world closes in. Lines become blurred and painterly. Colors are more saturated. Fog operates like a giant diffuser.

In addition to these effects, which can cover an entire scene or affect only a portion of an image, fog tends to make things brighter. To a surprising extent, I find I end up with shorter exposure times when capturing a scene that is foggy overall at night.

Although there does tend to be a surprising amount of ambient light when conditions are foggy, it depends on the light sources involved. And even though there can be more overall light than you expect in fog at night, I often expose in the fog to maximize exposure time. This has the effect of increasing the impact of the fog, because the fog is in motion during the exposure.

Partial fog can add a magical touch to an image, but don't give up on night photography in total fog! While you don't have the glorious assistance of celestial objects, fog can be wonderfully atmospheric. The challenge is to create compositions that use fog in ways you might not expect, because fog has great properties: it increases saturation, makes hard edges soft, and adds an overall feeling of mystery.

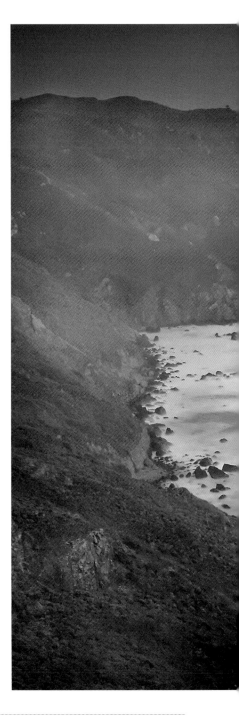

▶ Standing high in the rugged Marin Headlands along the coast of California, there was a light fog coming in off the sea. I intentionally used a small aperture to stop the camera down so I could use a longer shutter speed to maximize the impact of the fog creeping over the water. The long exposure picked up colors in the Headland cliffs along with mist and fog that were not visible to my naked eyes.

26mm, 30 seconds at f/20 and ISO 100, tripod mounted

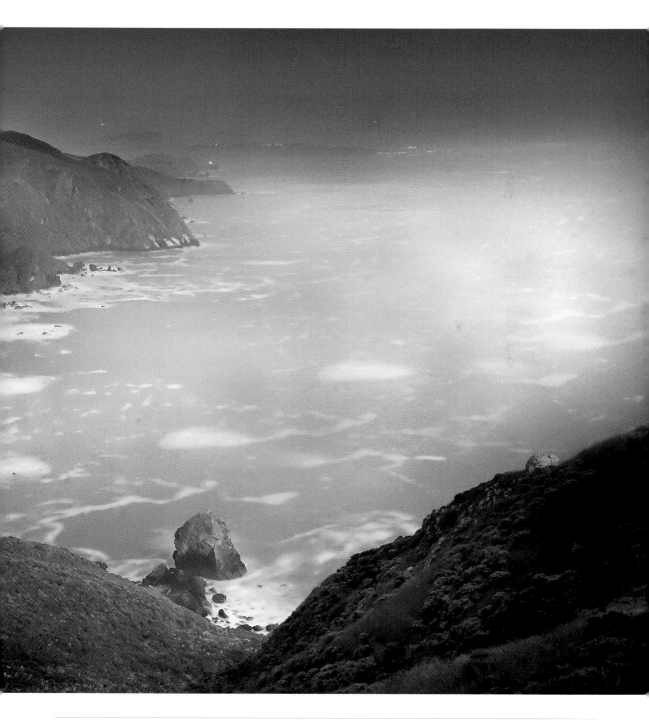

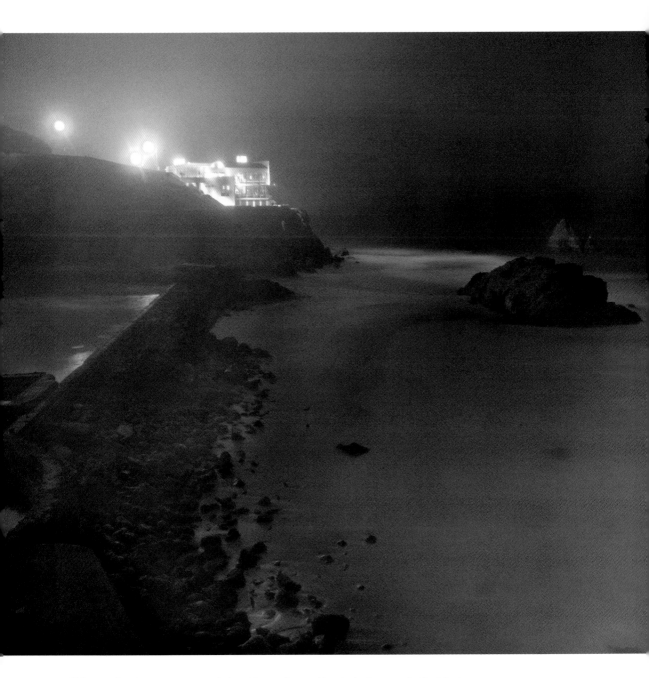

▲ Cliff House is a famous restaurant beloved by tourists and locals. It sits opposite Seal Rocks along the San Francisco coast. In a pea soup fog, with moisture clinging to my camera and tripod, I had the scene to myself. The restaurant looked like a fun house to me as the fog diffused its lights.

18mm; five exposures combined in Photoshop; exposure times between 10 and 55 seconds; average exposure time about 25 seconds at f/5.6 and ISO 200 tripod mounted

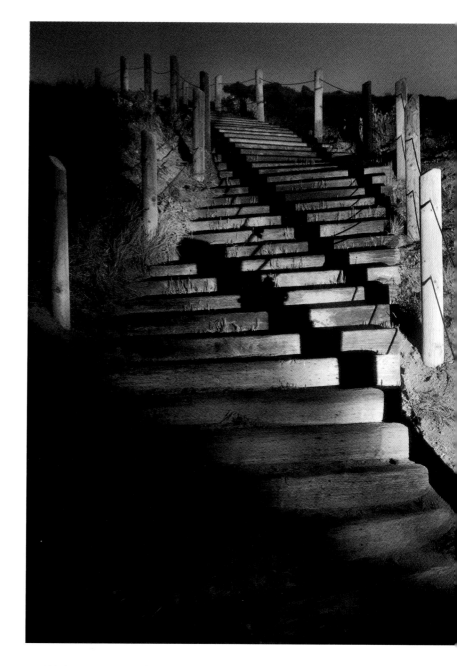

▲ This image was created using light painting to bring out the shadows of the posts against the stairs in foggy conditions. The fog accentuated the light you see in the background, which is orange from mercury vapor street lamps. Overall, the fog adds to the slightly sinister impact of this image.

22mm, 30 seconds at f/9 and ISO 200, tripod mounted

In the pitch black of night in a eucalyptus grove, I purposely chose a small aperture for these shots, so I could make the exposure times longer. My idea was to create a dream-like effect. The portions of vegetation that are farthest away are more blurred than those that are nearer, because they moved more in the wind.

Note that the overall exposure creates something of a "day in night" effect (see page 150 for more about making day look like night). You'd never know by looking at them that these photos were taken in pitch black conditions.

Above: 12mm, 80 seconds at f/22 and ISO 100, tripod mounted
Right: 16mm, 80 seconds at f/22 and ISO 100, tripod mounted

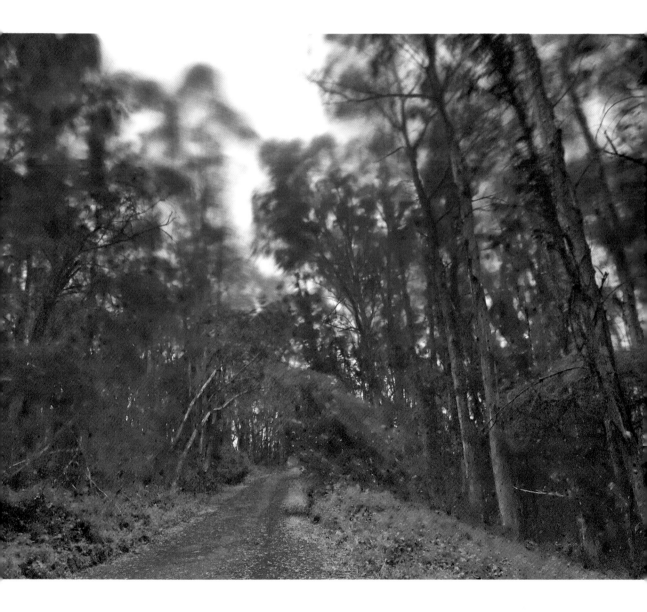

Clouds

As with fog, photographers of both day and night can make the mistake of avoiding clouds and rainy weather. Yet, many of the best photos in both day and night are taken in rough weather. True, you have to protect your gear—and yourself—from the elements; but if you are not out in a squall, then you'll never capture a clearing storm or the drama of a battle between clouds and wind.

At night, you might think that clouds will make it harder to photograph the night sky, and there is some truth to this. However, the long duration of night exposures means that stars tend to peek through moving cloud cover. In addition, colors left over from sunset tend to transform clouds captured during long exposures—both shortly after sunset and in the deep night—into wonderful, magical and sometimes surreal shapes that seem to owe more to watercolor than to photography.

There's not much you can do with a solid, overhead mass of clouds though. Clouds at night are most interesting when they are moving.

To take advantage of moving clouds, try to arrange your camera's position so it is pointed at an angle to the movement. You want the clouds to move almost perpendicular to the camera. In this respect, the movement of clouds is a bit like the movement you might try to create when you paint with light. The movement of clouds in a photo appear less pronounced and less interesting when travelling directly toward or away from the camera.

At shutter speeds that are a fraction of a second, just after sunset, cloud movement becomes slightly blurred. This can be a very attractive effect. Between two and ten seconds, clouds take on a life of their own; and at thirty seconds they are an emphatic presence—only to become wispy and ephemeral as exposures veer into the minutes.

After a while, you'll get the hang of how these shutter speed variations impact and render clouds in your night photos. The key thing is to use this information, and to realize that night clouds form a vital part of almost any outdoor composition.

▼ Pages 116-117: Coming out of a hike in a deep coastal valley at the tail end of sunset, I saw these clouds forming bands in the sky. With my camera mounted on a tripod, I shifted my angle so that my camera was pointed perpendicular to the clouds. I made as short an exposure as possible, so that I wouldn't lose the shapes of these wonderful clouds.

28mm, 3/5 of a second at f/4 and ISO 200, tripod mounted

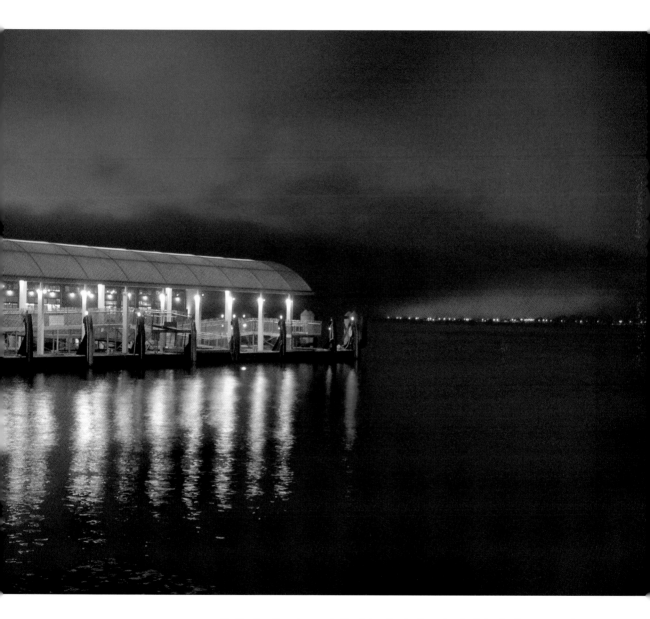

▲ On the San Francisco waterfront, I noticed a huge bank of clouds about to envelope the entire city. I waited until the clouds partially obscured my view, and then angled my camera toward the moving clouds. This helped turn an otherwise straightforward photo of a ferry terminal into something more magical.

28mm, 5 seconds at f/6.3 and ISO 100, tripod mounted

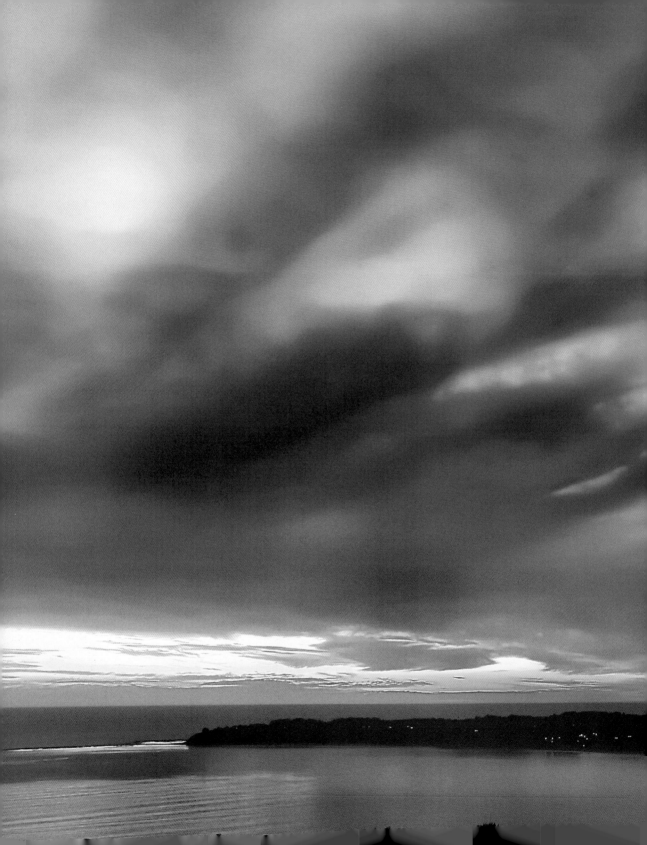

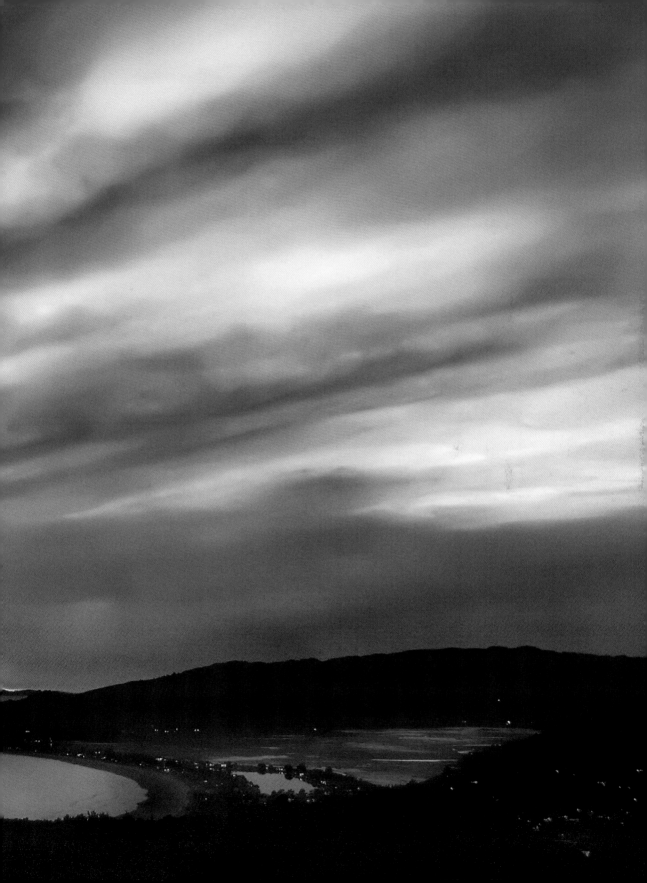

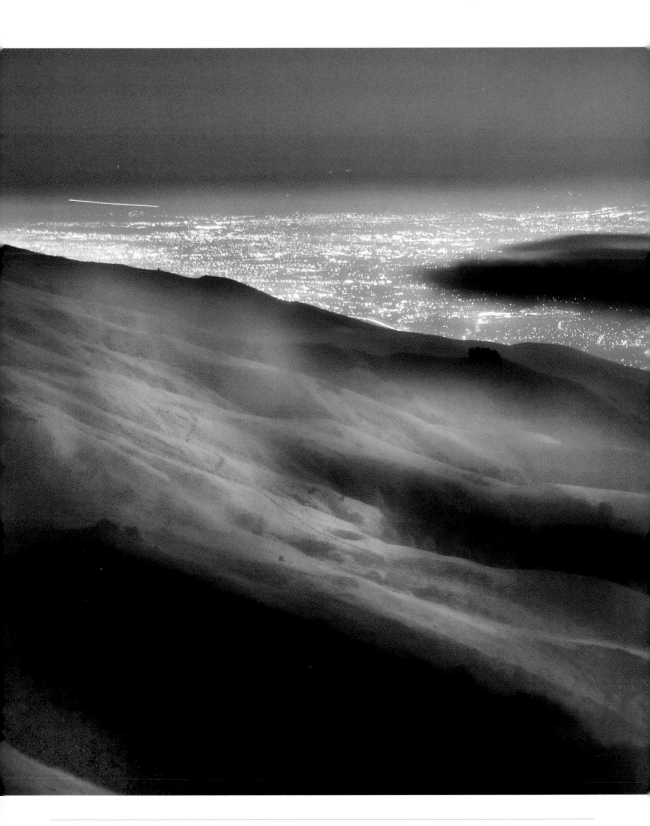

◀ High on Mission Peak, looking down at San Jose, California, I saw the somewhat sinister looking, dark cloud crossing my frame. I purposely underexposed so that the darkness of the cloud would be exaggerated against both city lights and hills.

34mm, 30 seconds at f/4.2 and ISO 100, tripod mounted

Photographing the Moon

What is life without the moon? Without it, there would be far less poetry, romance and magic in the world. The moon adds a distinctive element to night photography that is definitely not prosaic.

Along with the wonderful properties that we associate with moonlight, however, comes a big photographic headache: the moon is a great deal brighter than the surrounding night sky. No successful night photograph that includes the moon can ignore this issue.

In addition, the moon can be surprisingly bright on an absolute basis. In fact, it is really difficult to underexpose the moon. Even knowing this, many times I've ended up with photos in which the moon is too bright for contours on its surface to show clearly.

The overall area of the moon reflects more or less light depending upon many variables, including atmospheric conditions, the phase of the moon, and its position in the sky. So there's no one-size-fits-all solution for proper exposure settings for the moon. To expose it properly, your best bet is to take a spot meter reading of the moon, being careful to aim the spot at one of the brighter areas on the moon's surface.

There are a number of strategies for dealing with the moon's brightness against the night sky.

- Expose for the background, allowing the moon to become a white disk.

- Allow some areas of the composition to be very dark, and expose properly for the moon.

- Photograph at dusk, before the sky assumes its full night blackness.

- Use city lights, or some other bright light source, in the foreground to balance the brightness of the moon.

- In the digital darkroom, combine a "darker" version of the photo that is exposed for the moon and a "lighter" version that's exposed for the landscape. (See page 130 for an example.)

▶ I knew that a full moon would rise at roughly 9 pm, so I positioned myself to capture the moon from beneath the Golden Gate Bridge. Residual light from sunset and the lights of the bridge and San Francisco helped to ensure that the contrast between the moon and background wasn't too great.

Just as the moon rose, a cruise ship passed in front of the skyline. I timed the ten-second exposure so the lights from the ship would become partially abstract, but the broad outline of the boat would be apparent.

140mm, 10 seconds at f/5.6 and ISO 100, tripod mounted

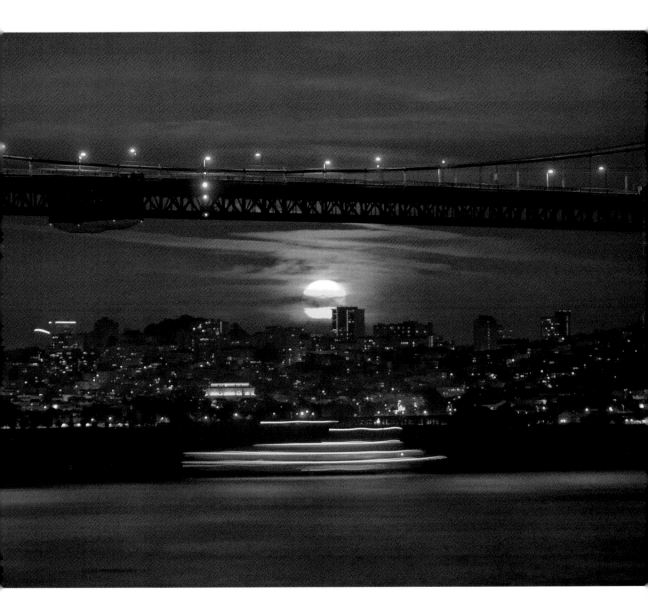

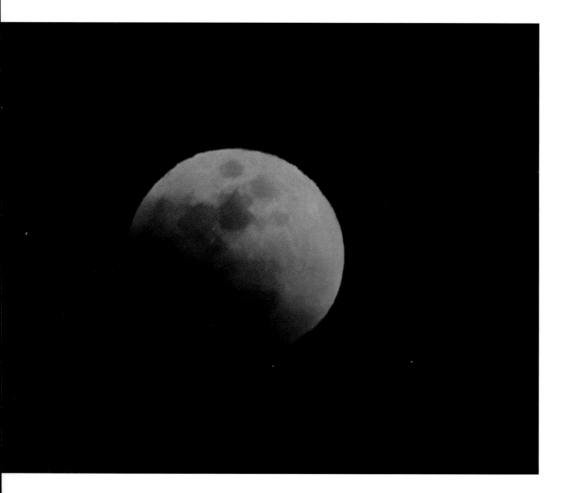

▲ This shot of the moon captures the early stages of a lunar eclipse. While overcast conditions combined with the eclipse to make the moon less bright than normal, I still had to take care to underexpose the photo (compared to an overall light meter reading) with the goal of making sure the moon didn't look washed out in the final image.

400mm, 1/15 of a second at f/8 and ISO 100, tripod mounted

▶ I spot-metered to expose for the moon, and then underexposed to bring out the shadows of the craters and valleys on its surface.

400mm, 1/2500 of a second at f/2.8 and ISO 200, tripod mounted

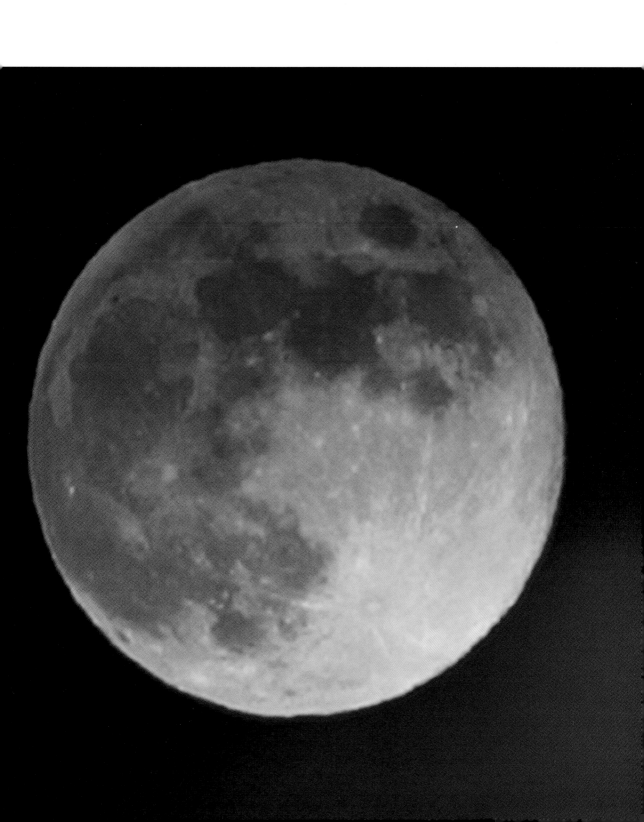

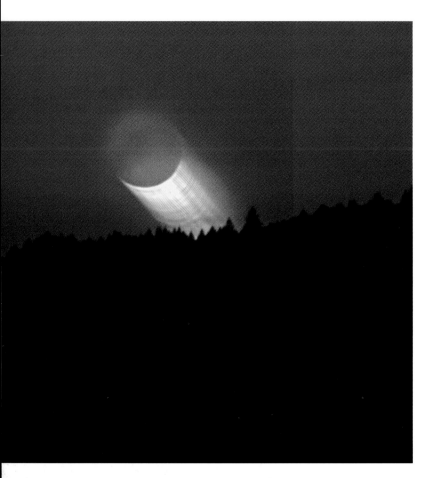

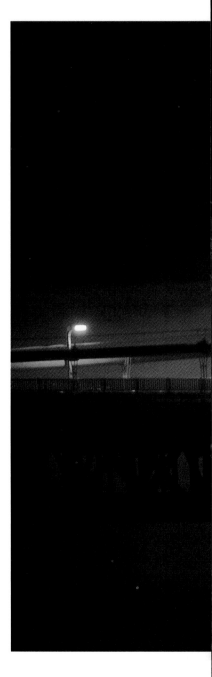

▲ With about four minutes until the moon set, I decided to hold the shutter open for the duration. The effect shows the moon's progress as it sets.

200mm, 4 minutes at f/5.6 and ISO 100, tripod mounted

▶ I exposed this photo so that some of the background would be apparent, causing the moon itself to blow out with overexposure. When I processed the image, I decided to leave the high-contrast effect intact. This abstracts the composition so the moon appears to be a cut-out white circle on a roll down the suspension cables of the bridge.

400mm, 2 seconds at f/5.6 and ISO 100, tripod mounted

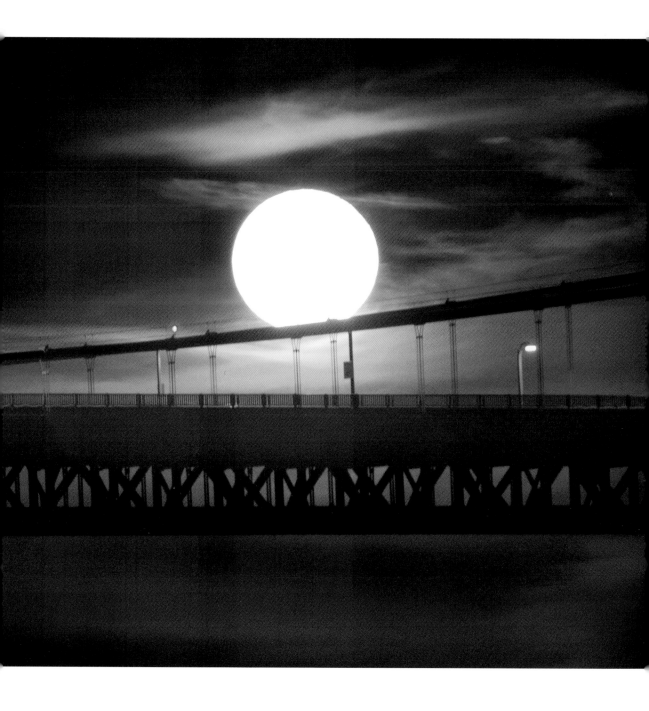

Night at Home

When I first started shooting as a night photographer, I thought I had to go out on trips for the specific purpose of finding night photo subjects. But the truth is that night surrounds us. Half the world is always cloaked in darkness; if it is not your half now, it soon will be.

As I started looking for night subjects at home, I realized that the key difference between night and day is the lighting. Since photography is notoriously about "writing with light," this should not have

been much of a surprise. But lighting at night is very different from the day in terms of its source, types of shadows, color cast and temperature. In addition, the relative darkness of night imagery means that the lighting in these photos is more high contrast and pronounced.

So when I try night photography at home, I look for everyday objects that are transformed by the light and darkness and colors of the night.

◀ During the day, there are no shadows on the wall next to my front door. But at night, street lights cast intriguing shadows through the bushes adjacent to the house. I decided to make a photo of these shadows, intrigued by the fact that they are invisible during the day.

22mm, 30 seconds at f/11 and ISO 100, tripod mounted

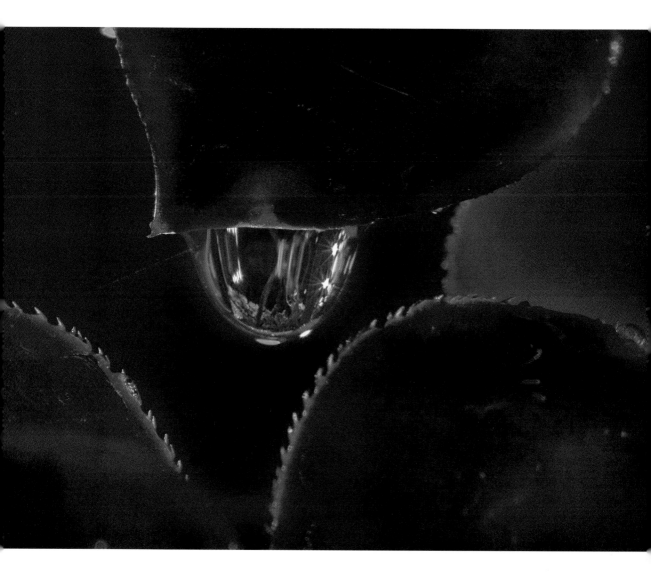

▲ This macro of a water drop shows Christmas lights in its reflections—a striking night image that has nothing to do with the night sky.

200mm macro, 36mm extension tube, 30 seconds at f/25 and ISO 100, tripod mounted

Everyday Objects

Once you've mastered the techniques of night photography, you might be surprised at subjects that occur to you. When the length of exposure is not an issue, low-light compositions and macros are very possible—sometimes with unexpected and striking results.

It's well-known that our eyes are capable of perceiving a greater range of lights and darks than a single version of a digital capture. This is sometimes called the problem of dynamic range. Images that use a variety of techniques to overcome this problem have "extended dynamic range," also called *High Dynamic Range* (HDR) images. (See page 130.)

My point is that you can use the extended dynamic range of your eyes to scope out possible everyday objects that will work for night photography.

If you come down for a sandwich in the middle of the night and see an interesting pattern in the low night lights of your home, this may be a subject for night photography. If you are walking along the street and see an attractive color reflection or shadow in a store window, there's another possible night subject—no matter how dark the scene.

If you are trying to capture an object in really low-light conditions, particularly if you need a great deal of depth-of-field, it is a good idea to consider boosting your ISO. With continuing improvements in the way cameras handle high-ISO images, this may be feasible without objectionable levels of noise—and might reduce the exposure from hours to minutes...or even to less than thirty seconds.

Now that I know about photographing at night, I have twice as much time to photograph, and I never hesitate to take a photo because there doesn't seem to be much light!

◀ In daylight, this fire hydrant looked pretty plain and undistinguished. At night, the glow of the street light turned rust and cracked patina into a canvas of colors. In making this exposure, I closed the aperture to a relatively small opening for the purposes of increasing depth-of-field, which led to a longer exposure (three minutes).

200mm macro, 3 minutes at f/25 and ISO 200, tripod mounted

▲ The restaurant was closing for the night. I looked through the window and saw these rows of glasses prepared for the next day's trade. To make the four-second exposure, I mounted my tripod precariously on a table that was pushed up against the window... and crossed my fingers that it would stay balanced.

20mm, 4 seconds at f/22 and ISO 100, tripod mounted

Extending Dynamic Range

As in the day, sometimes the night photographer is presented with an impossible exposure situation in terms of dynamic range. In this situation, the range between the lightest and darkest values in an image is so great that either dark tones or light tones (or both) lose detail when the image is rendered.

Common examples of this situation at night include a bright moon above a relatively dark landscape and a star-filled sky over a foreground landscape that is relatively dark.

Here, if you do a middle-of-the-road exposure, the bright areas will be overexposed, and the dark areas underexposed. No matter what you do, there's no way the photo will come out rendering lights and darks as you might like—unless you extend the dynamic range.

If you set your camera to shoot RAW format, which I always suggest for night photography, you can *Multi-RAW* process the file and then combine versions processed at different exposure values to extend the dynamic range. This means using software such as Adobe Camera RAW (ACR) and Photoshop to blend different versions of the same RAW file that have been processed with different exposure values.

Another technique for extending dynamic range, shown here, is to start by shooting two or more images at different exposures. Take care to shoot the bracketed exposures at the same apertures by varying the shutter speeds. Otherwise the depth-of-field may be different in the two versions, and you won't be able to combine them seamlessly. In addition, you may have problems with this technique if the subject is moving, because it won't be in the same place in the different frames.

There are quite a few software programs you can use to combine the different exposure versions automatically, including Photomatix and Photoshop. But most of the time, I prefer to blend my images by hand because I know the effect I want to achieve better than any ole automated software program.

This process is called *Hand HDR*. The example here shows you how to use Hand HDR in Photoshop to extend the dynamic range by blending two images—each shot at a different exposure and combined into one final photo. (See page 234 for resources related to Multi-RAW processing, HDR and Hand HDR processing.)

▶ Both: As I waited for the full moon to rise over the historic ghost town of Bodie, California, I realized I had a true exposure dilemma. I couldn't expose an image to properly render both the bright moon and the comparatively dark town in the foreground. So I shot two versions: a darker version for the moon and a lighter version for the foreground. I made sure not to move my camera on the tripod between exposures, and I used the same aperture (f/5.6) for both shots.

Light version (top): 34mm, 2 seconds at f/5.6 and ISO 100, tripod mounted

Dark version (bottom): 34mm, 1/4 seconds at f/5.6 and ISO 100, tripod mounted

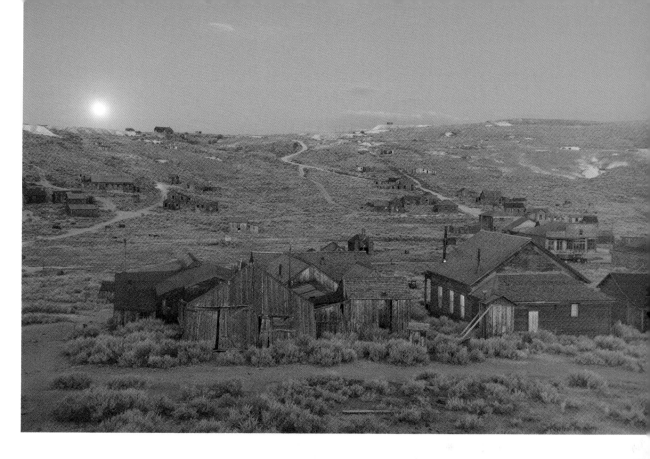

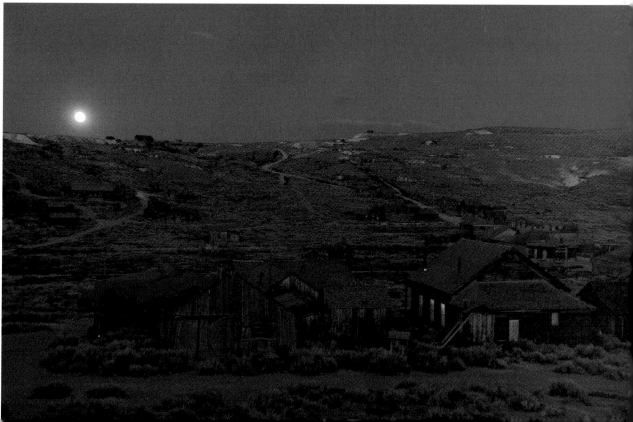

Hand HDR in Photoshop

With the light and dark versions opened in their own image windows in Photoshop, the idea is to combine the two images by positioning the light version on top of the dark version as a layer. Add a Hide All (black) layer mask to the top layer and partially reveal that layer using the Gradient Tool. Once you get the hang of it, this is a process that takes about thirty seconds from start to finish.

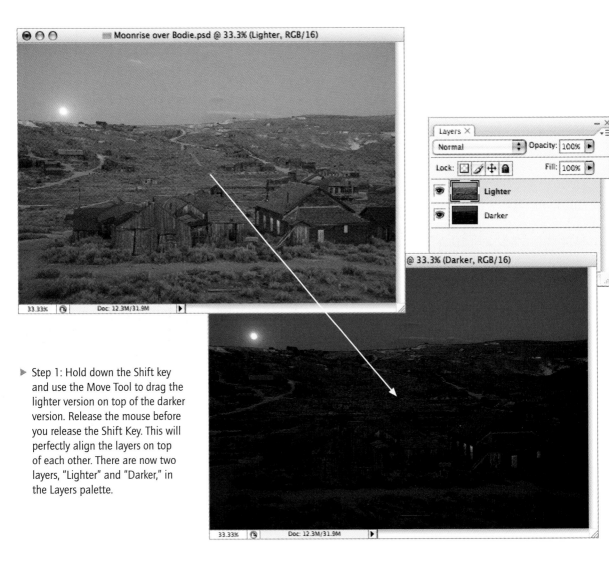

▶ Step 1: Hold down the Shift key and use the Move Tool to drag the lighter version on top of the darker version. Release the mouse before you release the Shift Key. This will perfectly align the layers on top of each other. There are now two layers, "Lighter" and "Darker," in the Layers palette.

▶ Step 2: With the "Lighter" layer selected in the Layers palette, choose Layer ▸ Layer Mask ▸ Hide All to add a Layer Mask to that layer. The Hide All Layer Mask hides the layer it is associated with (in this case the "Lighter" layer) and appears as a black thumbnail in the Layers palette associated with the "Lighter" layer.

▶ Step 3: Make sure the layer mask on the "Lighter" layer is selected in the Layers palette. Choose the Gradient Tool from the Toolbox and drag a black-to-white gradient from the middle of the image window, starting roughly at the horizon line and extending down to the bottom of the image window. This will leave the sky dark and lighten the foreground in a natural way.

▼ Pages 134–135: The completed image, *Moonrise over Bodie*, looks appropriately exposed both in the foreground and the sky.

34mm, two composited captures, at 1/4 of a second and 2 seconds, both captures at f/5.6 and ISO 100, tripod mounted

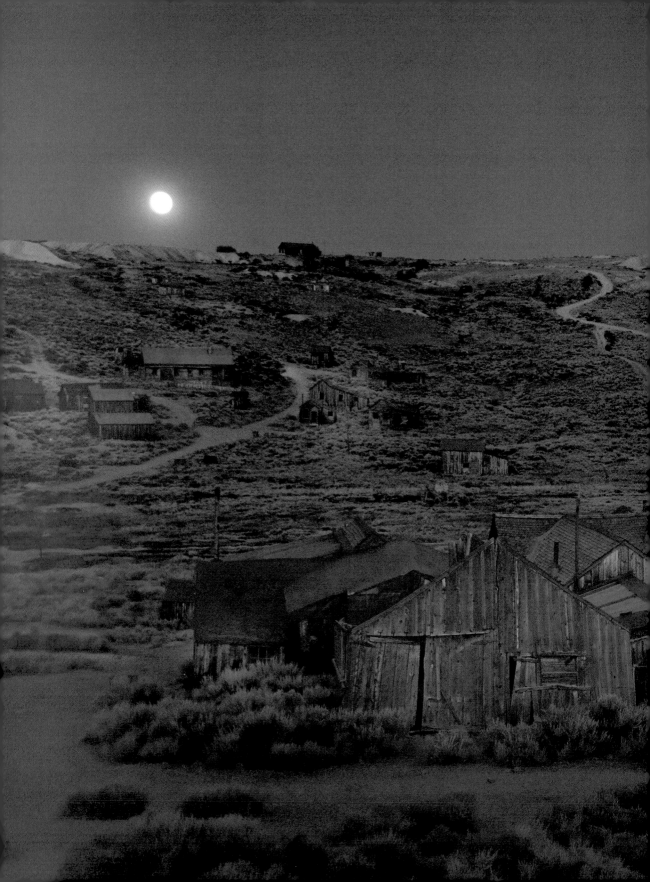

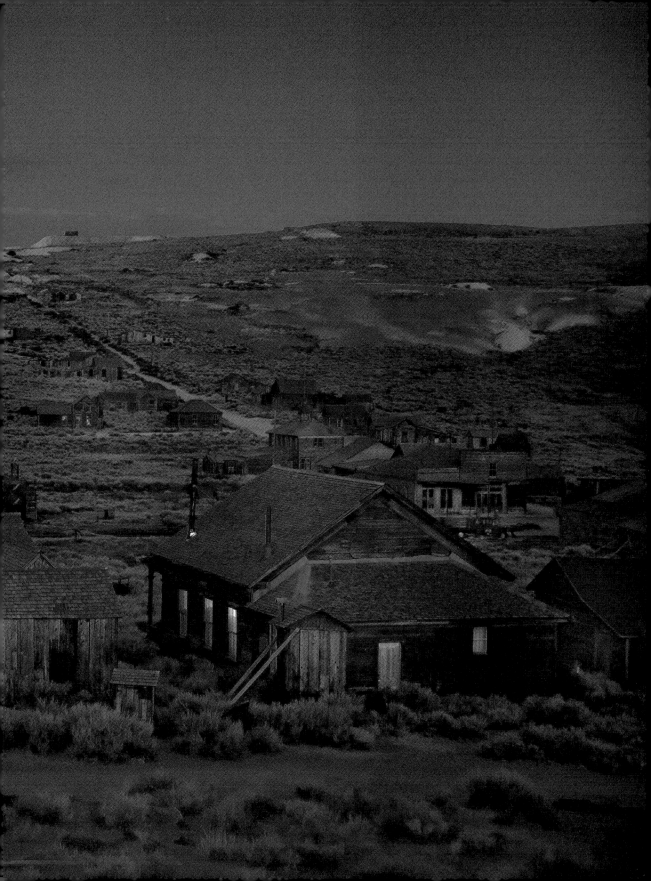

Night in Black and White

Since the colors of the night were what first interested me in night photography, it took me awhile to become comfortable with black and white images of the night.

The truth is that not all night subjects are suitable for black and white. If color is important to a composition then, obviously, it will not work as a monochrome image. Black and white requires high contrast and inherently strong compositions that do not rely on color.

Once I realized this, I came to love black and white at night for the way it can represent the vast open spaces of the night and also for the way that the absence of color can visually imply color.

Many digital cameras have a black and white capture mode, but it is not a good plan to use this mode except as a tool for aiding in pre-visualization. Speaking of pre-visualization, more and more DSLRs are starting to have Live View capabilities, which enable you to see the photo you are about to take in the LCD. If you have Live View, and it can be set to display in mono-chrome, you'll find that this is an excellent pre-visualization tool to help determine if a photo will work in black and white.

The best approach for creating high-quality black and white images in digital is to shoot in color as you normally would. Once you have the image in your digital darkroom, there are a number of techniques for converting it to black and white that don't just drop the color information. The color information in the digital file is used to make a richer black and white image. You'll find more information about this process in the resources listed on page 234.

When you look at good black and white photos of the night, you should viscerally feel the color, the black-blueness of the night—even though there is no color in the image. This is the feeling to aim for when you make your own black and white photos of the night.

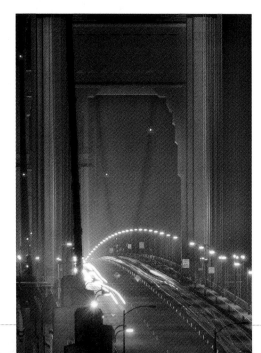

◀ I shot this image of the Golden Gate Bridge in color, pre-visualized it after processing as a color image. I found it an attractive night photo in color.

▶ But I realized that the composition didn't depend upon the color in any way, so I converted the color version into a relatively rare category of image: a black and white night photo involving moving lights that were originally captured in color.

380mm, 10 seconds at f/11 and ISO 100, tripod mounted

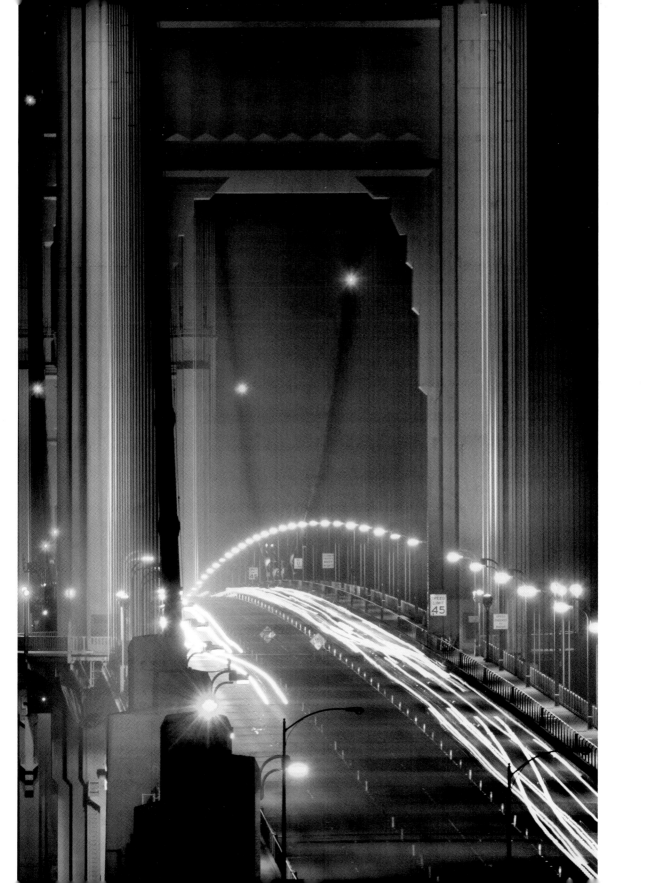

▶ In black and white images that include the night sky, I look for high contrast between the light sources in the night sky and interesting compositional elements that do not depend upon colors in the foreground.

44mm, about 3 minutes at f/4.5 and ISO 100, tripod mounted

▼ Pages 140–141: From a parking lot, I looked at this row of trees through a dense fog. The trees were backlit with emphatic orange light from street lamps, but I pre-visualized the image ignoring the color, because I thought it was irrelevant to the composition.

56mm, 52 seconds at f/4.8 and ISO 100, tripod mounted

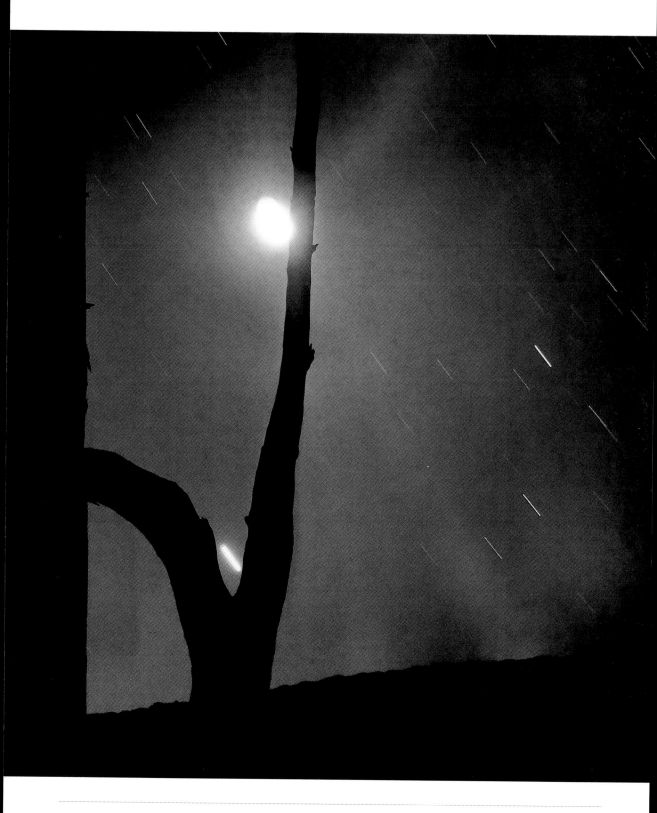

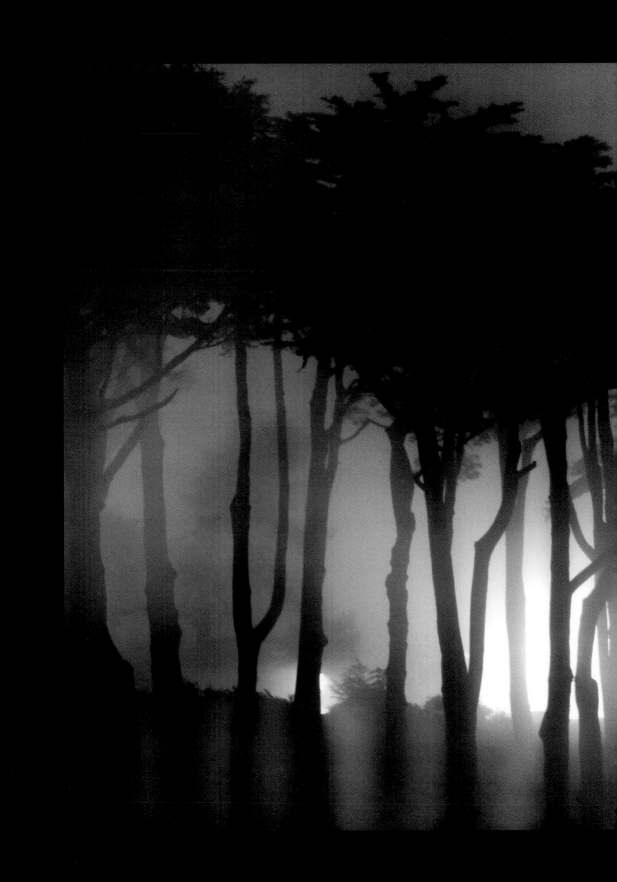

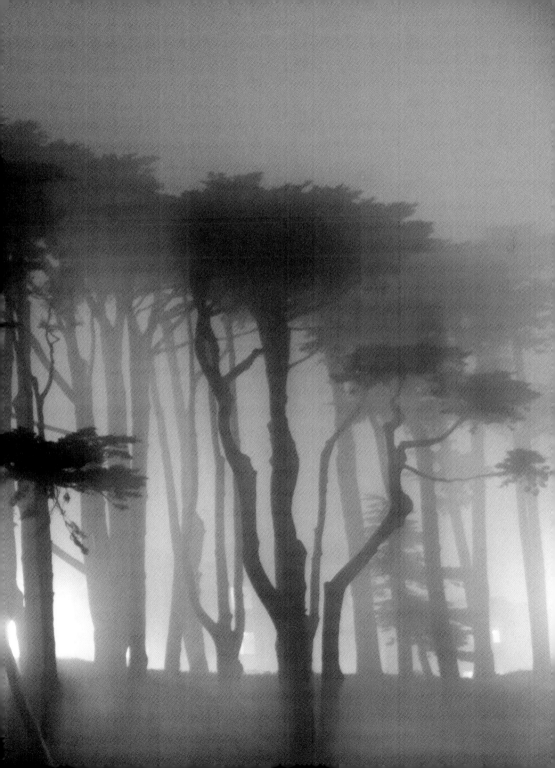

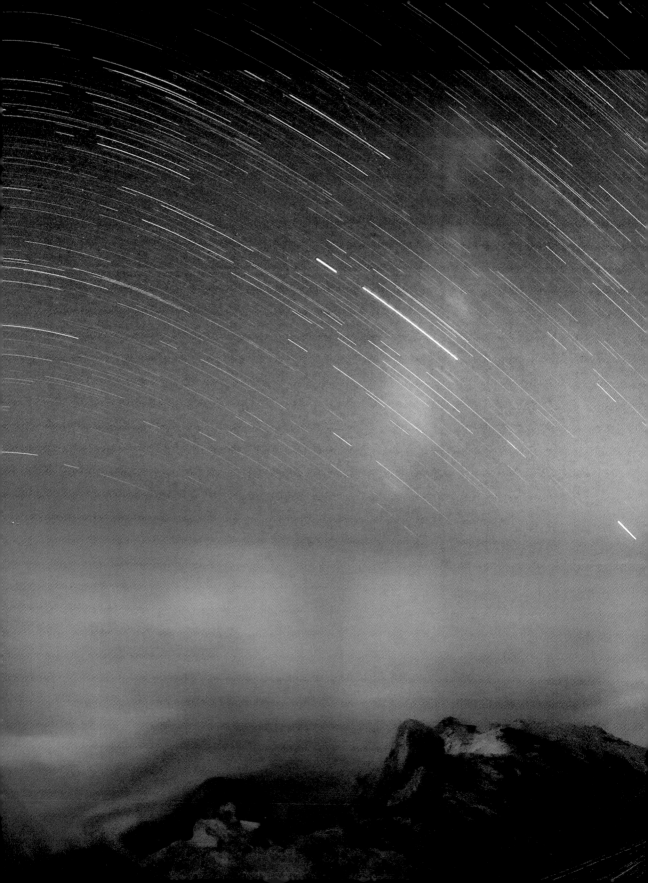

Freedom of the Night

Becoming comfortable with photographing the night has many advantages. When darkness is familiar, you can photograph at the "golden hour" and beyond in remote locations without worries about getting back safely. Most people never see the world of darkness, and this world is revealed to you as a night photographer. You get the chance to explore a world that appears dark but is actually full of color—in places that seem familiar and in more exotic locations.

Night photography reduces exposure considerations to the basics. You'll want full manual control, often using the Bulb setting (see pages 40–51). Once you get night exposures right, you are far less likely to have problems in any daytime situation—however extreme.

All these benefits of night photography sum up to a creative form of "freedom of the night." And with freedom comes responsibility.

Responsibility in the context of night photography has two major implications. You need to take common sense precautions to stay safe (see page 22 for some suggestions). And to come back with compelling photos of the night landscape, you need to plan your shots.

Planning a night photography shoot means pre-visualizing the image you want to achieve. Your plan should consider how you will arrive at the right location, at the right time. You should also plan to bring the right gear to take your photo, and to keep you safe and warm.

Becoming comfortable in darkness and experiencing the freedom of the night is great. Add to this a bit of pre-visualization and planning, and you have the recipe to make great images of the empty spaces of the night.

▲ Pages 142–143: Against the backdrop of pounding surf and a light mist on the ocean, I photographed star trails between Point Reyes Lighthouse. I think of this image as a portrait of "the edge of night."

The star trails are shorter and less curved than you might expect for an exposure of this duration because I was facing south (rather than north). You can see the separation in the star trails between the ten-minute exposure and the stacked composite (the longer segments of each star trail). This kind of "gap" in the path of the individual stars is not approved of by star trail "purists," but I like the effect in this image.

There's an explanation of stacking, one of the techniques I used to make this image, starting on page 194.

10.5mm digital fisheye, composite of foreground (10 minutes at f/2.8 and ISO 100) and sky (13 stacked exposures, each exposure at 4 minutes, f/4, and ISO 100), tripod mounted, total exposure time 62 minutes

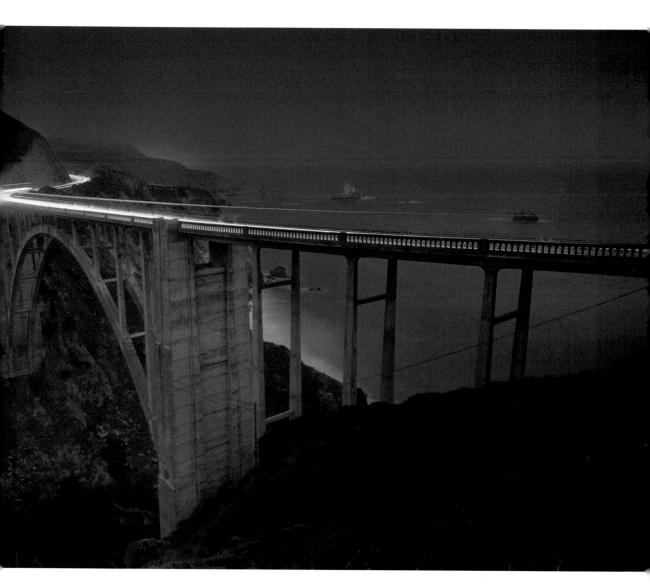

▲ My idea with this photo was to present a different view of this iconic bridge along US 1 in Big Sur, California. I spent several days in the area, photographing mostly under heavy coastal cloud cover as I planned this shot. I established a base for night photography along the Big Sur coast, and then drove 25 miles in the gathering dusk toward the bridge, which I had previously scouted. I waited for more than an hour for the light to dim enough for a thirty-second exposure and for the right combination of cars to cross the bridge.

16mm, 30 seconds at f/7.1 and ISO 100, tripod mounted

Nightscapes by Moonlight

Once the sun goes down, the moon may take its place. Assuming that the moon is in the sky in one of its fuller phases, it is a surrogate for the sun. What I mean is that the moon is so much brighter than any other celestial object, and no night photo can be made without taking into account the moon's position and comparative brightness. This is exactly like considering the sun when photographing during the day.

If you are photographing during the day, you need to assess the direction, quality and intensity of the light. Is the light strong and direct, or is it filtered and diffused? Does the light look warm or cool?

Nightscapes by moonlight present the same set of questions to the photographer. Where is the moon in relationship to the subject matter, and what is the direction of light cast by the moon? How strong is the moonlight? What is the impact on the subject in terms of the shadows it creates?

A strong, overhead moon may not create much in the way of shadows, but it is also not great lighting for a landscape—unless your primary interest is the moon itself. (See pages 120-125 for more about photographing the moon.)

Generally, if I am interested in creating a nightscape that's lit by the moon, I prefer to use the moon as a source of backlighting. It's also very effective to create compositions that combine bright, moonlit areas with relatively dark areas of the night landscape. I find that this kind of photo seems to come together when my tripod is positioned in a shadowed area.

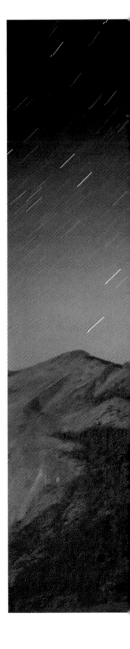

▶ I took this photograph during the course of a night I spent on the top of Half Dome in Yosemite National Park, California, at about 11:20 pm. The view is facing nearly due east with the bright setting moon behind the camera. You can see the recognizable profile of Half Dome in the moon shadow in the foreground of the photo.

12mm, about 9 1/2 minutes at f/4 and ISO 100, tripod mounted

▼ Pages 148-149: This photo shows the road down from Tioga Pass in the Sierra Nevada Mountains of California. Closed much of the year because of snow, Tioga Pass is the highest auto road through these mountains.

I photographed the road from the top of a vast gulch with my camera and tripod in deep shadow. The light of the full moon behind me illuminated the cliff side and clouds, and a single car light traversed the Tioga Pass road, bisecting the photo and creating an unusual night composition.

14mm, 2 minutes at f/5.6 and ISO 100

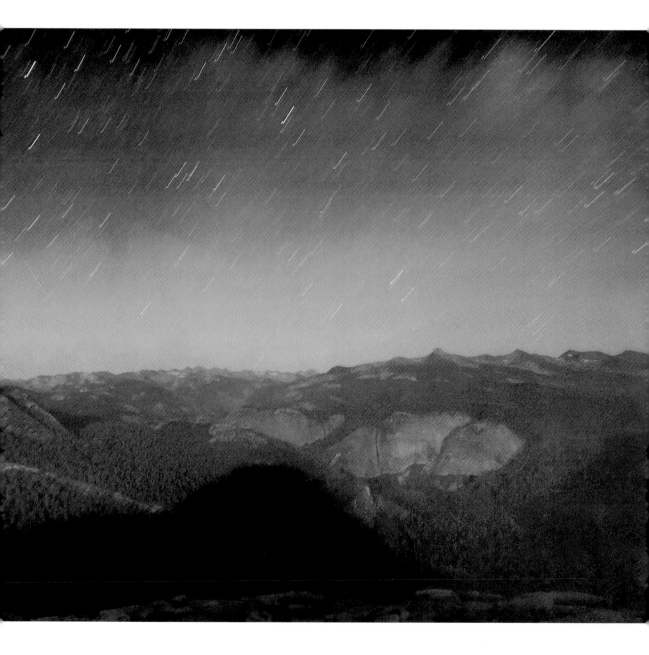

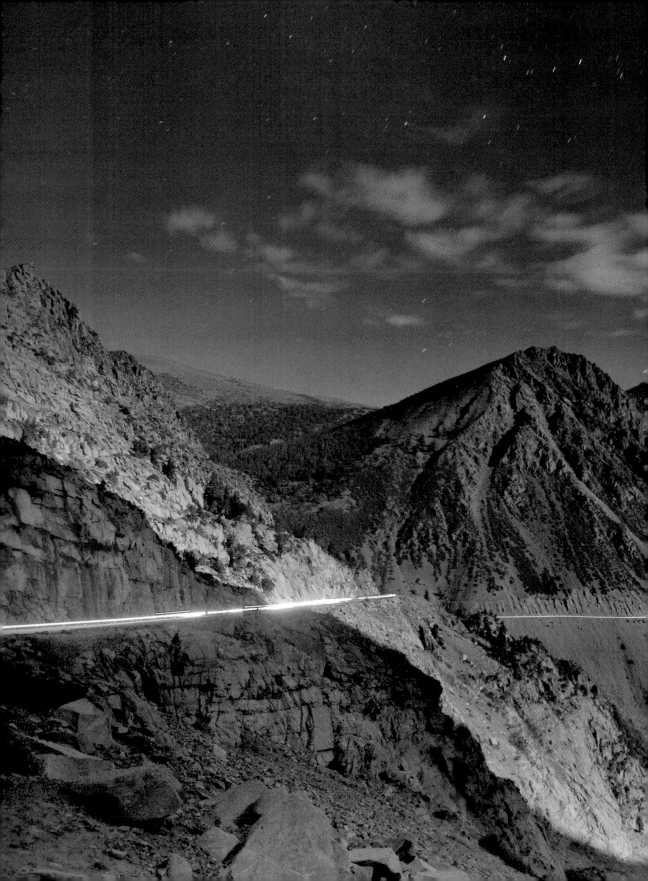

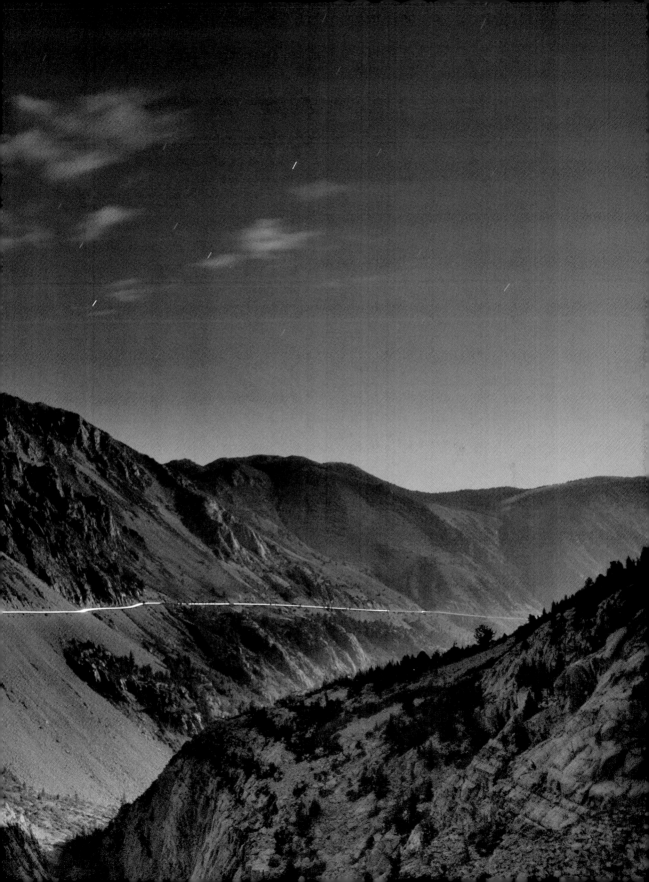

Making Night Look Like Day

You look at a photo of a landscape. At first glance, it seems normal enough. But there's something about this landscape that is unusual and maybe not quite right. After a few moments you realize that the landscape photo was taken at night.

Night landscapes that look almost like day can be excellent for creating an "Aha!" moment. Setting up the viewer with this kind of "double take" is a great way to get attention for your images. Of course, there must be more than this visual sense of dislocation to make a photo worthwhile—but it is a good starting place.

I find that the day-for-night effect requires moonlight. Starlight just isn't bright enough, and it has a different look and feel—perhaps because of the relative motion of the stars or the variable color temperature of starlight.

The trick to making a moonlit landscape look like it might have been taken during daylight hours is to aim for a histogram smack dab in the middle of the exposure range. Or you might want to overexpose and see the histogram over to the right.

(See pages 58–61 for an explanation of using exposure histograms.) This is the opposite of what I usually do at night. My typical night photos, when I want them to look like they were taken at night, feature a left-biased, underexposed histogram.

Creating an exposure means matching the settings that control your camera's reaction to incoming light with the amount of light in your subject. Obviously, there is less light by moonlight than by sun. But if you ratchet the exposure settings on your camera to reflect this fact, then it's quite easy to create night landscape photos that appear to be taken during the day.

It's worth noting that the strength of illumination coming from the moon is extraordinarily variable. As with the sun, it depends on weather and atmospheric conditions as well as the moon phase, its distance from the earth and other astronomical variables. So be prepared for a wide range of exposure settings when creating night landscapes that use moonlight to partially create a daytime effect.

▶ At first glance, this photograph of the historic Standard Mill in the ghost town of Bodie, California, looks like a daytime shot. It's only when you look closely and see the star trails in the sky that you realize it must have been taken at night.

When I made this photo, I calculated that an exposure time of three or four minutes would adequately capture the buildings and foreground. I intentionally used a longer exposure to produce star trails with some noticeable heft to create the day-for-night effect.

26mm, about 6 minutes at f/8 and ISO 100, tripod mounted

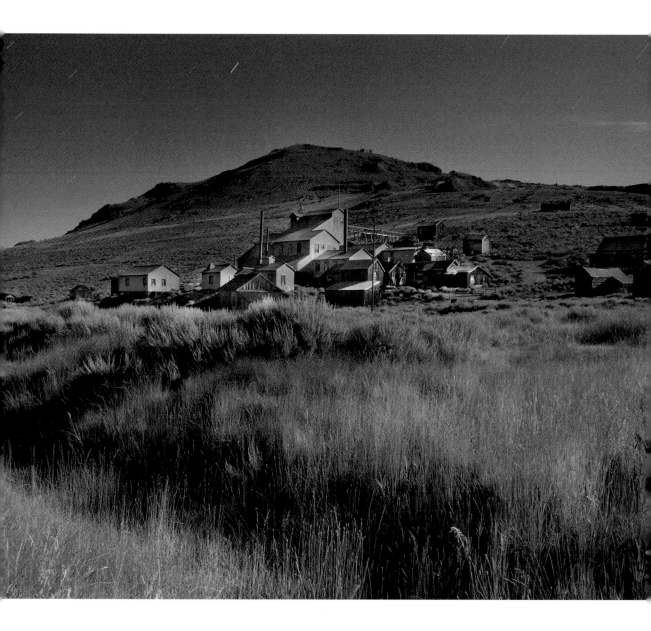

▶ In this thirty-minute exposure, the climbing walls of El Capitan and Yosemite Valley are partially illuminated by moonlight. If you look closely, you can see the lights of climbers who are bivouacked for the night on the "big wall."

I used light painting (see pages 62–67) to lighten the tree in the foreground, so that the contrast between the dark tree and the moonlit scene wouldn't be too great.

12mm, about 30 minutes at f/8 and ISO 100, tripod mounted

▼ Bright moonlight and a right-leaning exposure histogram make this beach scene seem almost like it could have been taken during the daytime … until you notice the stars.

18mm, 3 minutes at f/5.6 and ISO 400, tripod mounted

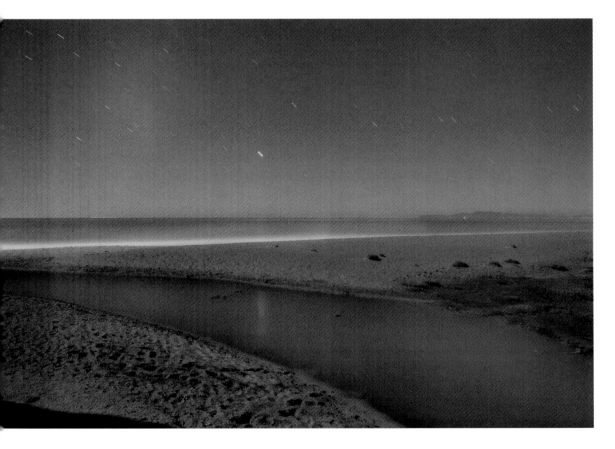

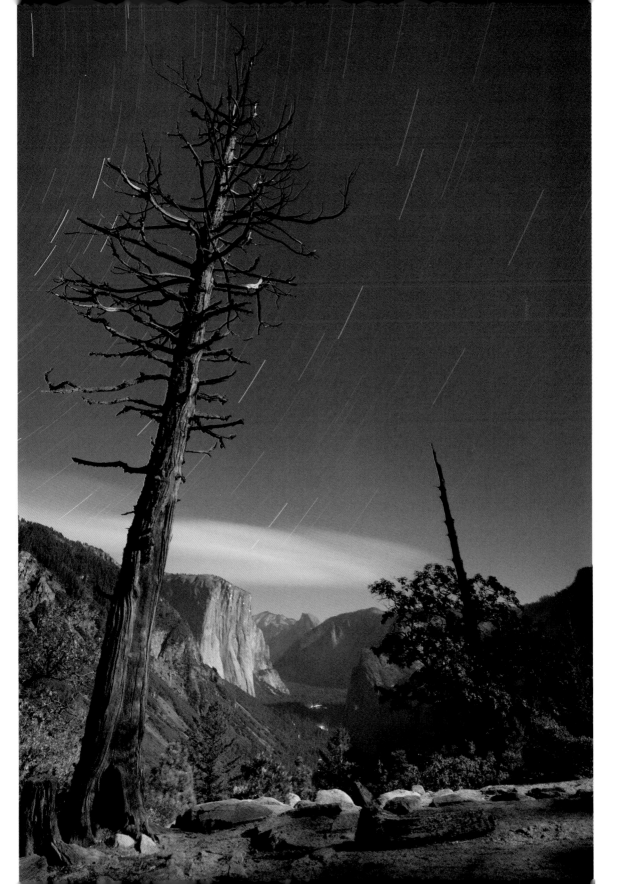

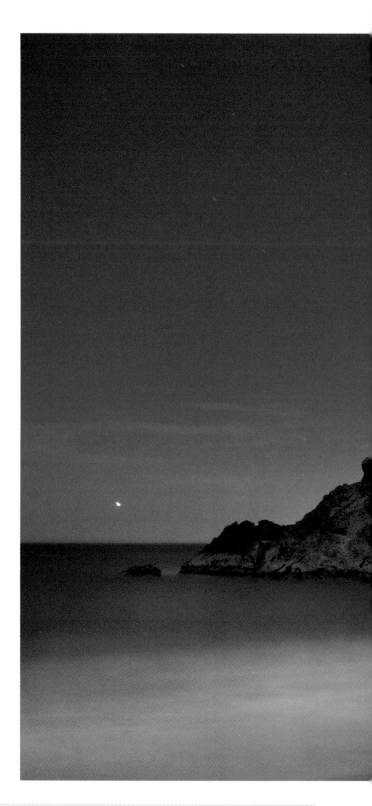

▶ The light of this powerful, full moon was so bright that the scenery seemed to be in daylight, even though my exposure was a relatively short 30 seconds. I composed this photo to line up a star directly through the hole in the rock wall. This would have been more difficult to achieve with a longer exposure, because the star would have moved relative to the cliff and would have appeared more like a line, or blur, than a point.

24mm, 30 seconds at f/3.8 and ISO 100, tripod mounted

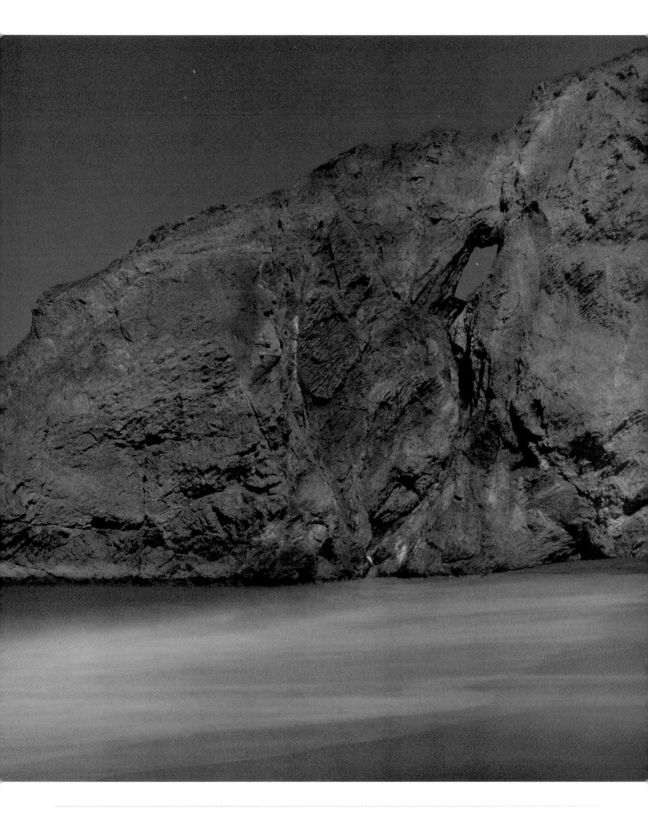

Understanding the Night Sky

If you are photographing night in a city, the state of the heavens doesn't matter much because ambient light tends to drown out whatever is in the sky. At most, astronomical objects provide an accent to this type of photo because they are not the central subject matter.

However, once you take on the challenge of creating images that show landscapes in the context of the lonely spaces of the night, the more you know about astronomical matters, the better you'll be able to plan your night shots. You'll find some of the websites I use to get astronomical information listed in the Resources Section on page 234.

No knowledge is wasted, and the more you know about the night skies, the better. But you don't need to have a PhD in astronomy to take great photos that include the night sky. It's fun to learn about stars and constellations; but there are only a few astronomical things you need to know about the night sky to take good night photos. This is true unless your interests run to astronomical photography that requires telescopes, which is a whole different world. In any case, the web is a terrific resource for finding what you need to know about the night sky. (See page 234 for some suggestions.)

We know that the earth is spinning on its axis in space. But from the viewpoint of the night photographer with a tripod fixed on a spot on the earth, the earth's rotation creates a visual effect that makes it seem as though the stars are moving across the sky over time—even though it is the earth that is, in fact, moving. Stars do also move own their own, but much more slowly.

Astronomers know that the spinning earth creates the motion effect; as a night

▶ In this photo, the "cup and handle" of the Big Dipper can be seen clearly. The constellation is upside down on the top right of the photo. If you can see the stars in the northern sky, it is usually pretty easy to find the seven stars that form the cup and handle pattern of the Big Dipper in the northern sky in the early parts of the night.

To find Polaris, the North Star, you start by locating the Big Dipper. With the Big Dipper in your sites, draw a mental line through the two bright stars on the "outside" of the cup (shown in this photo on the left side of the Big Dipper). Continue drawing this mental line straight until it hits another, moderately bright star. This distance to this other star, Polaris, is about five times the distance between the two stars on the handle, and Polaris is by no means the brightest star in the sky.

If you draw another mental line from where you are standing to Polaris, this second line is pointing north.

This old fishing trawler in Inverness, California, is lined up facing north in a number of my photos. (For other examples, see pages 192 and 223.)

12mm, 3 minutes at f/5.6 and ISO 100, tripod mounted

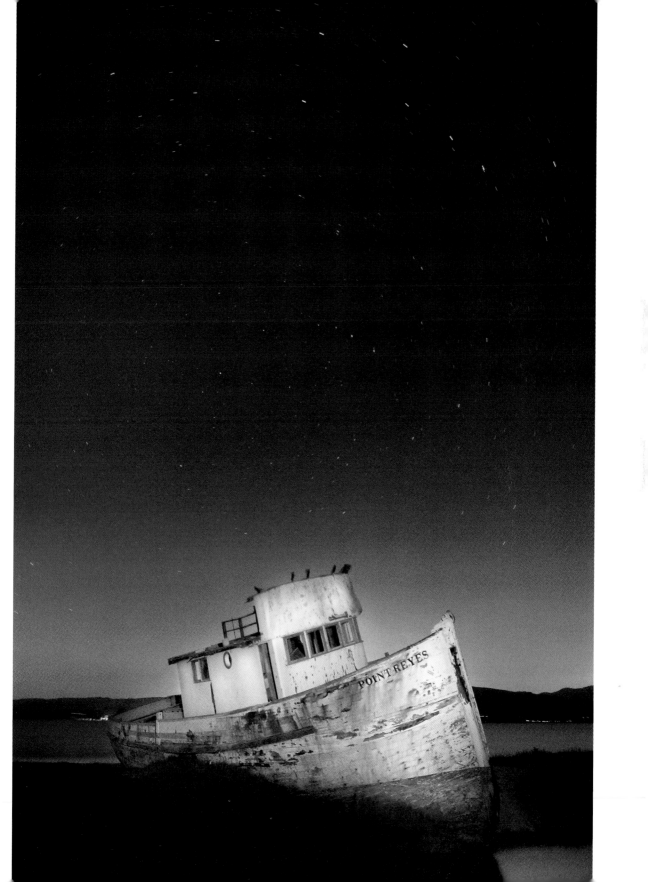

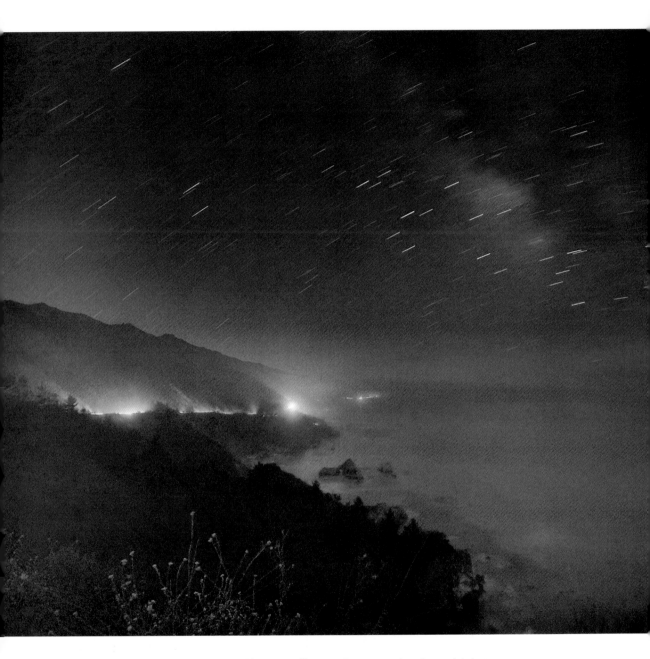

▲ When I framed this photo, my idea was to illustrate the concept that the earth is just one component in a system that includes stars and space. So part of the appeal of this night photo of the coastline of Big Sur, California, is that the Milky Way is an important part of the composition.

12mm, about 8 minutes at f/4 and ISO 200, tripod mounted

photographer I use the apparent motion of the stars to paint with light in the skies of my compositions.

To plan and pre-visualize night photos, it helps to have the following information:

- **Sun:** At what time does the sun set, and when does it rise? Where on the western horizon will the sun set? (This all varies based on the time of year.)

- **Moon:** You'll want to know the time of moonrise, moonset and the phase of the moon. Depending on your plans, the position of moonrise and moonset may be significant.

- **Polaris:** In the northern hemisphere, it is important to be able to locate Polaris, also called the North Star. (See photo caption on page 156 for information on how to do so.) Knowing how to locate Polaris is vital for navigation for those who don't have access to a GPS. It's also useful for night photographers, because stars appear to curve around Polaris, which seems stationary in the night sky. All other things being equal, the closer to north your camera is pointing—meaning, the more Polaris is centered in your frame—the more curved the star trails in your photo will be in a timed exposure.

- **Astronomical Phenomenon:** You'll want to know about any pertinent astronomical event, such as meteor showers, planetary conjunctions, particularly bright planets or stars, and so on.

- **Milky Way:** The Milky Way is the galaxy on which our solar system is located. As city dwellers, we don't often get to see the Milky Way; but before the days of ambient light pollution, seeing the Milky Way at night was a common part of the human experience. Our solar system is out on one arm of the Milky Way; and when we look at the Milky Way in the night sky, it appears as a kind of dense, sometimes sideways, gateway. It can be an extraordinarily interesting element in compositions that include the night sky.

- **Weather:** Don't underestimate the importance of basic weather. Clouds and fog can be great for some kinds of night landscapes. Other night shots call for an open sky with stars. Knowing what to expect will help you better plan your photographic journey under the night skies.

The Night Landscape

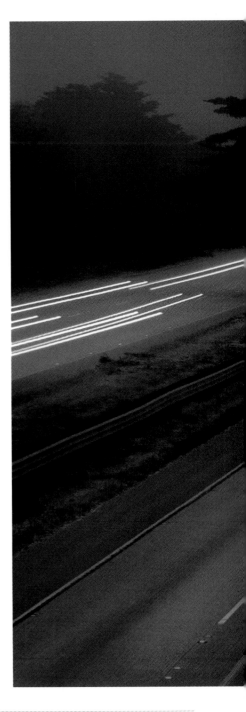

What is the night landscape? The answer is that it is anywhere and everywhere during the night. However, as I already noted, it can be difficult to see the night in the presence of artificial lights. And it's often a challenge to truly get away from the lights and light pollution that are a side effect of our civilization.

"Night" itself is not a constant state. Rather, night is a process. As the earth spins on its axis, late afternoon changes into evening as the sun sets. Evening fades to true night, which is darkest before dawn—proving that some clichés are accurate.

How long night last depends on time of year and location. The state of weather has a huge impact on the quality of atmosphere and light at night, too. And if the moon is up, its light tends to monopolize the illumination of the scenery. Night landscape by moonlight has a unique look and feel (see page 146).

There are many variables that go into the perception of the night landscape. It's your job as a photographer to observe these variables carefully and use them in your photos.

Consider two progressions:

- Darkness of the country to the core of the city

- Evening just after sunset to the deep night

Think about what it's like to start out in the wilderness at night. Perhaps you've been hiking

▶ On a remote overpass in a dense fog as evening turned to night, I intentionally underexposed to exaggerate the bleakness of the surroundings and to make the tree seem alone in contrast to the car lights passing by on the highway.

65mm, 6 seconds at f/16 and ISO 100, tripod mounted

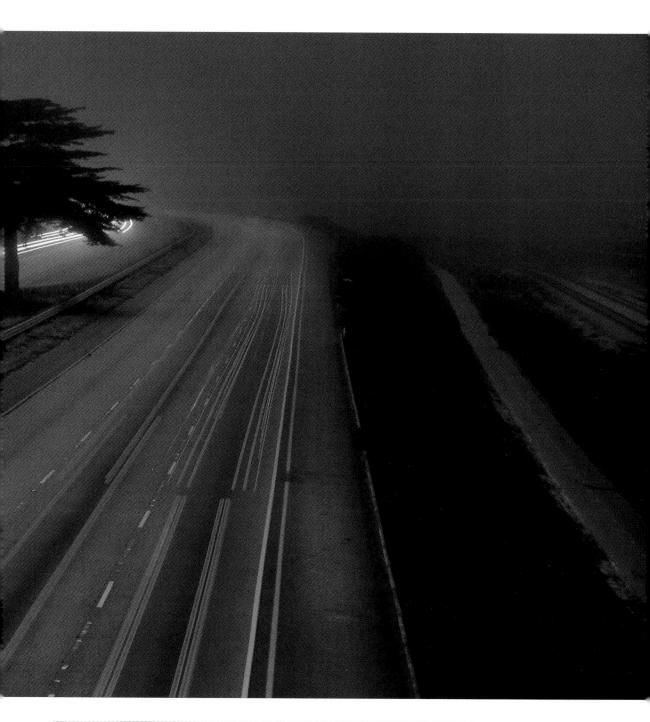

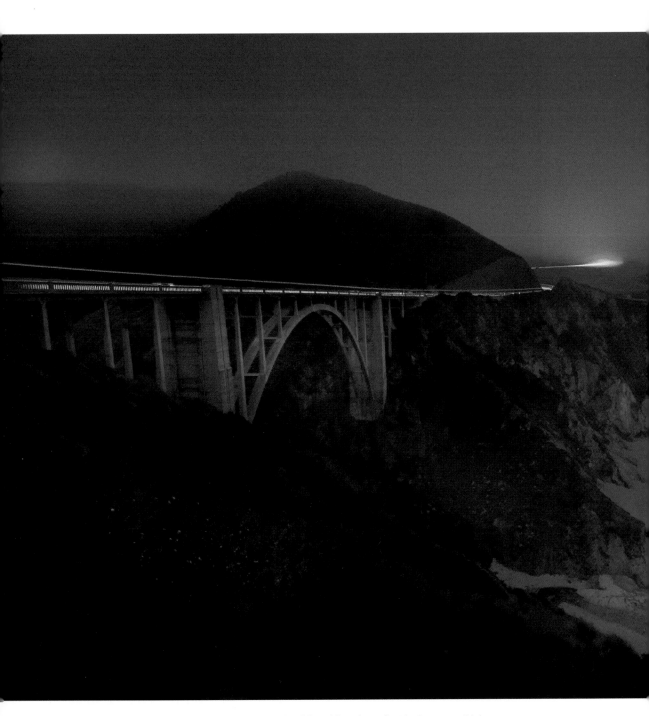

▲ Until full night was upon me, this shot of the iconic Bixby Bridge along the Big Sur coast didn't work because the contrast between the car lights and surroundings wasn't intense enough. As true night came on, I was able to maximize the contrast of the car lights with the background landscape while keeping the surf visible, for an unusual view of an often-photographed subject.

12mm, 30 seconds at f/5 and ISO 100, tripod mounted

and emerge at the trailhead after dark. There are no lights around; and absent the moon, you'll be amazed by what you can see by starlight. (Your camera, of course, can "see" even more than you can.)

As you speed along the highway toward your home in the city, you pass isolated farmsteads and houses. Light from these structures, and from passing cars, contrasts with the darkness of the landscape. Maybe being within the circle of light while all outside is black gives you a sense of comfort, but you still have a sense of being within the night landscape.

This is lost as you reach the suburbs. Ambient light pollution keeps the night at bay, and it seems like a wall of light in the city meets a wall of blackness in the night—even though as photographers of the night, we recognize the fact that night isn't truly black.

The second progression is from dusk to night and back again.

As you plan shoots of the night landscape, try to position the photos you'd like to make in context of these progressions. Photographs showing car lights, highways and bridges can be redolent of lonely spaces and nostalgia, but they are likely better made during early night or just before dawn, when the contrast between these lights and the night landscape isn't too great. The subject matter of these photos is not the night sky.

On the other hand, if you photograph the night landscape in locations where there isn't much trace of humanity, deeper night often works better. With these photos, try to compose your image to balance the celestial and earthly content, and to convey the feeling that the earth is a rotating ball connected to movement in the sky.

▶ Wet fog enveloped most of Yosemite Valley as I wandered with my camera through the winter night. From time to time, I observed odd pockets of open sky.

I took advantage of one of these breaks in the clouds to take this twelve-minute shot from Swinging Bridge on the Merced River.

From this bridge, I had a pretty straight shot at the stars over Yosemite Falls. From my vantage point, the falls aligned fairly closely with Polaris.

The falls themselves were partially hidden by the darkness and fog, but the entire cliff face was illuminated by the light pollution from Yosemite Lodge. So in this case, light pollution has a positive effect on the photo, and the reflection of Yosemite Falls in the river would probably not be recognizable without this intense ambient light source.

10.5mm digital fisheye, about 12 minutes at f/4.5 and ISO 200

▼ Pages 166–167: Photographing in the middle of the night in Zion Canyon, Utah, I was midway between the canyon floor and the high towers of Angel's Landing. I knew it was dark, but I had no real idea how dark. So I ran a test exposure at ISO 2000, three minutes and f/4. This seemed okay when I checked the exposure histogram, so I burnt my battery to the ground with this 30-minute exposure at ISO 200. (In-camera noise reduction was turned on, which added to the processing time.)

A single car moved along the road at the bottom of the canyon, creating a surprising amount of light. You can tell how dark this night landscape was by noting the impact of a single set of car headlights.

12mm, about 30 minutes at f/4 and ISO 200, tripod mounted

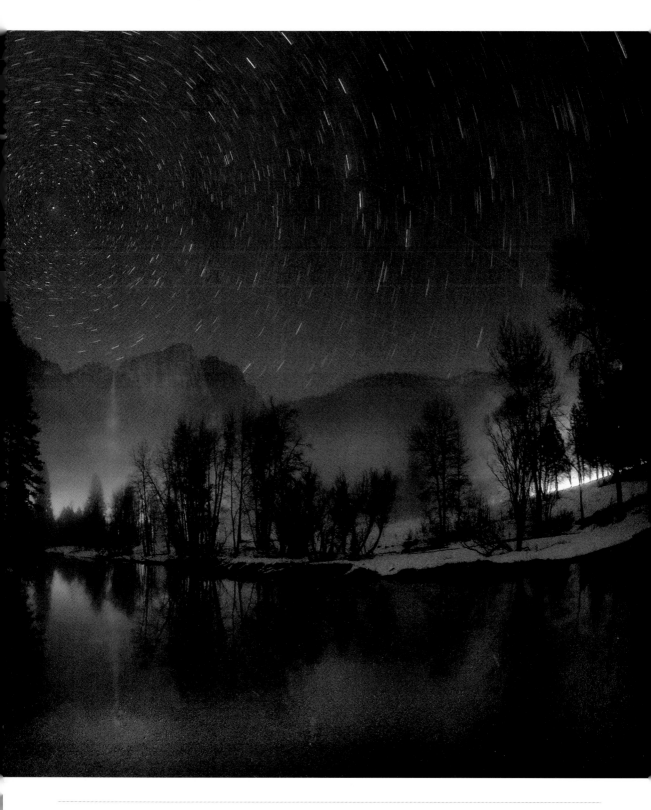

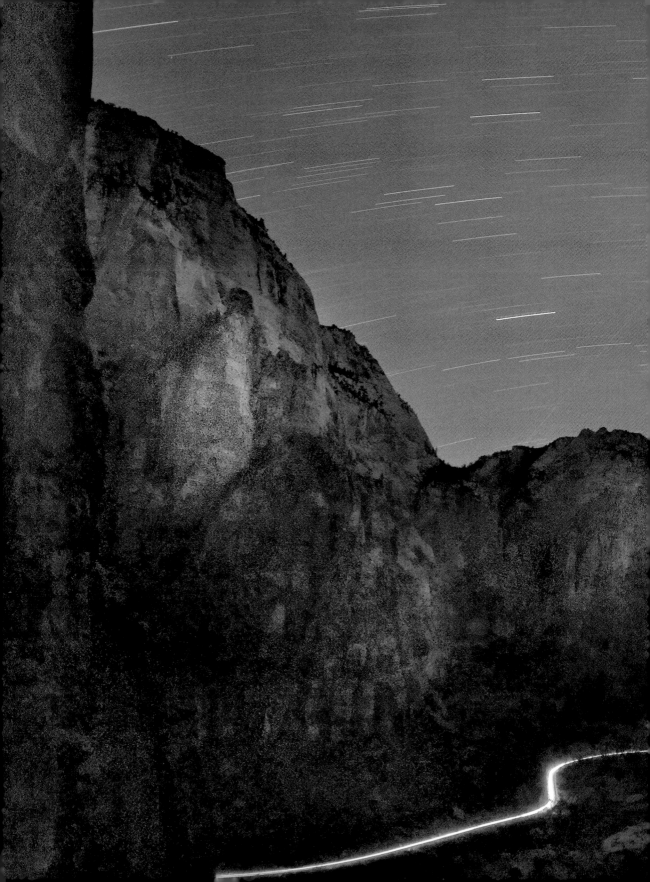

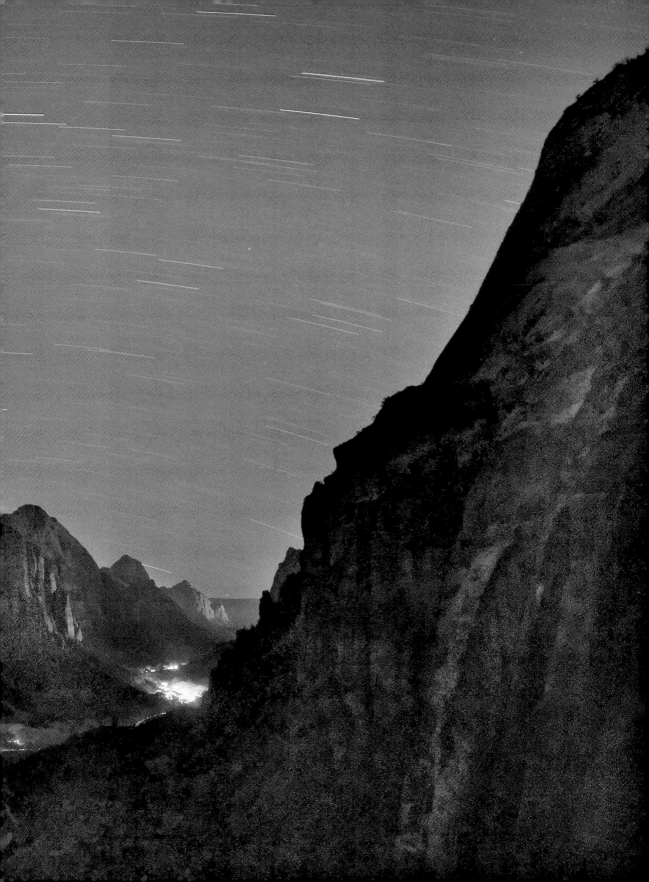

Flowers of the Night

Landscapes are not the only subject matter that comes alive in the spaces of the night. It turns out that flowers emit light waves at night that are beyond our ability to see.

It's fairly well-known that digital sensors are more sensitive to infrared (IR) light waves than either film or the human eye. In fact, this is so much the case that digital cameras are equipped with a filter that screens out IR from the sensor. You can capture IR photographs either by removing this factory-supplied CCD filter or by adding your own filter to the camera.

Less appreciated is that digital sensors can also pick up more ultraviolet (UV) light waves than film or the human eye. As with IR, this effect can be amplified using filters; but long exposures at night will pick up UV that you can't see even without special equipment.

Of course, since you can't see UV waves, you don't really know what you are going to get until you try. Light waves emitted by flowers vary tremendously, and they seem to depend upon their propagation strategies, atmospheric conditions and other variables.

The most important thing to a flower is to attract propagators, mostly bees and other insects. The markings on flowers are not cosmetic eye candy intended to make flowers pretty to us humans. These markings are intended to attract insect propagators and, in some cases, to help guide the flight paths of these insects. This is the point of the markings on an Iris, for example, which looks much like a landing strip close up.

So if a flower emits light waves beyond the spectrum that we can see, the point is to help insect propagators find the sexual organs of the flower. I haven't found any way to recognize this phenomenon or to know whether these light waves will be picked up by a given digital sensor. You just have to experiment. The problem is compounded by the technical challenges facing macro photography at night.

While UV emissions can appear as very vibrant colors in digital captures, they are fainter than the light waves emitted from more common sources, such as sunlight. If you try to light a flower yourself or to capture one lit by a distant street lamp, you are unlikely to capture these emanations.

Because of the magnification involved, any movement of a subject in macro photography is exaggerated. Also, the closer you get to a subject, the less depth-of-field you have. This means you need to stop the camera lens down to a small aperture. The combination of factors leads to a situation in which any movement, however slight, on the part of the flower, will spoil the sharpness of your photo. Night photography of flowers should probably not even be attempted if there is the slightest bit of wind.

Another problem is the critical focus that's required of macro work. This is hard to achieve at night, but it can be accomplished by using a flashlight or headlamp to light the flower while you focus.

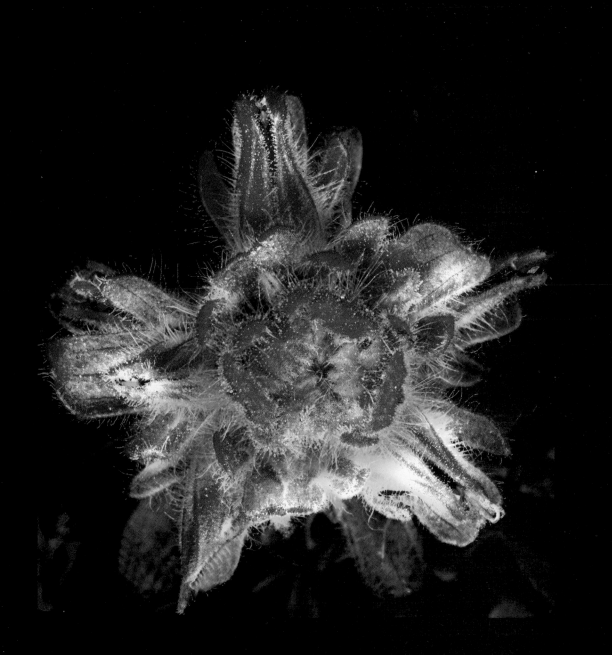

▲ Hiking on the Chimney Rock Trail in Point Reyes National Seashore after dark, I came across this Indian Paintbrush.

It was a bright night, with a low but intense coastal fog and almost no wind. This flower was sitting by the edge of a headland cliff. Even in the dark, I could see that the reds and greens of the flower glowed with an incredible intensity. They almost seemed to smolder, or vibrate, but the blue tendrils in the photo were not visible to me.

I used a headlamp to focus precisely on the flower, and I stopped the lens down to a small aperture (f/32) for depth of field, as I would have done during the day. I was lucky that unusually still wind conditions prevailed during my long (eight minute) exposure.

105mm macro, 36mm extension tube, about 8 minutes at f/32 and ISO 200, tripod mounted

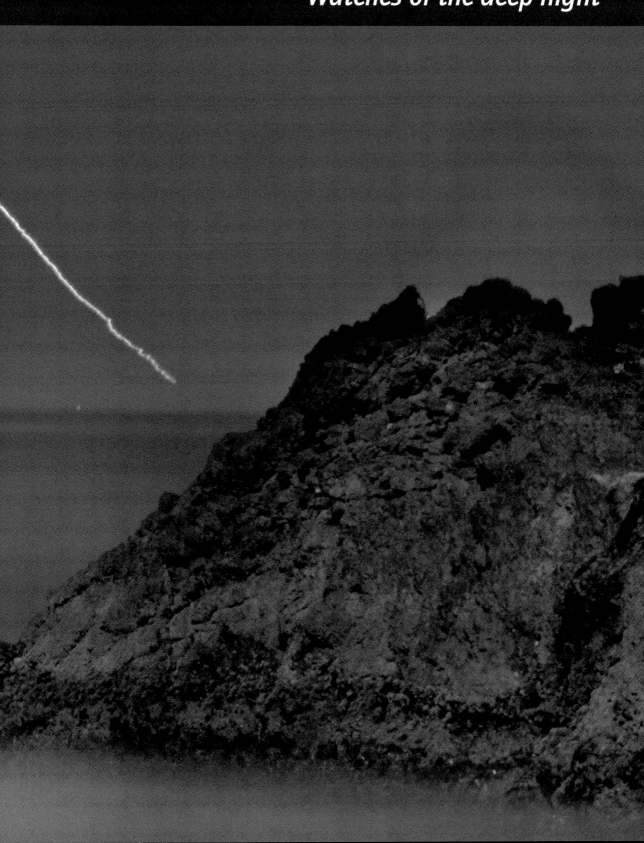

Long Exposures in the Night

Whenever I give a night photography workshop, participants ask how I determine exposure settings when it is truly dark. It's a good question.

You'll find information about exposure settings at night on pages 40–61. It's important to remember that when you're working in the middle of the night, you need to think about exposure settings a bit differently. For one thing, the idea of setting up before darkness and gradually adjusting your exposures just doesn't get you to midnight or 2 am in any feasible way.

The photos in this book, and the related exposure data that I've provided with each one, should provide a starting place for deep-night exposures.

Observation is probably the most important part of deciding on exposure settings. At night, this takes a bit more work than during the day because you have to let your eyes gradually adjust to the low light levels. Once your vision has adapted, consider the light sources. Are you exposing just by starlight? Or is moonlight acting as a "fill" light to brighten some areas of your composition?

Given that stars themselves can be properly exposed between three minutes at f/5.6 and ISO 100 (the darker end of an acceptable exposure range) and four minutes at f/4 and ISO 200 (the lighter end of the range), you can use starlight as the basis for finding a long nighttime exposure. Obviously, your exposure will depend upon the lightness or darkness of the elements in your composition other than stars. If you want to render a dark forest lit only by starlight as anything other than a black mass, you'll need a much longer exposure time than if you are choosing settings for starlight.

Since movement of the stars (and moon) is crucial to many nighttime compositions, it often makes sense to start with the shutter speed you want. You can then calculate aperture and ISO roughly based on the known settings for starlight. Note that if the moon is in an exposure calculated this way, it will appear as blown-out highlights. (See pages 120–125 for more about photographing the moon.)

When I'm contemplating a really long night exposure, I know that I'm likely to only get (at most) a couple of shots per night.

▶ During this roughly twenty-minute exposure, Half Dome was lit by the moon. I reduced the aperture to f/8 to compensate for more brightness than would normally be found in a deep night landscape.

17mm, about 20 minutes at f/8 and ISO 100, tripod mounted

▲ Pages 170–171: This photo shows the planet Venus setting into the Pacific Ocean in the dark watches of the night.

135mm, 8 minutes at f/16 and ISO 100, tripod mounted

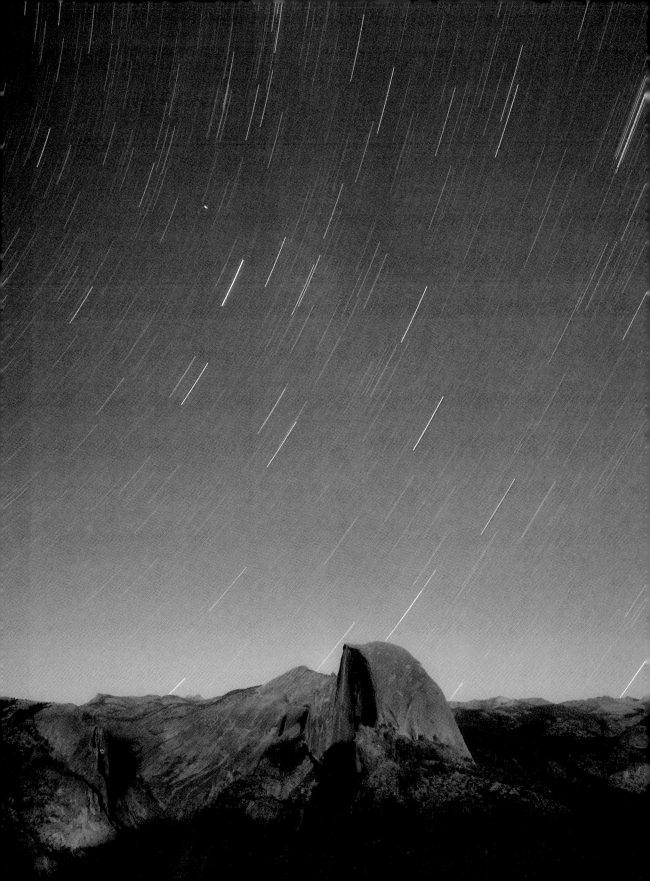

So I like to run a high ISO test in advance to make sure I am getting the exposure right.

The first step in this process is to set the camera at a fairly "short" (for deep night) shutter speed—somewhere between thirty seconds and three minutes. Next, try a range of high ISO settings, perhaps between ISO 500 and 2000. Determine which ISO is right. Be sure to use the exposure histogram as well as the view in the LCD; although the LCD can be particularly deceptive at night.

For example, the image shown to the right was shot as a test at thirty seconds and f/4. I then tried various ISO values and decided that ISO 640 was about right.

This was the data point that I needed for my longer exposures. I wanted to shoot the longer versions at ninety minutes to maximize the motion of stars and moon, and I needed to use an ISO setting of 100 to minimize noise. The missing variable was aperture (f-stop).

To go from thirty seconds to roughly ninety minutes meant I would let in 180 times as much light (without other adjustments). To go down in sensitivity from ISO 640 to ISO 100 meant reducing the amount of light by 6.4. (Okay, call it 6 to make calculations in the dark easier!) Divide 180 by 6 and you can see that the aperture I selected should let in roughly 1/30 of the light as f/4.

The aperture in a lens is approximately circular, and the designation of aperture openings (f-stops) is on a logarithmic scale. Starting with f/4, each of these apertures lets in roughly half the light of the preceding aperture:

f/4, f/5.6, f/8, f/11, f/16, f/22

This means that:

$$1/2 \times 1/2 \times 1/2 \times 1/2 \times 1/2 = 1/32$$

This is why I chose f/22 for my exposure (at roughly 5393 seconds and ISO 100).

Since I thought the test exposure was a little too bright (the reflection of the moonlight below shows some highlight blowout), I cut the exposure by a little more (by dividing by 6 rather than 6.4 and by cutting the aperture by 1/32 rather than my estimated 1/30). I threw in an extra ten minutes exposure time on pure instinct—after all, what's the difference between one hour and thirty minutes and one hour and forty minutes in the dark watches of the night?

The photo created on the basis of this test and calculation can be seen on pages 190-191; an even longer version I made the next night is shown on the title page (pages 2-3).

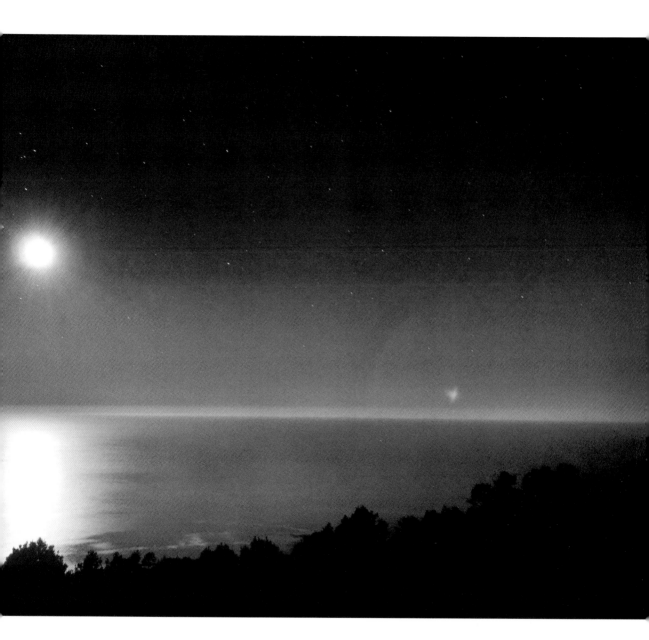

▲ This photo was a high-ISO test capture for the image shown on pages 188–189 (see accompanying text). By confirming with this photo that I had the exposure roughly right at ISO 640, I could calculate back for my subsequent, much longer exposure.

18mm, 30 seconds at f/4 and ISO 640, tripod mounted

Minimizing Noise

Noise is a kind of static in a digital image. All digital signals, including digital photographs, create some noise—a side effect that is often (but not always) undesirable when too pronounced. Noise is the closest thing in the digital era to grain in a film photograph.

There are many causes of noise, and some noise is theoretically inevitable. But noise is a particular problem with night photography. Using a high ISO, underexposure and a long exposure time all increase noise levels, and all three commonly occur in night photography.

Depending upon your equipment and the situation, when you use an ISO above 500 or 600 to take relatively short exposures at night, you should expect to see an increased level of noise. Make sure that high-ISO noise reduction is turned on in your camera, if this option is available. The good news is that digital cameras are getting much, much better at high-ISO processing. It's likely that by the time you read this, the threshold ISO that you can use without having to worry about unacceptable noise levels will be higher.

Underexposed areas in a photo—or a photo that is underexposed overall, as shown by a left-biased histogram—will have more noise than a "properly" exposed photo. (See pages 58–61 for more about using exposure histograms.) I find some underexposure inevitable in many of my night images—both because I prefer the color saturation of underexposed captures and because it is so darn dark.

There's not much you can do about noise from underexposure at the time of exposure except be aware that it is an issue. (You can plan to underexpose if you think your image might benefit from increased noise.) Consider post-processing this kind of noise in the digital darkroom, as I explain starting on page 178.

Noise caused by long exposure times is the true bugaboo of night photography. Some of the noise that is added during long exposures occurs because the camera sensor gets hot. You can combat this issue by keeping your camera as cool as possible during long exposures. For example, I've found it practical on occasion to cool my camera with snow packed in a plastic bag while the camera chugs away.

Many DSLRs have an in-camera long exposure noise-reduction option available. Unless you are shooting for a stacked composite (see pages 194–223), this option should be turned on.

In-camera long exposure noise reduction works by shooting a second exposure following the long exposure. The second, a so-called "dark frame," is shot with the shutter closed. The dark frame is then subtracted in-camera from the original exposure, which reduces much of the noise through a noise-cancellation process.

A downside to in-camera long exposure noise reduction using dark-frame subtraction is that your camera will be "locked out" and unavailable for the length of the second exposure—no small

matter when you are dealing with hour-long exposures and considering that the length of the dark-frame exposure itself may add to sensor noise (not to mention battery drain).

An advanced option for resolving this problem is to turn long exposure noise reduction off and to shoot your own dark frame with your lens cap on, either before or after a sequence of exposures. You can then combine your dark frame in the digital darkroom with your actual captures. In Photoshop, place the the dark frame as a layer above the image and select the Difference blending mode at about 20% Opacity to blend the dark frame pixels with the image pixels.

▼ In near total darkness, I stood up to my knees in the mud of the salt water flats across from San Quentin State Prison. Also known as the "Big House," this prison is the state of California's only death row for male inmates and is the largest death row in the United States.

I wanted to make this photo as ominous and creepy as possible, so I intentionally underexposed to increase the noise in the dark, cloudy areas.

200mm, 3 seconds at f/5.6 and ISO 100, tripod mounted

Post-Processing Noise

Let's face it: A long exposure taken at night will have some noise. That's the bad news. The good news is that you can reduce noise by post-processing in the digital darkroom.

Before I start showing you how to reduce noise in post-processing, you should understand that reducing noise inherently also reduces sharpness in an image. You can't have it both ways. Part of what makes an image appear sharp is the noise in the image. So successful post-processing for noise involves a balancing act.

The trick is to selectively noise reduce areas that are particular visual problems, without reducing the sharpness of an entire image by using overall noise reduction. Taking this concept one step further, you can reduce noise selectively at different intensities, so that really heavy duty noise suppression is only applied to a few spots.

In order to selectively process an image, I use duplicate layers and layer masks in Photoshop.

There are some choices to make about what noise reduction tool to use within Photoshop. In addition to Photoshop's own noise reduction filter, there are third-party noise reduction plug-ins available from PictureCode, Nik Software and others. My mild preference, because I think it does the job best, is the Noise Ninja plug-in from Picture Code (which is what I'll show you here). You can download a trial version at *www.picturecode.com/download.htm*.

But it doesn't matter so much what tool you use. The important thing is that you process selectively, rather than the whole image at a single setting.

▶ Step 1: This image, which I've processed from the RAW file, is shown in Photoshop. It has quite a bit of noise.

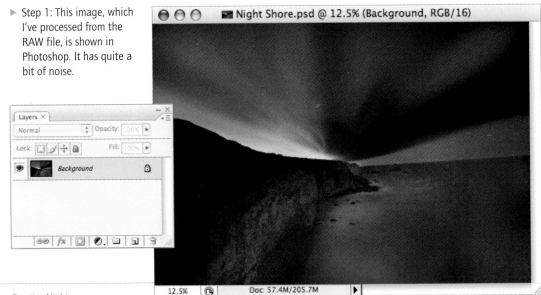

▶ Step 2: Choose Layer ▸ Duplicate Layer to duplicate the "Background" layer. Name the new layer "Noise Reduction Standard." There are now two layers: "Background" and "Noise Reduction Standard" in the Layers palette.

▶ Step 3: Choose Filter ▸ Noise Ninja to open Noise Ninja.

▶ Step 4: With the Profile tab selected in the Noise Ninja window, click Profile Image. Noise Ninja scans the image for noise and verifies the amount of noise in the image.

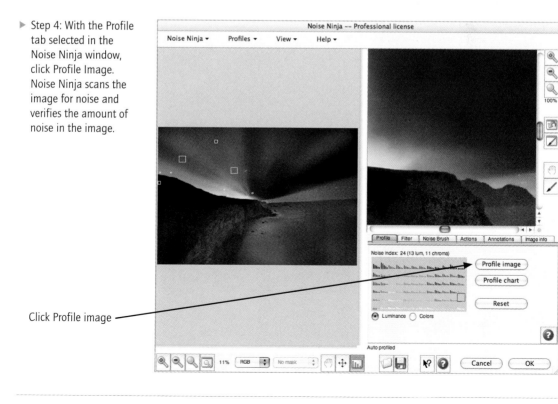

Click Profile image

▶ Step 5: Click OK to apply the noise reduction to the "Noise Reduction Standard" layer. The Noise Ninja window closes. In Photoshop, take a look at the results to see where the noise processing looks good and where it does not.

▶ Step 6: With the "Noise Reduction Standard" layer selected in the Layers palette, choose Layer ► Layer Mask ► Hide All to add a layer mask to that layer. The Hide All layer mask hides the layer it is associated with (in this case the "Noise Reduction Standard" layer). It appears as a black thumbnail in the Layers palette associated with the "Noise Reduction Standard" layer.

▶ Step 7: In the Toolbox, set white as the Foreground color. With the layer mask on the "Noise Reduction Standard" layer selected in the Layers palette, use the Brush tool to paint in the areas where you want to selectively apply the noise processing. Set your brush to 100% Opacity and 100% Flow.

▶ Step 7: Follow Step 2 on page 179 to duplicate the "Background" layer again. Name this layer "Noise Reduction Heavy" and move it to the top of the layer stack in the Layers palette.

▶ Step 8: Make sure the "Noise Reduction Heavy" layer is selected in the Layers palette. Choose Filter ► Noise Ninja to open Noise Ninja again. Click the Filter tab. To perform heavier noise processing, set Strength to 20, Smoothness to 20, Contrast to 3 and check Course noise. Click OK to apply the noise reduction and close the Noise Ninja window.

▶ Step 9: With the "Noise Reduction Heavy" layer selected in the Layers palette, choose Layer ► Layer Mask ► Hide All to add a layer mask to the layer (as you did in Step 6).

▶ Step 10: Follow the directions in Step 7, but this time select the "Noise Reduction Heavy" layer mask in the Layers palette, and use the Brush tool to paint in the areas where you want to selectively apply the noise processing. Turn to page 182 to see the finished image.

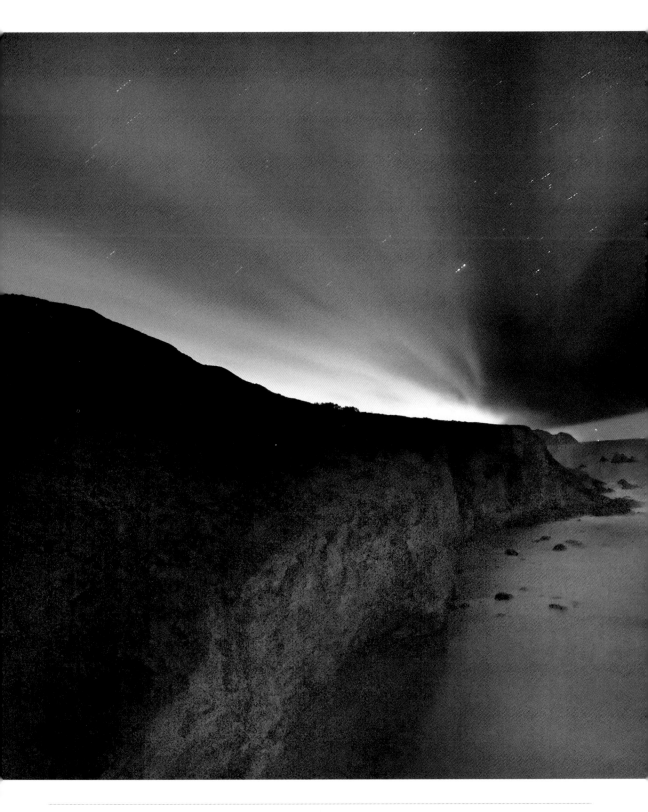

◀ This nighttime view of the Pacific coast shows the movement of the clouds in front of the stars and the distant ambient light of San Francisco. Even after noise post-processing, you can still see plenty of noise in the photo, but the overall effect is quite pleasing.

12mm, 5 minutes at f/4 and ISO 100, tripod mounted

Capturing Star Trails

In certain circles, so to speak, capturing star trails that are as long and curved as possible has become a trophy element of night photography. It's therefore worth considering the elements that create longer and more curvilinear star trails.

To capture star trails and render them as long and curved as possible, use these techniques:

- Camera Direction: Point your lens as close as possible to due north. (See pages 156–159 for information about locating north at night without a compass or GPS.)

- Angle of View: The wider the angle of your lens, the more curved the star trails will be. To get really curved star trails, use as wide an angle lens as you have—a digital fisheye is great!

- Total Exposure Time: From our perspective on the earth, the stars appear to be in motion, so it stands to reason that the longer your total exposure time, the longer your star trails will be. Keep in mind that for really long total exposures, a stacked composite (explained starting on page 194) may work better than a single exposure—that is, in terms of producing a final image with acceptable levels of noise.

Using any one of these techniques will increase the length of the star trails...as they are rendered, their curvature, or both. Using all three techniques will help you create a photo with the maximum star trail curvature and length.

Keep in mind that a photo of star trails by itself is likely to be a bit boring. You need to create compositions that have interest in the foreground as well as the sky.

An implication of including the earth as well as the sky in photos is that your foreground will be in silhouette, or you'll probably have to composite images for appropriate exposure control. The foreground is likely to be much darker than the sky, and the only way to handle this (if you don't want your foreground to go very dark) is to shoot it separately with the plan of combining it and the sky. (See pages 220–223 for more information about this technique.)

Bigger, well longer, is not always better in my opinion. Long star trails are great! But it's also nice to capture star trails when they have a modest and poetic quality about them, and when there are only one or two in the sky.

▶ Hiking down in the dark from Angels Landing in Zion National Park, I paused after the set of switchbacks known as Willy's Wiggles.

In a narrow chasm between towering cliffs, in profound darkness, I pointed my camera due north to maximize the curvature and length of the star trails that I could capture in this twenty-minute exposure.

12mm, about 20 minutes at f/4 and ISO 200, tripod mounted

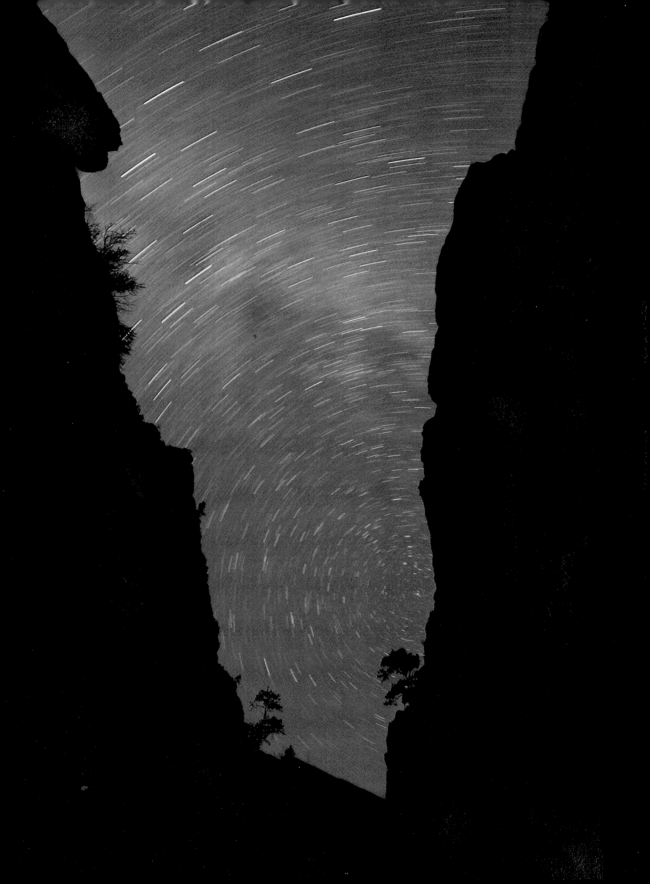

▲ To me, this photo depicts that time when evening turns to night—when stars wake up. My idea was to create a star trail image with minimalist qualities.

22mm, 5 minutes at f/16 and ISO 100, tripod mounted

▼ Pages 188–189: On a narrow platform high above the rock-bound Marin Headland coast in California, I steadied my tripod. The climb to get to this location, and the platform itself, were not for the faint of heart, particularly at night. There was a straight drop down to the pounding surf hundreds of feet below.

To maximize trails made by the stars, I used an extreme wide-angle lens (my digital fisheye) pointed due north. To capture star trails of substantial length, I needed a long total exposure time, so I planned to combine exposures for a total time of 46 minutes. This was a long enough to wait to make me appreciate my warm clothing on the narrow ledge above the waves.

10.5mm digital fisheye, composite of foreground (6 minutes at f/4) and sky (ten captures each at 4 minutes and f/5.6), all captures at ISO 100, tripod mounted

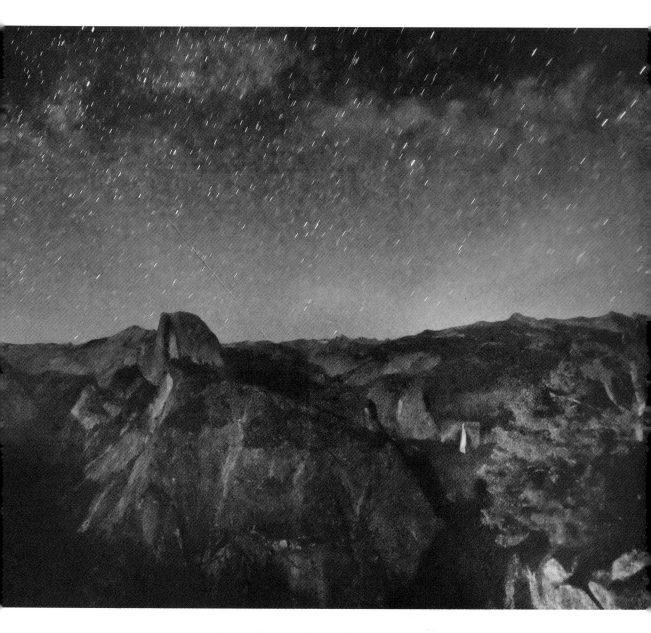

▲ The combination of a relatively short exposure time, a high ISO, and extensive noise post-processing creates a dreamy view of Half Dome by starlight. The red "accent" line is an airplane light.

12mm, 150 seconds at f/4 and ISO 640, tripod mounted

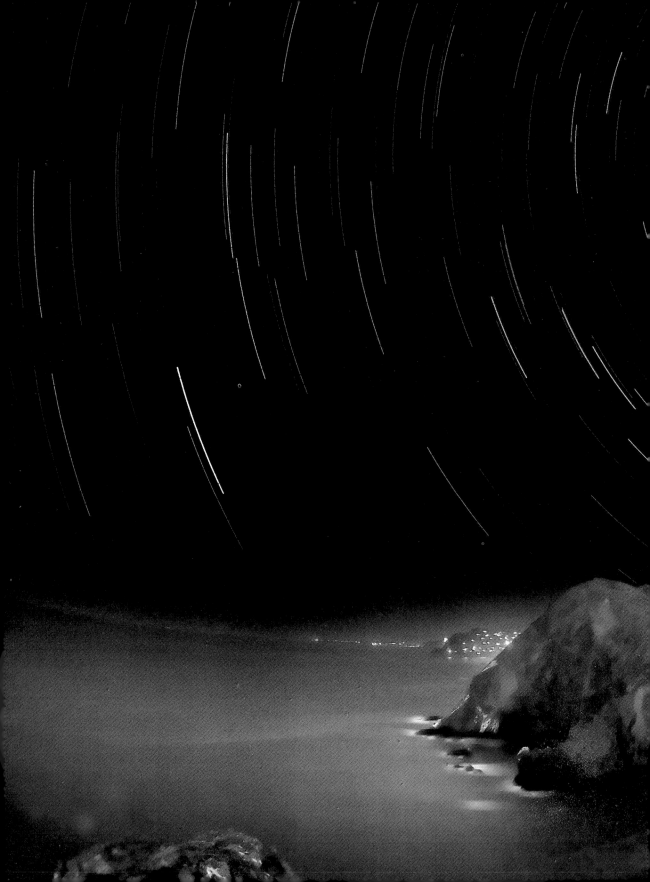

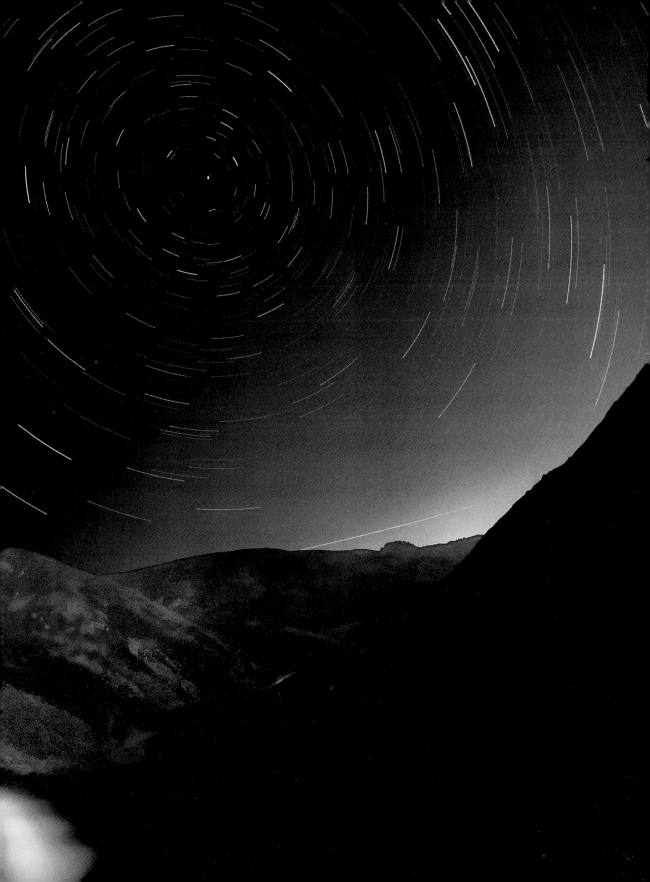

Night Music

This is a 5,393-second exposure, or about an hour and forty minutes, that started at about 12:30 am and ended a bit after 2:00 am. The bright, comet-like light is the setting moon going down into the ocean while stars wheel around above. You can see lens artifacts in the image; they were caused by the comparative brightness of the setting moon during this long-time exposure.

When I post-processed this image, I intentionally left noise in the sky. It seems to me a better effect than making the star trails appear too smooth.

I derived the exposure settings for this photo (and the one shown on pages 2–3, which has an even longer exposure) from a high-ISO test shot, shown with an explanation of the process on page 175.

With both exposures, I tried to time the delay before the exposure started—and the length of the exposure itself—so that the process of the moon setting into the Pacific Ocean would be captured along with the music of the stars.

The long exposure time would not have been possible on a single battery. The photographs shown on this page and on pages 2–3 were made using a direct AC power connection with an adapter and a long extension cord.

Lest you think that all night photography is about macho photographers suffering in foul weather, I'd like to point out that these images were taken at the Sea Ranch community in northern California. While the programmable timer took care of my exposures, I lounged in the hot tub that was directly behind the camera.

▶ *18mm, 5,393 seconds (about 1 hour 40 minutes) at f/22 and ISO 100, tripod mounted*

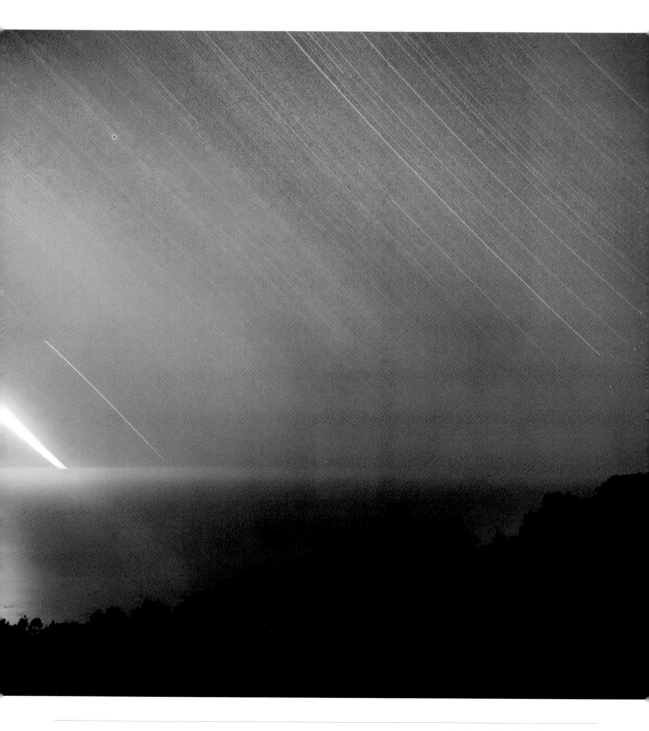

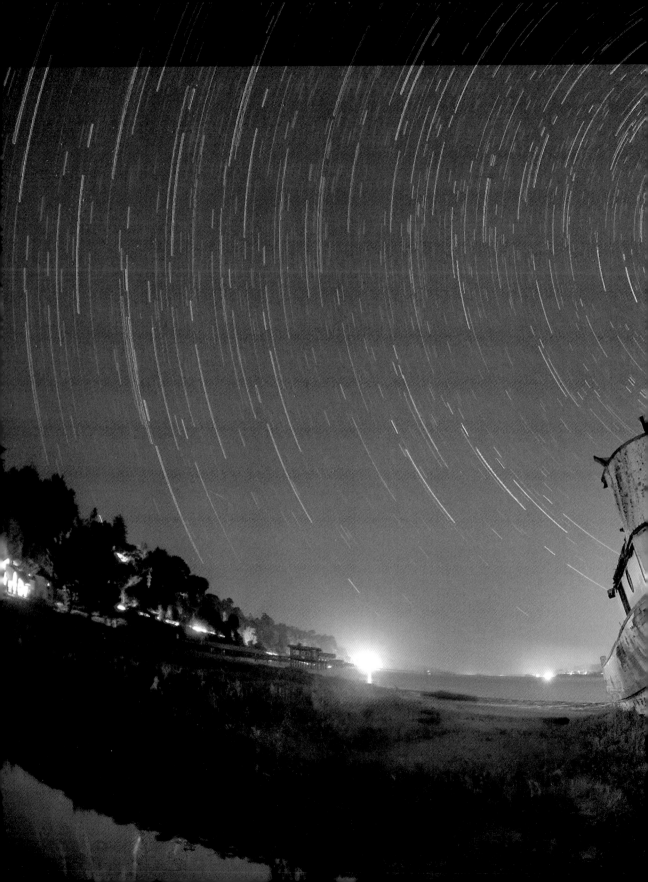

Understanding Stacking

Stacking was developed as a technique to use in digital astrophotography—photography through a powerful telescope—to reduce noise. The technique works just as well for terrestrial night photography that includes the earth as well as the sky.

By segmenting a single very long exposure into many shorter exposures and then recombining the shorter exposures in post-processing, most of the noise in each individual image gets canceled out. While this technique is conceptually simple, it takes planning and practice to execute successfully. And it requires work at the shooting stage as well as when post-processing the image stack.

Once you know the routines, the work that I refer to is not actually your work! An old advertisement suggested, "Let your fingers do the walking" to look up businesses in the Yellow Page phone directories. Similarly,

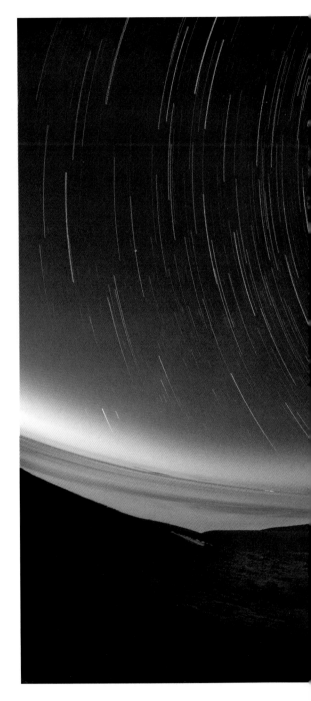

▶ On a relatively balmy November evening shortly after sunset, I drove out to the end of the North Fork of the Point Reyes, California, peninsula.

I pointed my camera due north for maximum star circles and lined up the historic Pierce Farm with Polaris. My plan was to stack at least twelve exposures as a composite and to use the lightest version for the foreground. My first exposure was, in fact, the lightest version, since a bit of light from the sunset lingered. So once I had created my stack, I separately composited the foreground from this version onto my stack.

As the camera did all the work, it was pleasant lying back on the grass, talking stars and philosophy with my oldest son, who had come along.

10.5mm digital fisheye, stacked composite of fifteen exposures, each capture 4 minutes at f/4 and ISO 200, tripod mounted, total exposure time 1 hour

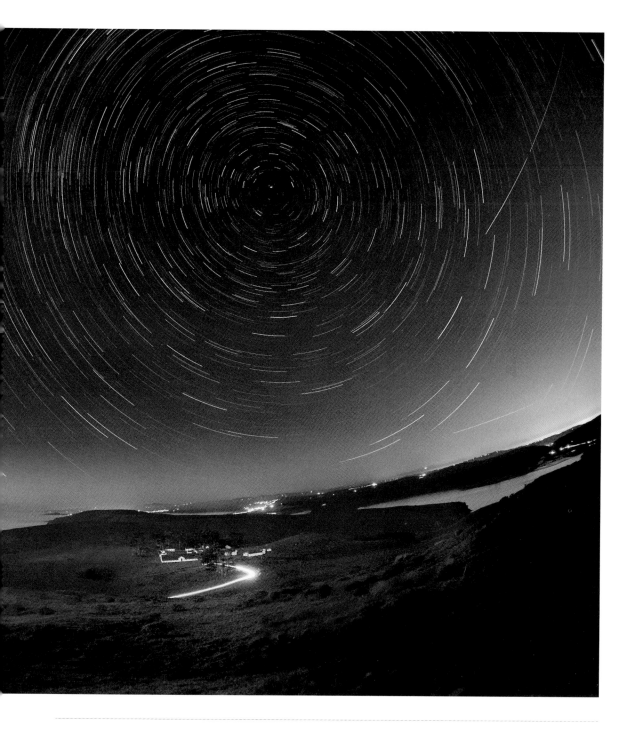

I like to let my programmable interval timer do the heavy lifting when it comes to creating stacks.

A programmable interval timer takes care of making the multiple segment exposures; your job is waiting, being patient and enjoying the night sky. You'll find information on interval timers and how to program them starting on page 226. It is, practically speaking, impossible to create a set of images that can be stacked without a programmable interval timer, because you just can't time things accurately enough over a long period manually.

Stacking works best when the background is dark, which is just fine for the night sky. You can often get acceptable results when the sky isn't completely dark, but the contrast between the star trails and the sky won't be as great.

It's important to turn **off** in-camera long exposure noise reduction when you are shooting a stack. For one thing,

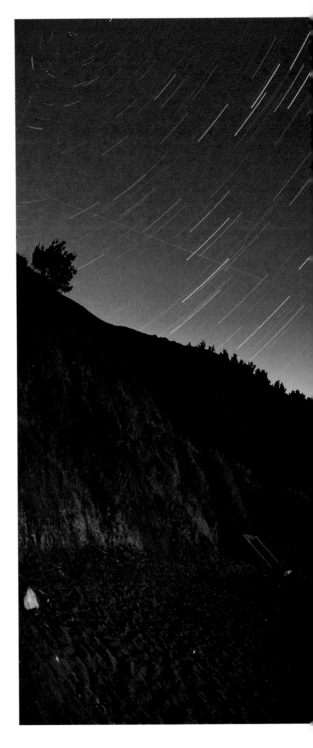

▶ It's unusual to create a viable image of star trails above a city, because the bright city lights tend to overpower the stars. This stacked composite works because of the relative isolation of the setting—a deserted beach along the Golden Gate strait, west of the Golden Gate Bridge—although you can see that the star trails are less bright than in a typical star trail image.

Since I wanted the bridge and its reflections in the composition, I couldn't point the camera north (the camera is pointing roughly southeast). You can see that the star trails show less rotation than they would have if the camera had faced north.

Originally, I planned more than twelve exposures for the image stack, but I had to discard some of the captures because they included distracting horizontal airplane trails.

10.5mm digital fisheye, stacked composite of twelve exposures, each capture 4 minutes at f/5.6 and ISO 100, tripod mounted, total exposure time 48 minutes

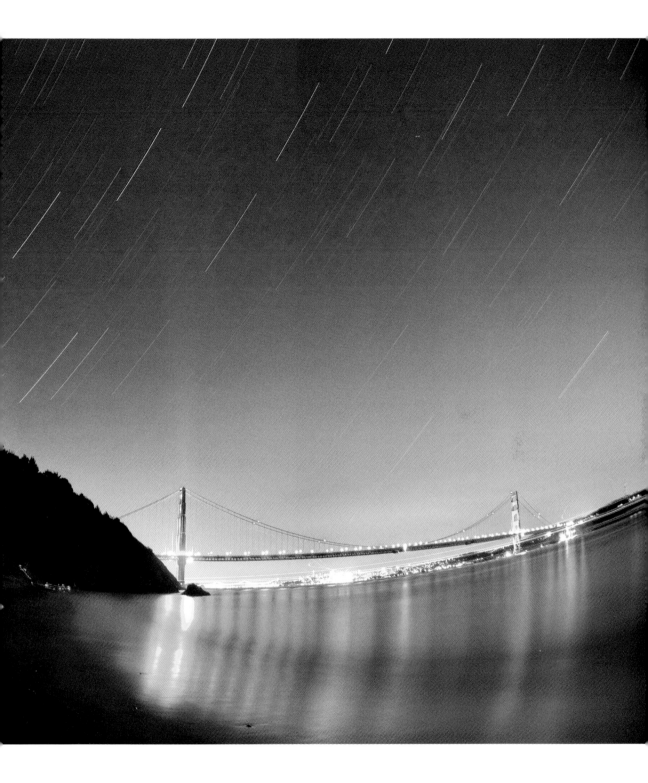

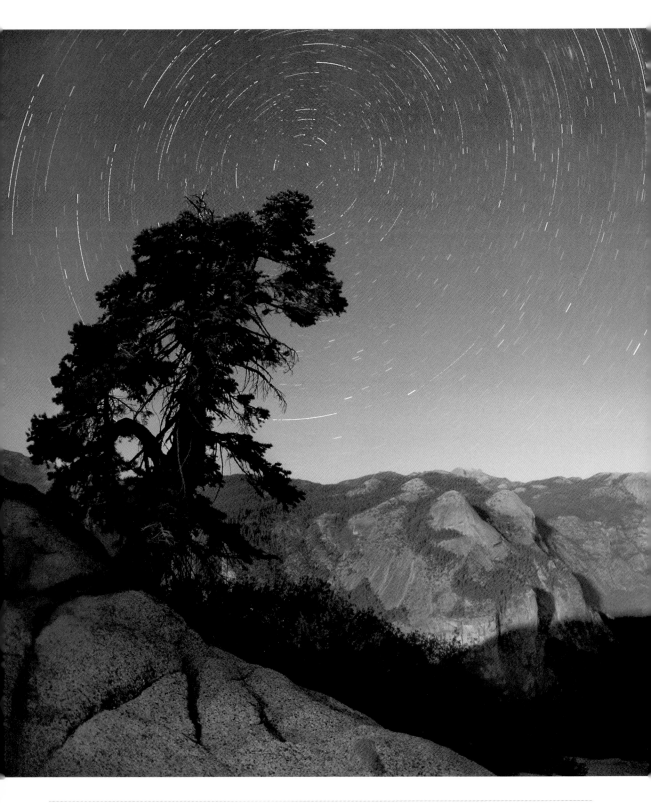

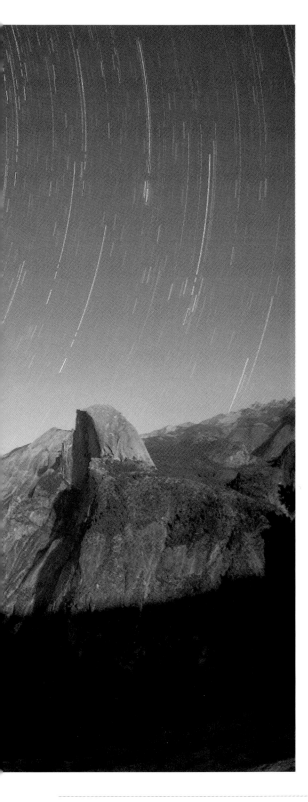

the inherent noise-cancelation feature of stacking means that you don't need in-camera noise reduction as much as you would on a single long exposure. More importantly, the time the camera takes to generate the black frame for in-camera noise reduction would produce huge gaps in the star trails of your stack.

To make up for the lack of in-camera long exposure noise reduction—you can't use in-camera noise reduction when stacking—an option is to shoot your own dark frame with the lens cap on before or after you shoot your stack. Combining this dark frame with the stacked composite (as explained on pages 176–177) may reduce the noise in the image. However, it's possible that your stack will already be noiseless enough and the dark frame subtraction won't make much visible difference.

Each of the segment exposures destined for a stack should be exposed for starlight. As I noted on pages 174–175, this implies an exposure within the range of three minutes at f/5.6 and ISO 100 and four minutes at f/4 and ISO 200—or the equivalent exposure value. For example, exposure settings of eight minutes at f/5.6 and ISO 200 would also work for starlight, although I prefer to keep segments that are destined

◀ In this stacked composite taken from Glacier Point in Yosemite National Park, a bright moon lit the mid-ground and the sky. To get a bit of detail in the foreground, I composited in a separate exposure that was intended to pick up detail in the shadow areas.

10.5mm digital fisheye, composite of foreground (8 minutes at f/2.8 and ISO 100) and sky (stacked composite of fifteen exposures, each capture 4 minutes at f/4 and ISO 100), tripod mounted, total exposure time 68 minutes

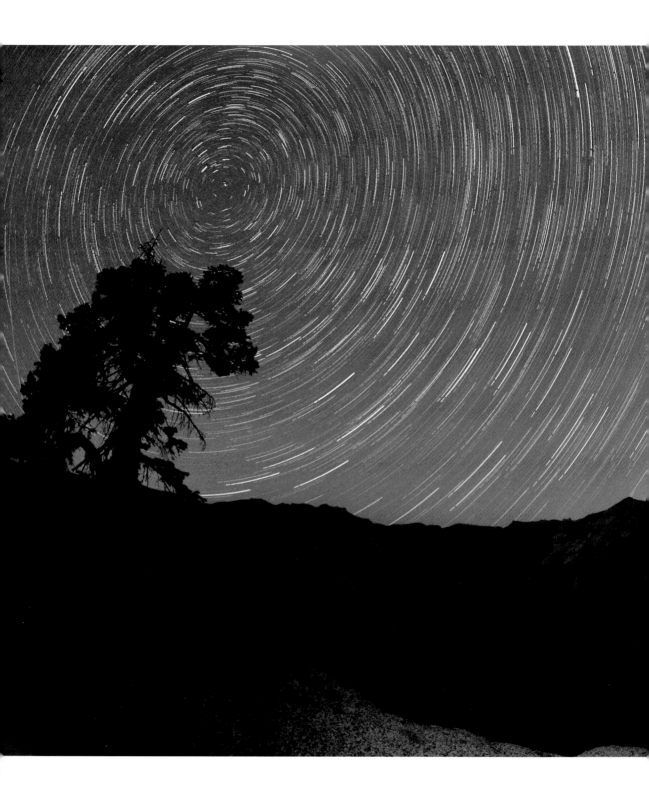

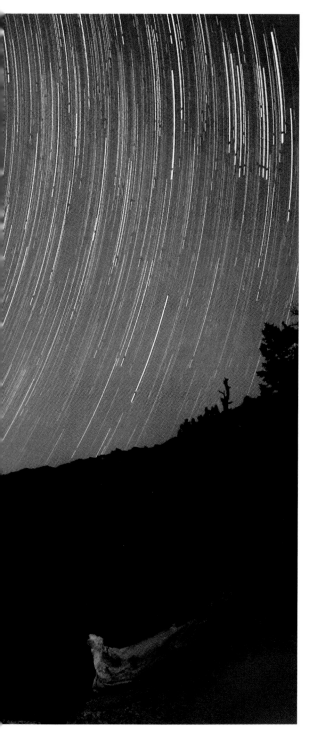

for a stack to three or four minutes in length.

Long star trails require time. Noise cancelation requires multiple exposures. These two facts imply that for most stacked star trail images, you should plan many exposures, especially since some exposures may need to be discarded. For example, if an airplane wanders into the sky in your photo, and you don't want to show the lights from the plane, you'll have to throw away the exposure that shows them. If a car headlight or your flashlight flares into an exposure, you also may need to discard the image from the stack.

Usually, a minimum of eight captures is a good idea. Theoretically, there's no limit to the number of captures you make. You are only constrained by the duration of night, your patience, the life of your battery, and whether you have the computing power for processing all your images in the digital darkroom. As a practical matter, I find that I rarely go beyond twenty different captures, if each one is in the three to four minute range.

◄ This stacked composite image is one of a series of stacked composites I made from Glacier Point without the benefit of moonlight. With this one, I experimented with adding a high-ISO version as one of the elements of the stack. I intentionally left the foreground dark (the way it looks in the individual exposures) rather than trying to blend in a brighter foreground, as I did in some of the other versions.

If you are wondering, the bright purple that can be seen in the star circles comes from sensor flaring due to overheating. I tend to believe that this dramatic color addition helps my composition rather than diminishing it.

10.5mm digital fisheye, stacked composite of thirteen exposures (twelve captures at 4 minutes, f/3.2, and ISO 100; one capture at 4 minutes, f/4 and ISO 800), tripod mounted, total exposure time 56 minutes

As I've mentioned, photos that show the night sky without foreground interest rarely work. And exposing for starlight creates problems with the foreground: the foreground is usually way too dark to show details. There are a number of approaches for dealing with this exposure problem.

- Use the foreground from the lightest version on the stack, perhaps lightened further in the digital darkroom.

- Shoot a special exposure for the foreground, allowing more light into the camera. Composite it with the stack in the digital darkroom.

- Create a composition with bright elements in the foreground, either naturally or via light painting, as explained on pages 62–67.

- Choose a composition where the foreground elements work well in dark silhouette.

Obviously, you should be sure that your tripod and camera do not move while exposing a stack. If you do move the camera during your exposures, you can try the auto-alignment features available in some stacking software, although it is better not to move the camera in the first place. In addition, be sure your camera is in an absolutely unchanged position if you shoot a special exposure for the foreground.

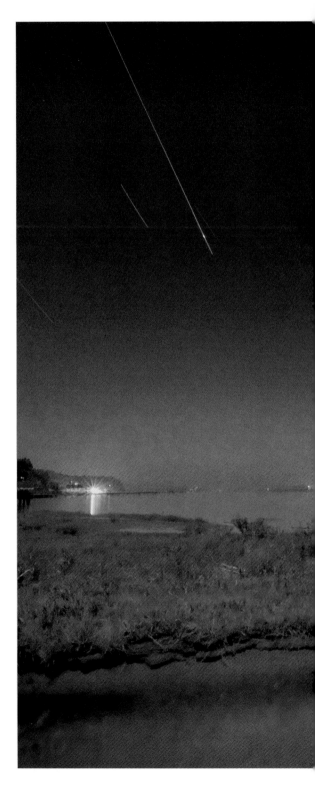

▶ This roughly twenty-minute exposure of the Inverness fishing trawler approaches the limits of possible exposure time without excessive noise in a single shot. (Compare a stacked version of this boat, shown on pages 192–193.) The lone, long star trail is quite nice, but the effect is not nearly as spectacular as you can get with stacking.

13mm, about 20 minutes at f/22 and ISO 100, tripod mounted

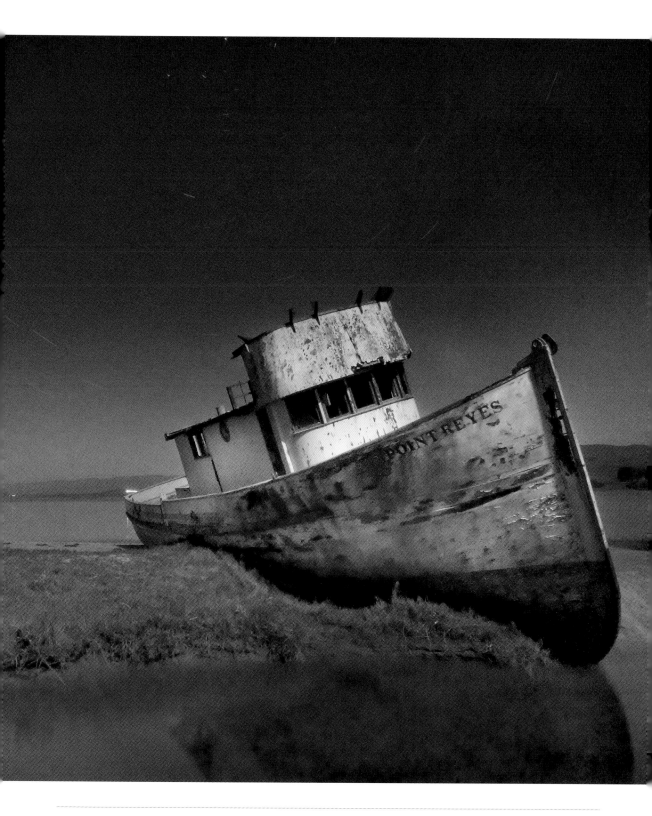

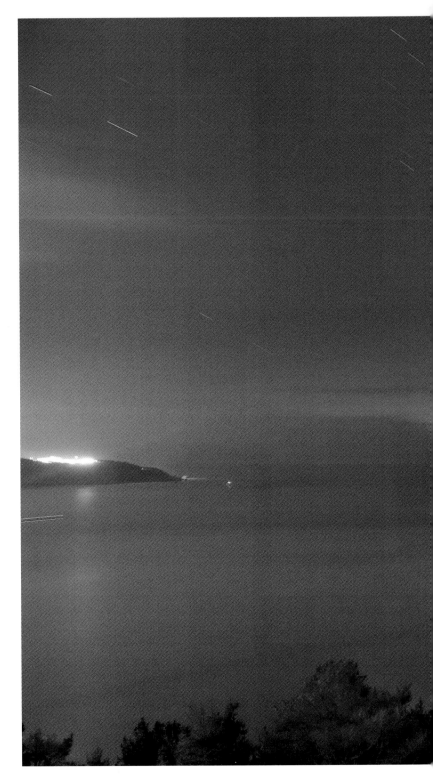

▶ Most of the time, I stack many images together. With this image, I decided to experiment with a stack of two images to capture stars by themselves. I allowed a substantial interval between the two exposures, and I'm pleased with the result: the star pattern resembles the short-long letter A in Morse code.

18mm, two stacked captures, one exposed at 5 minutes and one at 8 minutes, approximately 6 minutes between the two exposures, both exposures at f/5.6 and ISO 100, tripod mounted

▼ Pages 206–207: Photography for a stack takes such a long time that sometimes I try to do two images at once, using two camera bodies and two programmable interval timers. With one camera in one direction, I photographed the images that I later combined into a stack shown in its finished version on pages 142–143. With my other camera, I photographed this stack, pointing straight north up Bodega Bay on the coast of California.

In this image, stacking created an interesting effect in the fog on the water as well as in the circular star trails.

12mm, stacked composite of twelve exposures, each capture 4 minutes at f/4 and ISO 100, total exposure time about 48 minutes

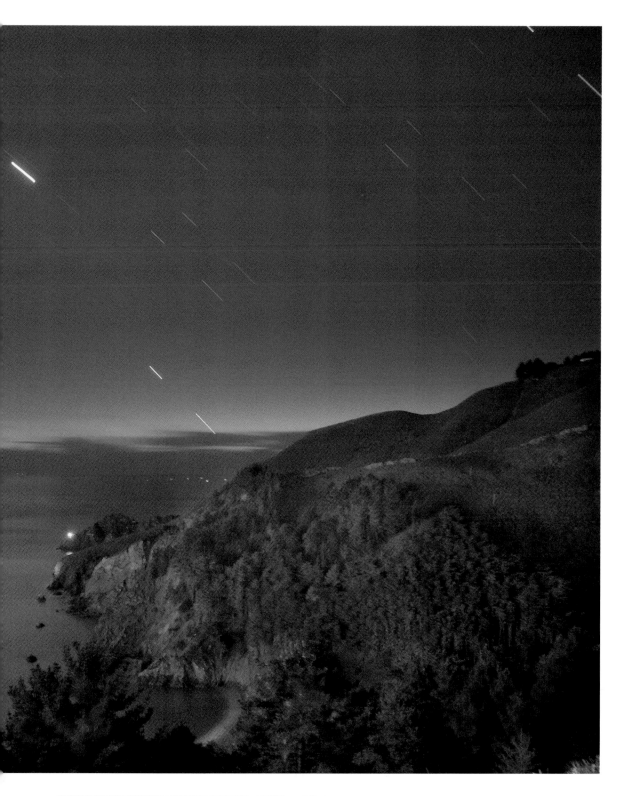

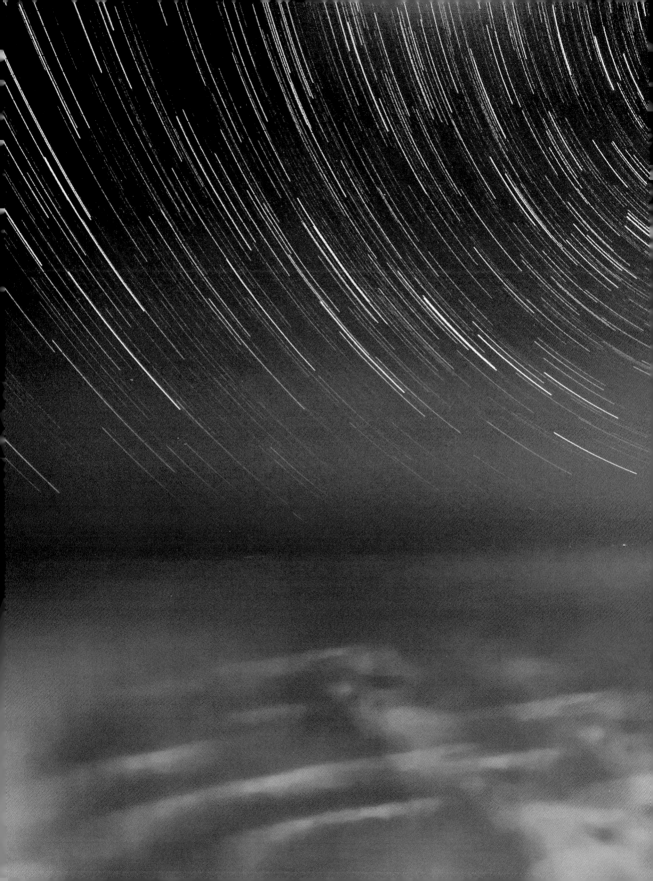

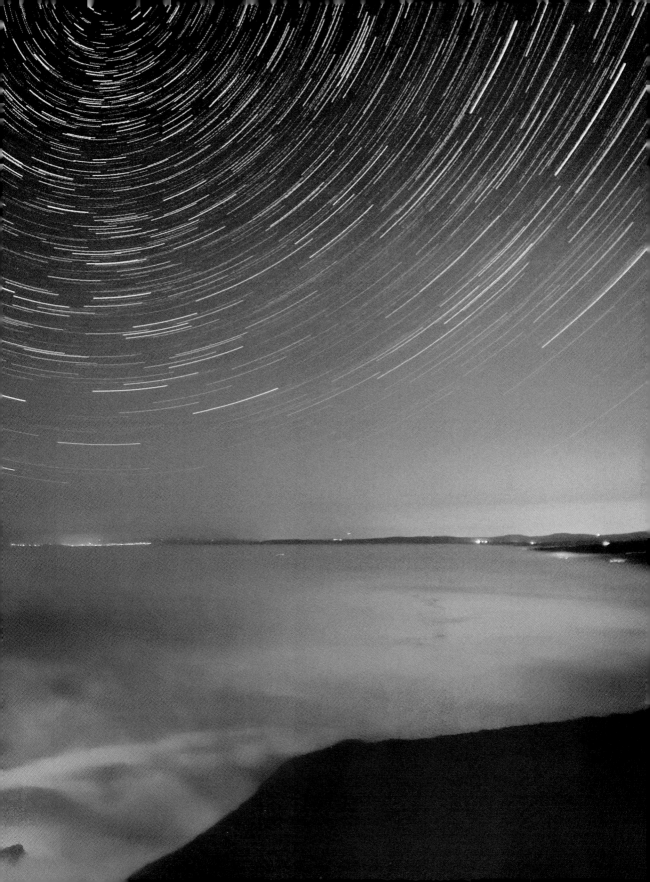

Stacking Software

I use the Statistics Script that ships with the Adobe Photoshop Extended (first introduced in the extended version of CS3) to create my star trail stacks. I'll show a detailed example of how I use Statistics to create my stacks starting on page 210. I believe that this is the most powerful tool available for creating stacks, and it yields the best high-resolution results. Since I'm already working in Photoshop, I can do all my post-processing work in one swoop.

But you don't need expensive software to create star stacks. There are quite a few options available at little or no cost, shown in the table below.

Software	Web address	Cost	Notes
DeepSkyStacker	http://deepskystacker.free.fr	Freeware	Easy-to-use interface with many options in this stand-alone program; does not provide digital darkroom options apart from stacking.
Iris	http://www.astrosurf.com/buil/us/iris/iris.htm	Freeware	This program is primarily intended for astronomical stacking applications rather than photography.
Photoshop Extended	www.adobe.com	Expensive; free trial versions available	This is the state-of-the-art, professional choice with many post-processing options besides stacking. It includes other stacking options besides the Statistics Script that I explain starting on page 210.
RegiStax	http://www.astronomie.be/registax/	Freeware	Full-featured stand-alone stacking program that includes registration (alignment); may be somewhat complicated to use; does not provide digital darkroom features besides alignment and stacking.
StarTrails	www.startrails.de	Freeware	Easy to use and produces great results with the limitation that input files can only be in JPEG format.

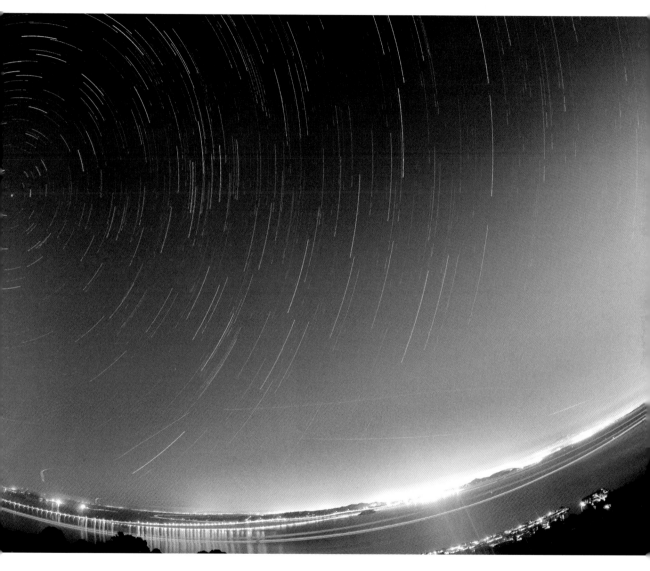

▲ In this stacked image of San Francisco Bay, the star trails don't appear as bright compared to the sky because of all the ambient light from nearby cities. Moving boats were captured in several of the images in the stack, and I decided to leave them in the final composite. (The light trail along the water is a ferry.)

For me, this image illustrates the activity that goes on above and around us that we are not aware of, even in big cities. In today's world, we are almost never alone.

10.5mm digital fisheye, stacked composite of fifteen exposures, each capture 4 minutes at f/5.6 and ISO 100, tripod mounted, total exposure time 1 hour

Combining a Stack in Photoshop

As I've noted (see pages 208–209), I use the Statistics Script, available in the Extended Edition of Photoshop, to process my interval-timed shots into a stacked composite. My choice to use Photoshop (compared to the other star stacking software that I've listed) is based on the ability to produce a high resolution stack. Photoshop also includes the functionality to handle all my digital darkroom needs.

When stacking, the first thing I do is inspect the images that I shot for the stack using Adobe Bridge. A few may be need to be eliminated from the stack, usually due to unwanted lighting effects or airplane motion in the sky; it is likely, however, that this will leave a gap in the star trails.

I open the acceptable images in Adobe Camera RAW (ACR), select all the images, and process them into PSD files using a single ACR setting.

As an example, I'll use a stack I shot at the historic Pigeon Point Lighthouse on the San Mateo coast of California. The giant light on this historic structure is lit once a year, and it always gathers crowds. I didn't want to be penned in by other photographers, so I found an isolated position across an inlet of water to photograph this event.

▶ This is the Adobe Camera RAW (ACR) window showing all 13 photos that will go into the stack, being processed at the same time. After converting the RAW images in ACR, they will be opened in Photoshop. Next, I'll save the images in Photoshop's native PSD format. After that, I'll use the Photoshop Statistics script to stack the images.

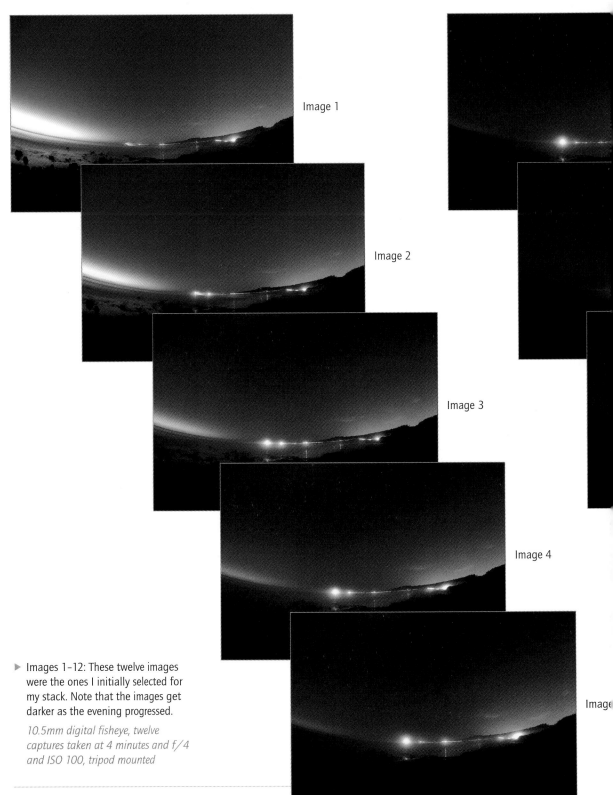

Image 1

Image 2

Image 3

Image 4

Image

▶ Images 1–12: These twelve images
 were the ones I initially selected for
 my stack. Note that the images get
 darker as the evening progressed.

 *10.5mm digital fisheye, twelve
 captures taken at 4 minutes and f/4
 and ISO 100, tripod mounted*

Image 6

Image 7

Image 8

Image 9

Image 10

Image 11

Image 12

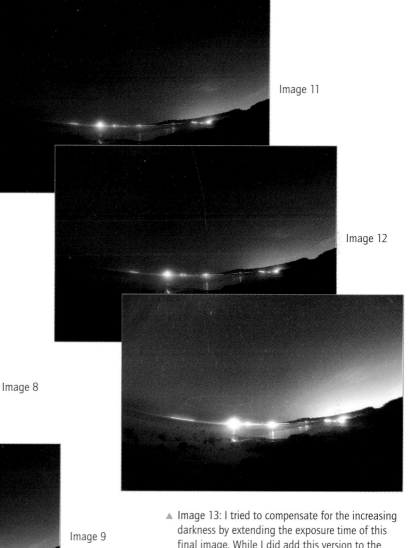

▲ Image 13: I tried to compensate for the increasing darkness by extending the exposure time of this final image. While I did add this version to the stack, ultimately it was not light enough to use as the foreground.

10.5mm digital fisheye, 8 minutes at f/4 and ISO 200, tripod mounted

Using the Statistics Script

Once all thirteen images were processed in Adobe Camera RAW, I saved them in Photoshop in the PSD file format. My next step was to open these processed images in the Photoshop Statistics Script window.

Note that I could have "saved" a step in this process by loading my RAW files directly into the Statistics Script without first converting them. I choose not to do this, and I make the extra step, because I want my interpretation of the data in the RAW file to be in place before the images are stacked together. I find that Photoshop's default rendering of RAW files taken at night can be way, way off.

Here's how to use the Statistics Script in Photoshop to stack a set of images.

Note: Setting the Stack Mode to Maximum in Step 2 gives you the brightest star trails. This setting is what I usually use. However, it is worth taking the time to play with some of the other stacking modes.

▶ Step 1: Chose File ▸ Scripts ▸ Statistics to launch the Statistics script.

▶ Step 2: In the Statistics window, select Maximum from the Choose Stack Mode drop-down list. Next, click Browse to select the folder in which the image set is saved. Click OK to run the Statistics script. Depending upon the number of images being stacked and the processing power of your computer, this could take awhile. (Some image sets that I've stacked have taken 45 minutes to process!)

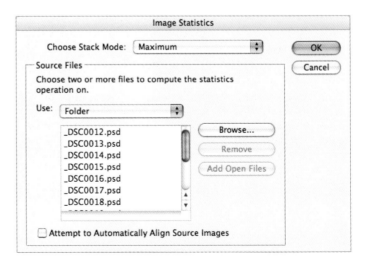

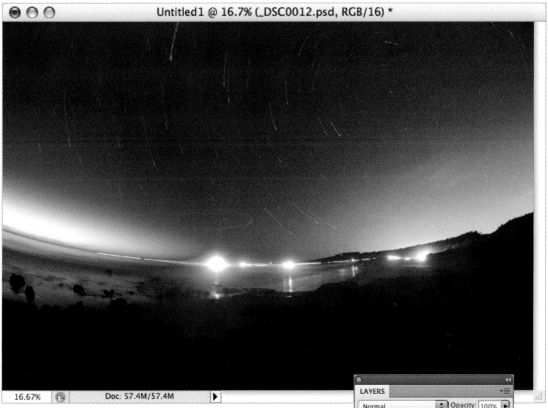

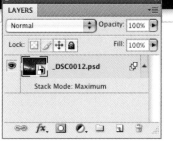

▲ When the Statistics script finishes stacking the images, the results appear in Photoshop as a smart object. (You can see the stacked image as a smart object in the Layers palette.) To continue to work on the image in Photoshop, you'll need to convert the smart object into a regular layer.

Looking at the results, I saw that the sky and star trails really looked good. However, that thirteenth image that I had exposed for the foreground for eight minutes had not worked as I wanted. The foreground was much too dark. *How was I going to save this image?*

Finding the foreground and saving the image

I had invested many hours into shooting this stacked image of Pigeon Point Lighthouse, but it wasn't coming out as I had pre-visualized it. The foreground was too dark.

I thought back to the afternoon and evening I had spent shooting this one scene. I literally had not moved from that spot for hours. In fact, I hadn't even moved my tripod or shifted the camera.

Inspiration struck: What if I use layers in Photoshop to combine an image that I took earlier in the afternoon showing the foreground with the darker, stacked image?

I went back to the captures from that shoot and found a photo with the afternoon sun lighting the foreground rocks and beach. Opening the image in Photoshop, I realized that I was back in business. My time hadn't been wasted; I would be able to finish the image.

▼ The sky in the stacked image looked great, but the foreground was way too dark. I wanted to see the details on the beach: rocks, sand and water.

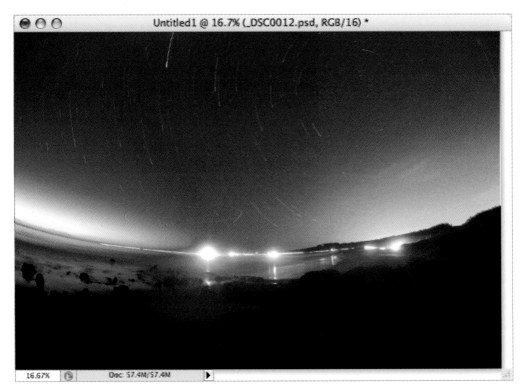

▽ I had taken this image in the late afternoon before shooting the image set that would later be stacked in Photoshop. Thankfully, I hadn't moved my tripod or camera, so it was possible to layer in this image showing the detail in the foreground with the darker stacked image.

10.5mm digital fisheye, 1/125 of a second at f/8 and ISO 100

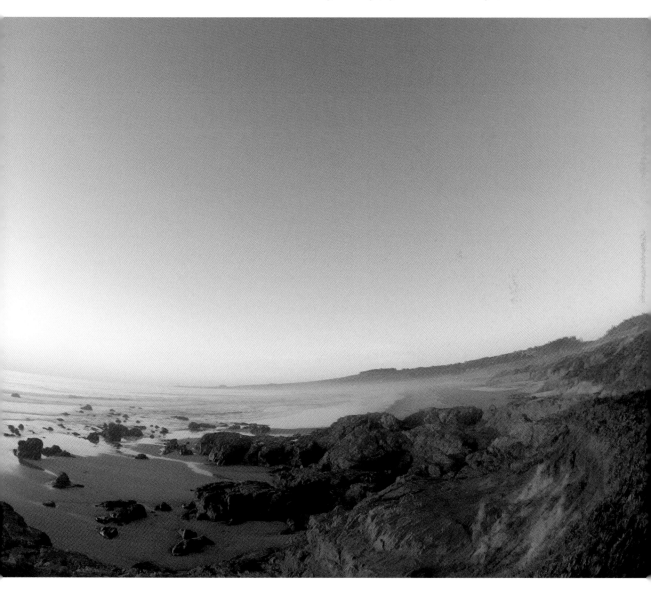

Layering the stacked image with the foreground image

With the stacked image and foreground image opened in their own windows in Photoshop, I combined them by positioning the foreground image on top of the stacked image as a layer.

Then, by drawing a gradient on a Hide All (black) layer mask on the foreground layer, I was able to reveal the foreground at the lower portion of the composite image while leaving the darker sky with star trails visible. This technique of using a gradient on a layer mask is also described on pages 132–133.

Once you get the hang of it, it is a simple operation that can be used to blend a lighter and darker version of the same scene. And it takes all of thirty seconds.

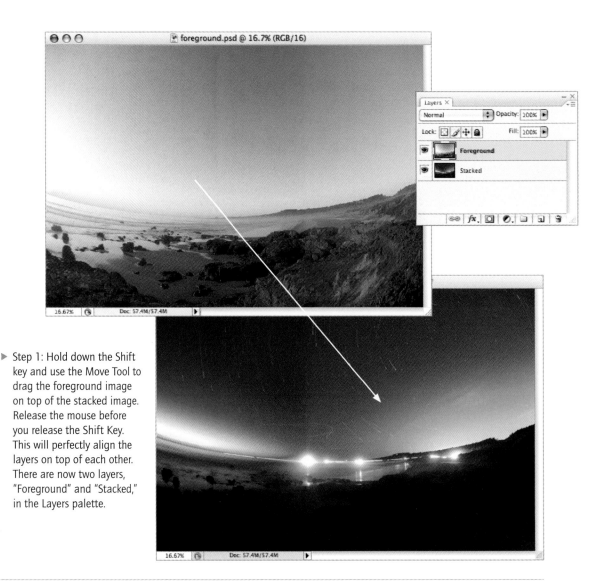

▶ Step 1: Hold down the Shift key and use the Move Tool to drag the foreground image on top of the stacked image. Release the mouse before you release the Shift Key. This will perfectly align the layers on top of each other. There are now two layers, "Foreground" and "Stacked," in the Layers palette.

▶ Step 2: With the "Foreground" layer selected in the Layers palette, choose Layer ▸ Layer Mask ▸ Hide All to add a Layer Mask to that layer. The Hide All Layer Mask hides the "Foreground" layer and appears as a black thumbnail in the Layers palette.

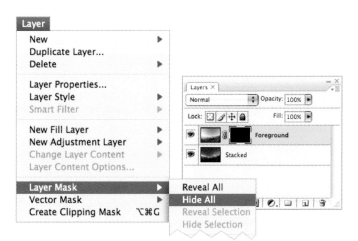

▶ Step 3: Make sure the layer mask on the "Foreground" layer is selected in the Layers palette. Choose the Gradient Tool from the Toolbox and drag a black-to-white gradient from the bottom third of the image window, starting roughly at the beach and extending down to the bottom of the image window. This will leave the star trails visible and lighten the foreground in a natural way.

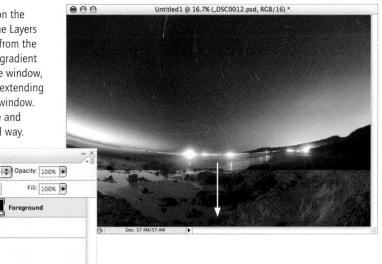

▶ The finished image shows the star trails in the sky and detail in the foreground. To see the image full-size, turn to page 222.

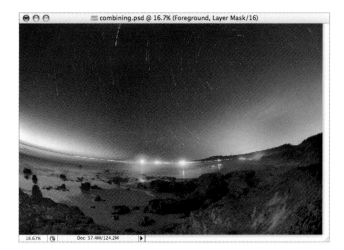

Finding a surprise

When I added up the hours of work that went into this image, I found that shooting alone totaled about seven hours. That's seven hours in one windy and treacherous spot, not moving the tripod by even a millimeter.

What I always worry about when I do a night photography trip that requires me to embed myself in a location long before dark...and then wait out the onset of night is: How hard will it be to get back out when this is done? Will the tide have come up? Will I remember how to get out? Will there be cliffs, potholes, poison oak or other obstacles to fall into or off of? It's this kind of suspense that keeps me on the tough but rewarding path of the night photographer!

Post-processing a stack does get easier as you get used to the concepts. But there are many captures involved. For each capture in a complex image involving multiple night exposures, it is still an experimental journey at the computer, with false starts and intermittent progress.

On top of all the time spent on location, I spent about ten hours post-processing before I noticed the airplane trail shown to the right. I'm not always pleased with airplane trails in my stacked photos—and sometimes remove the exposure with the trails from the stack, although this can leave a gap in the star trails.

But this red airplane tail light reminded me of a whimsical insect, flitting from point to point, and I think the oddball doodle that its flight path makes is the kind of serendipity that can make long exposures at night truly interesting.

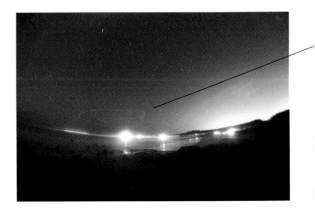

▲ After finishing the Pigeon Point Lighthouse image, I was surprised to find some red airplane trails in the sky. Looking back at the thirteen images I had stacked, I discovered that airplane trails only appear in the thirteenth image (shown above). This image was my original failed attempt at creating a foreground image for the set. (See this image with the entire set of photos on page 213.) So, this image wasn't a wash after all! If I hadn't extended the exposure time to eight minutes while taking the photo, I would have never captured the airplane trails.

10.5mm digital fisheye, 8 minutes at f/4 and ISO 200, tripod mounted

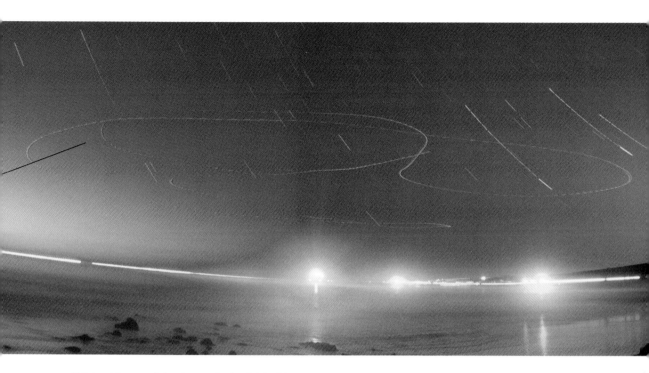

▲ This is a blow-up of the sky area in the finished image. You can clearly see the red airplane trails.

▲ Pages 192–193: The wreck of the *Point Reyes*, a fishing trawler, lies beached outside the town of Inverness, California, and is a favorite subject of mine.

To start, with the camera pointing north, I lined up the boat in front of the North Star. I used a digital fisheye lens to maximize the celestial rotation of the star trails. I tested the light with a one-minute exposure at ISO 800 at f/3.5. Then I made an eight-minute ISO 100 exposure (with in-camera long exposure noise reduction enabled) for the foreground.

Next, I turned off noise reduction and programmed my interval timer for twenty exposures, each capture at four minutes, ISO 100, and f/5.6.

When I looked at the photos I'd captured on my computer monitor, I saw that an airplane had made it into one of them. I decided to keep this visual anomaly in the final image; it appears as the straight line in the sky behind the ship.

10.5mm digital fisheye, composite of foreground (8 minutes at f/3.5 and ISO 100) and sky (stacked composite of twenty exposures, each capture 4 minutes at f/5.6 and ISO 100), tripod mounted, total exposure time 88 minutes

▼ Pages 222–223: This was an unexpected image for me in several ways: My hope had been to get closer to the lighthouse. Airplane trails in star photos are often a nuisance that need to be removed, but in this case I thought they added a touch of whimsy to the final stacked composite. (See blow-up of the detail above.) I had thought that by shooting a longer (eight minute) exposure and adding it to the stack that I'd be able to add foreground detail. But it didn't work. So I "rescued" the image by heroically compositing in a shot taken of the exact scene earlier, just around sunset.

10.5mm digital fisheye, composite of foreground (1/125 of a second at f/8 and ISO 100, photographed just after sunset) and sky (stacked composite of thirteen exposures taken at 4 minutes and f/4 and ISO 100, and one capture taken at 8 minutes at f/4 and ISO 200), tripod mounted, total exposure time about 62 minutes

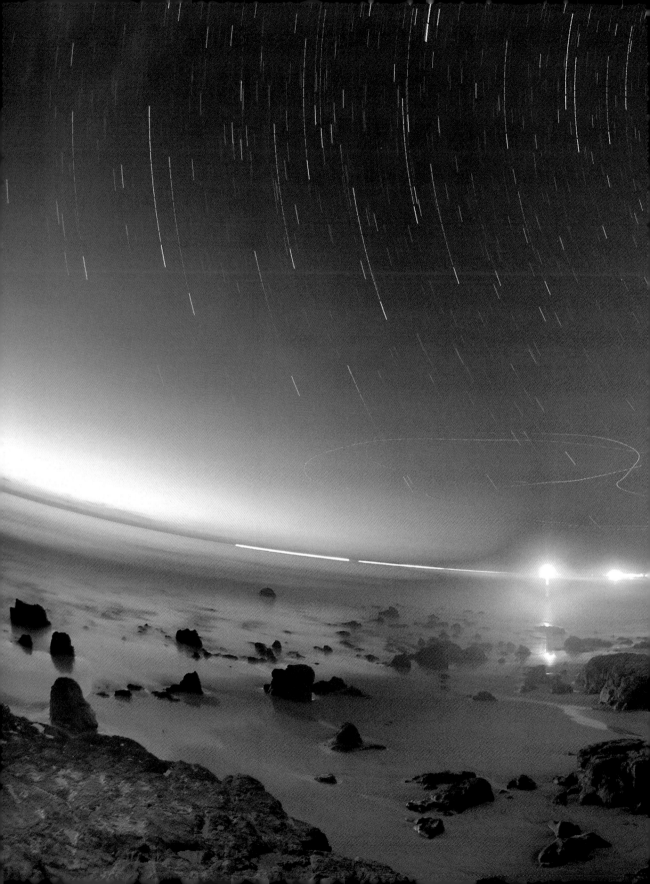

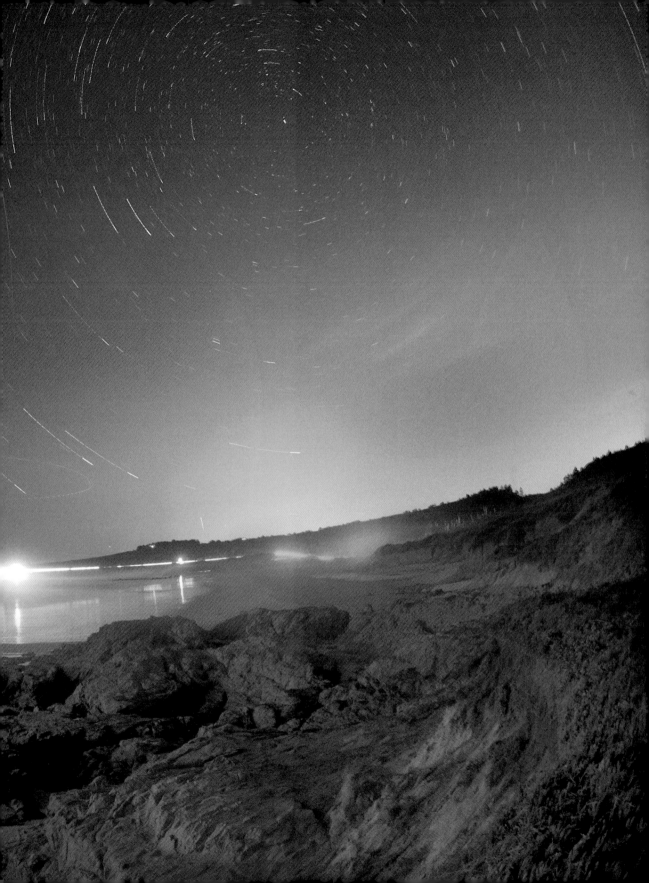

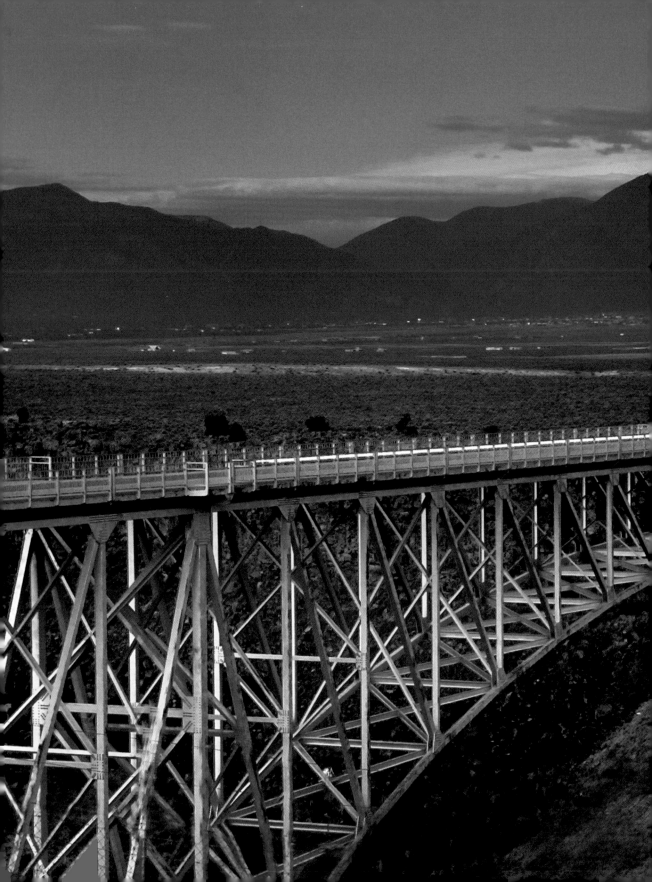

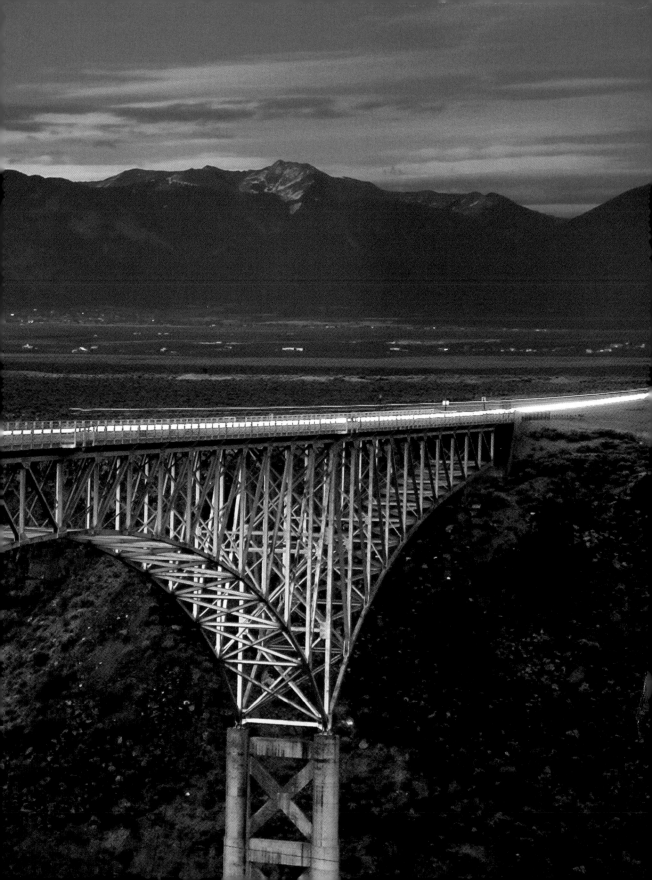

Programming an Interval Timer

A lack of sharpness in photographic images can be attributed to several issues. One of the most important to control is movement of the camera itself, because even the slightest movement of a camera can ruin a long exposure. No one likes to see hard work wasted. So start armed with the knowledge that you need to keep your camera shake-free.

Keeping a camera motion-free is the point of using a remote control, as well as its more sophisticated "big brother," the programmable interval timer. Before I explain how this piece of equipment works though, let me point out the basic things you need to know to reduce camera motion.

Reducing Camera Motion

When you press a shutter by hand at shutter speeds longer than 1/30 of a second—which is standard for all night photography—the very act of touching the camera will vibrate it and thereby decrease the sharpness of your photo. So you don't want to fire your shutter by hand at night. As I explain in a bit, a remote control is used to trigger the shutter of a camera at night to avoid movement.

A camera's **self-timer** can also be used in a pinch to fire an exposure, but it's not as effective as a remote control. A self-timer is not vibration free and a self-timer can usually initiate exposures only up to about thirty seconds (for reasons that will become clear in a moment).

For the most part, when you are making a long exposure, your camera will be mounted on a tripod. The photographs shown in this book were all taken using a tripod (or, in a couple of cases, improvised camera support).

When your camera is on a tripod, generally you should turn off **image stabilization** (also called vibration reduction), if your camera or lens has this feature. Since there are a very few exceptions to this rule, take the time to check your product manual to verify the setting you should use when the camera is on a tripod. Image stabilization is designed to compensate for vibration when you hold a camera, but it can actually add camera movement when the camera is on a tripod.

In night photography, **wind** can be a problem because it can cause a camera on a tripod to move. Some wind conditions are simply too intense to allow long exposures. In moderate wind, it helps to add weight to a tripod. You can place rocks around the tripod's legs or hang something heavy—such as a camera bag—from the hook that many tripods provide at the bottom of their center pole.

In a DSLR, when you look through the viewfinder and lens, a **mirror** is used so you see what the sensor would see. To take the actual photo, the mirror must be raised at the beginning of an exposure. Raising the mirror can vibrate the camera. A good way to mitigate this problem is to raise the mirror as a separate operation at least five seconds before you make your exposure.

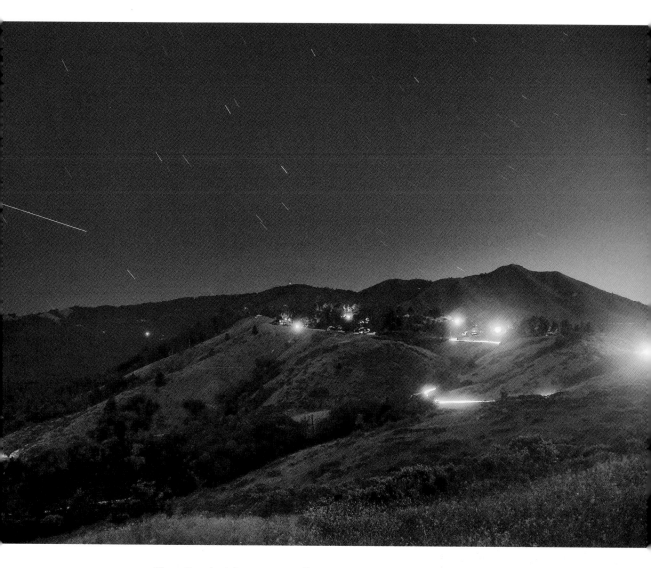

▲ Mount Tamalpais is near metropolitan San Francisco and displays quite a bit of light even in the middle of the night.

18mm, 5 minutes at f/3.5 and ISO 100, tripod mounted

▲ Pages 224–225: I stood at the edge of the Rio Grande Gorge near Taos, New Mexico, and waited for a car to come along the empty highway to cross the Rio Grande Gorge Bridge. I knew that a twenty-second exposure would create a nice abstract effect from the movement of the car headlight.

38mm, 20 seconds at f/16 and ISO 200, tripod mounted

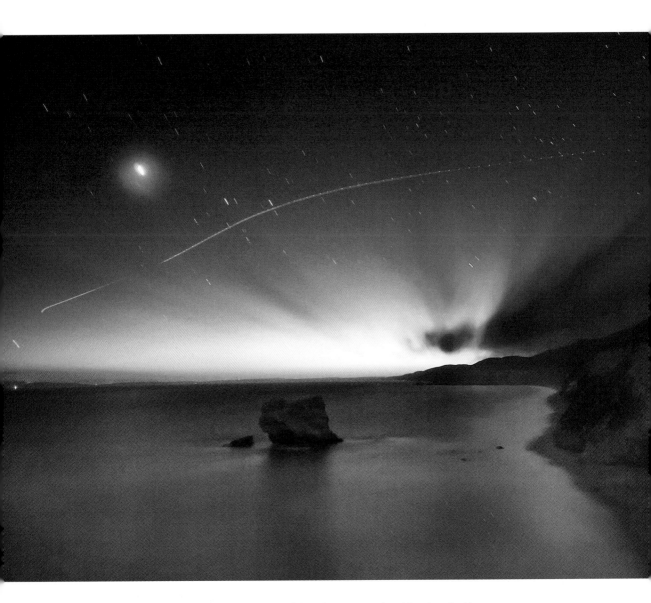

▲ This is a three-minute timed exposure from Arch Rock in Point Reyes National Seashore looking northwest up the coast toward Limantour Beach, Drakes Bay and the Point Reyes Lighthouse.

As I exposed the image, Venus was shining brightly in the sky and an airplane wandered across the night moonscape.

The waves were crashing below where I was standing with my camera and tripod, and there was quite a bit of wind blowing the clouds seen in this image. If you look carefully, you can even see reflected stars on the surface of the ocean.

15mm, 3 minutes at f/4 and ISO 100, tripod mounted

(Check your camera manual to see if it allows you to raise the mirror in advance of your exposure.)

You might expect that the longer the exposure, the more important it is to raise the mirror in advance. But, this is not the case. As exposures get really long, the amount of vibration that the action of the mirror adds at the beginning of the exposure becomes proportionally minimal. Raising the mirror in advance has the most significant benefit at moderate shutter speeds—between roughly 1/125 of a second and two seconds.

Using a Remote Control

A remote control lets you trigger the shutter from a distance. The remote control is connected to the camera on the tripod with a cable or via wireless. Both are fine. With a wireless remote, you can usually get further from your camera, and you don't have to worry about the remote cable falling off the camera. On the other hand, a remote control connected with a cable is simpler and less prone to failures.

Back in the days of film, there was a standard size "cable release" for the connector to a remote control. With the onset of digital, electronic communication with a camera has become more complicated. There is no one-size-fits-all connector. Only remote controls designed for use with your camera will work with your camera.

Simple remote controls provide a button; when you press the button, the shutter on the camera is triggered.

The longest shutter speed provided by most cameras is thirty seconds (although this does vary, so check your manual). To make exposures with a shutter speed longer than thirty seconds, you need to use manual exposure mode, with the shutter speed set to Bulb. On Bulb, the shutter stays open as long as it is depressed. (See page 45 for more about using the Bulb setting. Not all cameras have a Bulb setting, so once again, check your manual.)

The need to keep the shutter button depressed in order to keep the shutter open for exposures longer than thirty seconds explains why a self-timer is not a substitute for a remote control. You don't want to keep the button on the remote control pressed during a long exposure. Fingers get cold. Fingers get tired. It's easy to lose track of time in the dark.

Fortunately, even the simplest remote control usually has a lock, so you can press the shutter button and leave it locked in the "on" position.

However, this still leaves the problem of timing long exposures in the dark, which is more difficult than it sounds. It is surprisingly easy to get disoriented about time in the dark of the night. Often, you can't use a light because of your exposure and staring at an illuminated dial will ruin your night vision.

You can't arrange for a photo to be taken after an interval of time with a simple remote control. It just can't be done. In addition, if you want to take a timed sequence of shots, perhaps for use in a star trail stack like the ones I show on

pages 192–223, it's very difficult to achieve this with a simple remote control.

This leads to the need for a piece of equipment that you'll find in the gear bag of almost every serious night photographer: ta-da ... the programmable interval timer.

Benefits of a Programmable Interval Timer

A programmable interval timer runs on batteries and starts with the functionality of a simple remote control. It has a button that triggers the camera's shutter release, which can be locked in an "on" position.

Besides the simple remote control functionality, a programmable remote control provides a timed function that's used to set an interval before the exposure. It also lets you make timed exposures (used with Bulb shutter speeds) and set intervals between exposures for creating a stack or other time-lapse effects. There's a separate button that triggers the timed functionality as opposed to the remote control (see the figure below).

A programmable interval timer also provides illumination, so you can see what is going on at night. Yet it is dim enough to not interfere with your photography or night vision.

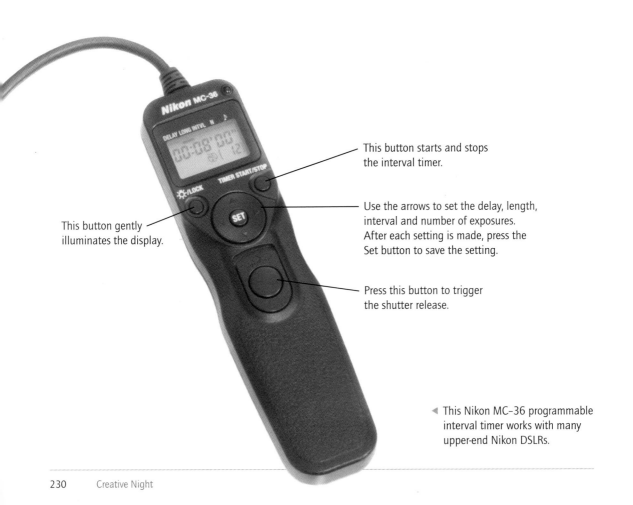

This button starts and stops the interval timer.

Use the arrows to set the delay, length, interval and number of exposures. After each setting is made, press the Set button to save the setting.

This button gently illuminates the display.

Press this button to trigger the shutter release.

◄ This Nikon MC–36 programmable interval timer works with many upper-end Nikon DSLRs.

Timers and Cameras

A good programmable interval timer costs between $100 and $200. Not all DSLRs can be equipped with one, so check your product documentation. If you have a choice between a programmable remote made by your camera manufacturer and a third-party remote, I suggest getting the camera manufacturer's product on the grounds of reliability, even if it is a little more expensive.

Generally, the least expensive DSLRs cannot be fitted with a remote programmable interval timer. The table below shows the two programmable interval timers that Canon and Nikon make, along with a list of some compatible camera models.

Brand	Programmable Interval Timer	Compatibility
Canon	Canon TC–80N3	Works with many upper-end Canon DSLR models, including the 1D, 1Ds, 1D Mark II, 1D/1Ds Mark III, 5D/5D-Mark II, 7D, 10D, 20D, 30D, 40D and 50D; it is important to note that it does not work with Canon Rebel DSLRs, and I don't know of any programmable interval timer that does.
Nikon	MC–36	Works with upper-end Nikon DSLRs with a Nikon 10-pin remote connector, including the D200, D300, D700, D3X

Using a Programmable Interval Timer

The first step is to connect the cord of the programmable interval timer to the connector on your camera, making sure the attachment is snug. It's often easiest to do this before you put your camera on the tripod.

Just like a simple remote control, a programmable interval timer has a button that presses the shutter release (and a lock). If your exposure isn't set to Bulb, this may be all you need to use, and you don't need to get into the complexity of the programmable timer.

If you do need to program the timer, set the following items in order.

Delay: If you want to start exposing right away, this should be set to "0." Otherwise, enter the delay in hours, minutes and seconds before you want the timed exposure (or exposures) to start.

Long: Set the duration of the exposure (or exposures) in hours, minutes and seconds.

Interval: If you are shooting a single exposure, this setting does not matter.

If you are shooting a sequence of exposures, and you want as little as possible time between the exposures, you have two options:

1. Set the interval to the least possible interval (one second), and set the *Number* of exposures to unlimited; or

2. Set the interval to one second longer than your *Long* setting, and set the *Number* of exposures to the number of captures you'd like as part of the sequence.

If you want a time delay between the exposures in your sequence, set the interval accordingly. (Note: If you've specified a **Number** of exposures, the interval starts from the beginning of the exposure, not the end of the exposure.)

Number: If you are taking one exposure, this setting should be "1." Otherwise, choose a number of exposures or use the unlimited setting. Just remember that with a specified number of exposures, the **Interval** starts at the beginning of the exposure, not the end of the exposure, and must be at least one second longer than the exposure time.

With your timer set, press the timed start button to begin your exposure or timed sequence of exposures.

A programmable interval timer gives you the ability to take really long Bulb exposures at night along with the flexibility to segment your exposures for noise reduction. Once you've begun exposing using this kind of remote cable, I'm sure it will become a permanent fixture in your camera bag.

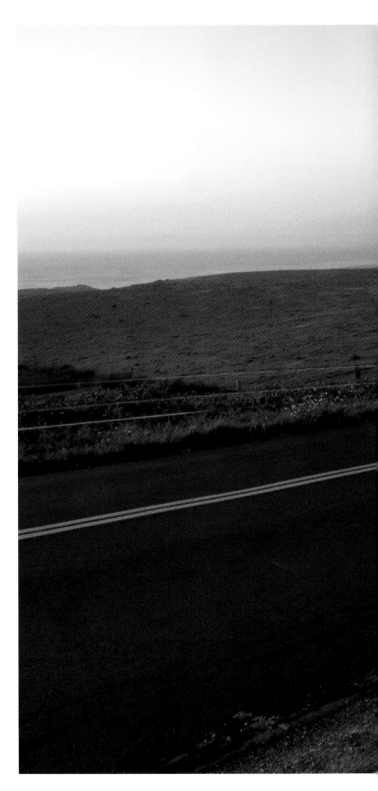

▶ I waited quite a while for a car to come along this deserted stretch of country road. I pressed the shutter release before the car came into view so I could capture its taillights as it passed.

18mm, 15 seconds at f/22 and ISO 100, tripod mounted

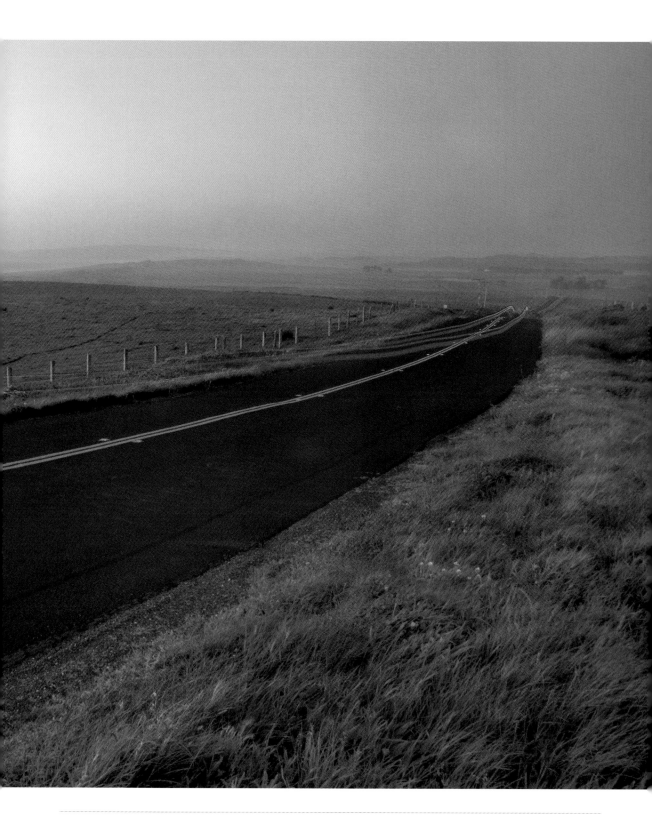

Resources and Websites

General night photography sites

Digital Night is my site with information about night photography: *www.digitalnight.us*

The Nocturnes is probably the classic source for information about night photography on the web: *www.thenocturnes.com*

Books about photographic technique

Harold Davis, *Creative Composition: Digital Photography Tips & Techniques* (Wiley, 2010), provides information about tools and techniques for visualizing and framing photos.

Harold Davis, *Practical Artistry: Light & Exposure for Digital Photographers* (O'Reilly, 2008), explains exposing digital photos.

Harold Davis, *The Digital Darkroom: Creative Digital Post-Processing* (Focal Press, 2010), explains Multi-RAW processing, Hand HDR processing, and digital black & white conversions

Sites about astronomy and the stars

Astronomy.com is a good site for general information as well as to learn about specific astronomical phenomenon: *www.astronomy.com*

Naval Astronomical Applications provides a portal with access to a great many astronomy resources: *www.usno.navy.mil/USNO/astronomical-applications*

The astronomy picture of the day is a great way to learn about the cosmos, and often beautiful, too: *http://apod.nasa.gov/apod/*

Spot Personal Satellite Tracker (page 22)

www.findmespot.com

Tripods and Heads (pages 26–29)

Gitzo: *www.gitzo.com*

Kirk Enterprises: *www.kirkphoto.com*

Really Right Stuff: *www.reallyrightstuff.com*

Gorillapod: *www.joby.com/products/gorillapod*

Understanding the night sky (page 156)

Find sunrise, sunset, moonrise, moonset, and rise and set times of all planets: *www.almanac.com/rise/*

Enter zipcode to get a star chart of where you are gazing from. On the star chart, click the star or planet for more info (including rise and set times): *www.wunderground.com/sky/index.asp*

Complete sun and moon data for one day at specified location: *http://aa.usno.navy.mil/data/docs/RS_OneDay.php*

Generate custom sunrise and sunset calendars listing local times: *www.sunrisesunset.com*

▶ Behind the picturesque fishing harbor on Monterey Bay, California, looms a gigantic natural-gas-fired power plant. I often wonder what compels some people to wreck the beauty that nature provides. Why site that power plant in such a special spot?

Perhaps it is to benefit night photographers. The power plant is always illuminated, and the lighting is interesting in both clear and cloudy weather.

55mm, 20 seconds at f/32 and ISO 200, tripod mounted

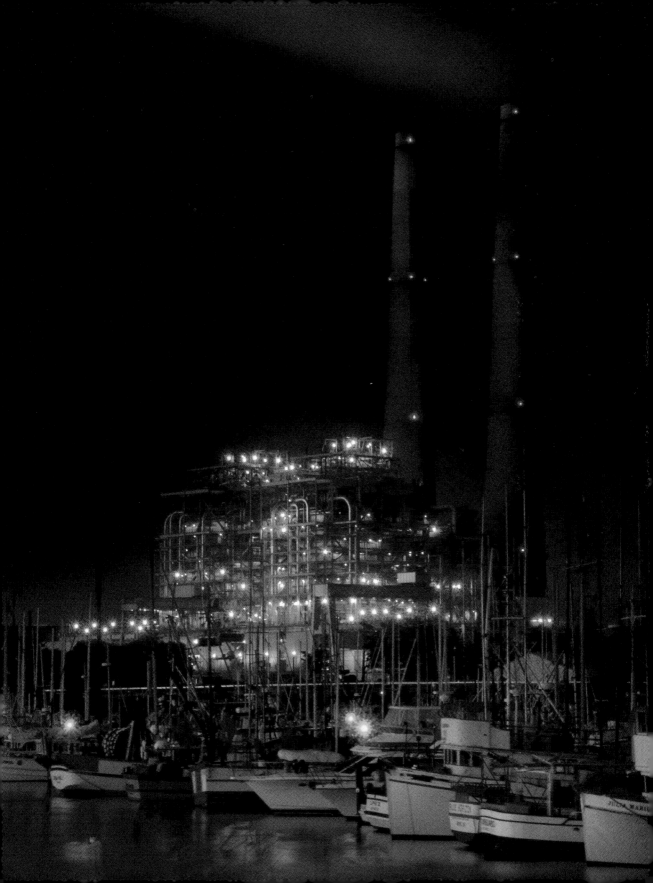

Glossary

Aperture: The size of the opening in a lens. The larger the aperture, the more light that hits the sensor.

Black frame: An image shot with the shutter closed or the lens cap on for the purpose of noise cancellation.

Black frame reduction: Combines a black frame with a photo in order to cancel noise in the photo.

Bulb: A Bulb exposure is one in which the shutter stays open as long as the shutter release is engaged.

CCD: *Charge-coupled device*, or filter, used to shift image signals from one spectrum to another.

Composite: Combined images that are used to create a new composition.

Depth-of-field: The area in front of and behind a subject that is in focus.

DSLR: *Digital Single Lens Reflex*, a camera in which photos are composed through the lens that will be used to take the actual image.

Dynamic range: The difference between the lightest tonal values one can see and the darkest tonal values in a photo.

Exposure: The amount, or act, of light hitting the camera sensor; also the camera settings used to capture this incoming light.

Exposure histogram: A bar graph displayed on a camera or computer showing the distribution of lights and darks in a photo.

f-number, f-stop: The size of the aperture, written f/n, where n is the f-number. The larger the f-number, the smaller the opening in the lens.

Focal length: The distance from the end of the lens to the sensor.

GPS: *Global Positioning System*, a radio-navigation system that provides location, navigation and timing services.

Hand HDR: The process of creating a HDR (High Dynamic Range) image from multiple photos at different exposures without using automatic software to combine the photos.

Histogram: A bar graph showing a distribution of values; see also *Exposure histogram*.

Image stabilization: Also called *vibration reduction*, this is a high tech system in a lens or camera that attempts to compensate for, and reduce, camera motion.

Infinity: The farthest distance a lens can focus.

ISO: The linear scale used to set sensitivity.

JPEG: A compressed file format for photos that have been processed from the original RAW image.

LCD: *Liquid crystal display*, a viewing device that's part of most digital cameras.

Long exposure noise reduction: When this setting is turned on, a camera shoots a black frame and uses noise cancellation to reduce long exposure noise.

Multi-RAW processing: Combining two or more different versions of the same RAW file.

Noise: Static in a digital image that appears as unexpected, and usually unwanted, pixels.

Noise cancellation: Uses black frame reduction to "cancel" the noise in an image.

Open up: To open up a lens means to set the aperture to a large opening, denoted with a small f-number.

Photo composite: See *Composite*.

RAW: A digital RAW file is a complete record of the data captured by the sensor. The details of RAW file formats vary between camera manufacturers.

Sensitivity: Set using an ISO number; determines the sensitivity of the sensor to light.

Shutter speed: The interval of time that the shutter is open.

Stack, stacking: Combining photos shot over time to create a single image with an effective exposure time of all the shots combined.

Star trails: Paths of light created by the apparent motion of the stars.

Stop down: To stop down a lens means to set the aperture to a small opening, denoted with a large f-number.

Vibration reduction: See *Image stabilization*.

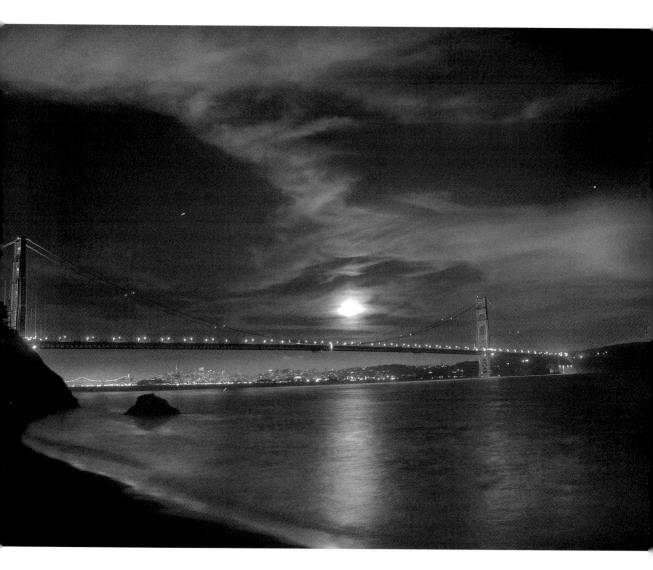

▲ Standing on a sandy beach near the Golden Gate Bridge, I shot this photo as the moon rose and the ambient light illuminated the clouds with an attractive, colorful pattern.

18mm, 6 seconds at f/3.5 and ISO 100, tripod mounted

Index

▼ I was struck by the patterns of light and dark and the mixed lighting sources shown in this composition. I stopped the camera down to a small aperture for depth-of-field so the foreground and background would both be in focus.

50mm, 20 seconds at f/20 and ISO 200, tripod mounted

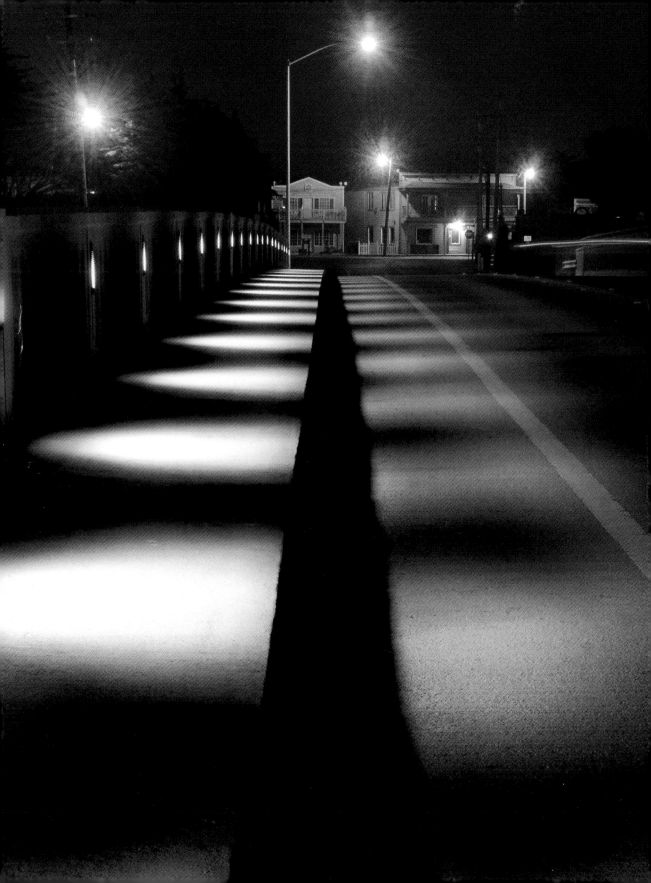